SECRETS *of*
SPINNING, WEAVING,
and KNITTING *in the*
PERUVIAN HIGHLANDS

NILDA CALLAÑAUPA ALVAREZ and
THE WEAVERS of the CENTER FOR TRADITIONAL TEXTILES of CUSCO

Publisher: Linda Ligon

Editor: Karen Brock

Contributing Editor and Consultant: Sarah Lyon

Design: Anne Clark

Text: © 2017 Nilda Callañaupa Alvarez

Photography: Joe Coca, Diana Hendrickson (except where noted)

Illustrators: Naomi Elting, Laurel Johnson, Michael Signorella

Cover image: Hilda Yesica Mamani Chura from Accha Alta and weaving from Pitumarca.

THRUMS
BOOKS

306 North Washington Avenue
Loveland, Colorado 80537 USA

603 Avenida del Sol
Cusco, Peru

Printed in China by Asia Pacific Offset

Library of Congress Control Number: 2017933267

DEDICATION

With humility and gratitude, we dedicate this book to the brilliant and beautiful young weavers of the *Centro de Textiles Tradicionales del Cusco.*

ACKNOWLEDGMENTS

This project would not have happened as a personal effort; it has been a team project, which is why my deepest thanks go to all who have shared their knowledge and time.

My first recognition is to my dearest friend and project partner Linda Ligon. Without her commitment effort, and vision, this book would not have been published. Also, to Karen Brock for her work in editing and making important additions to the book; to our dearest Joe Coca for his passionate and professional photographs; to Diana M. Hendrickson for her time, effort, and important contributions to photography, and to Sarah Lyon for generously sharing her time, for helping me with the English text, and for making important additions to the book. To Laverne Waddington and Ann Budd for so willingly sharing their expertise in reviewing the weaving and knitting chapters.

My appreciation also goes to my dear husband and sons for supporting me, to my sister Flora for assisting me in the project, and to extended family for their help. To the board members of the *Centro de Textiles Tradicionales del Cusco* who encouraged me to take on this project, and to Thrums Books for publishing the book.

I owe my deepest thanks to the young and adult weavers for their time and patience in showing their work and for their efforts to clarify all of the complicated techniques from the ten communities: Accha Alta, Acopia, Chahuaytire, Chinchero, Huacatinco, Mahuaypampa, Patabamba, Pitumarca, Santa Cruz de Sallac, and Santo Tomas.

It is impossible to list all the people who have played an important role in this book, but I extend my thanks to all of them, especially the weavers for sharing their rich knowledge of the textiles and traditions of the Andes.

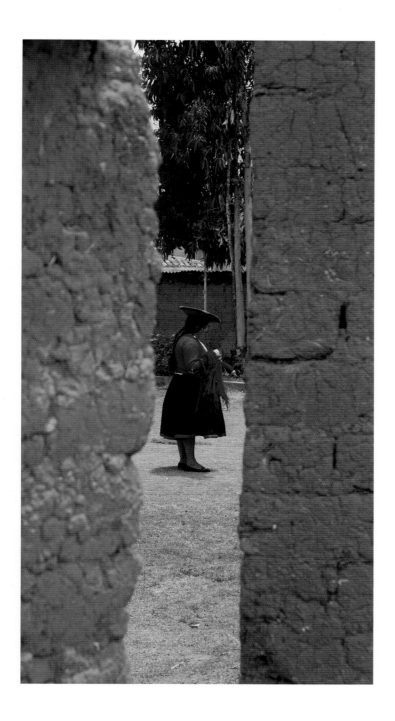

CONTENTS

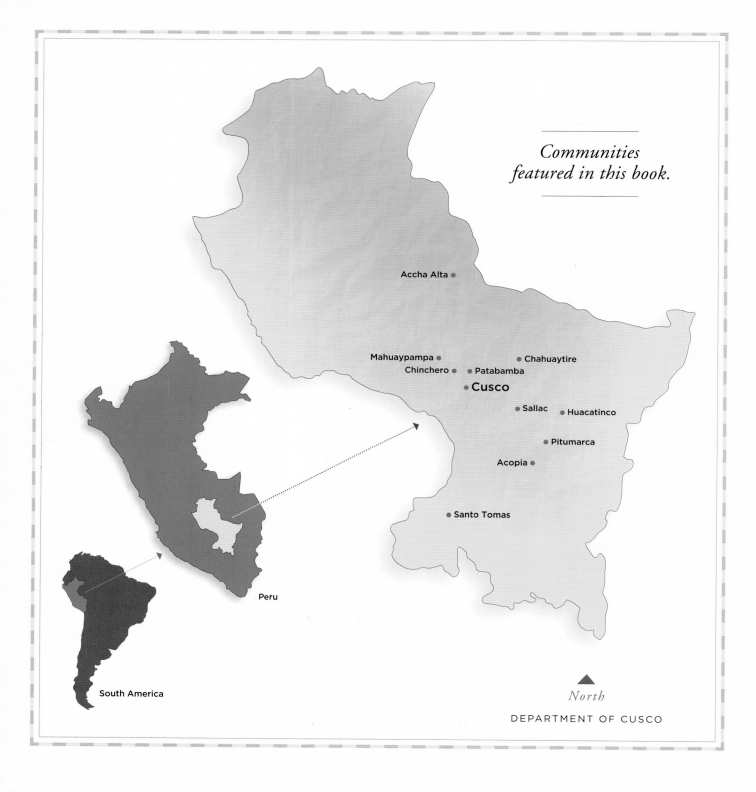

Communities
featured in this book.

Accha Alta

Mahuaypampa ● ● Chahuaytire
Chinchero ● ● Patabamba
Cusco

● Sallac ● Huacatinco

● Pitumarca

Acopia ●

● Santo Tomas

Peru

South America

North

DEPARTMENT OF CUSCO

LIVING THE TRADITION

This book was inspired by the young weavers of the *Centro de Textiles Tradicionales del Cusco*, Center for Traditional Textiles of Cusco (CTTC). With joy and pride, they have worked relentlessly to learn from their elders about the creation and use of traditional textiles. In the Andes, textiles are not a hobby; they are a way of life. To live is to create textiles, and in creating textiles, you live. The young weavers know this to be true and are dedicated to the hope that this traditional way of life will not only continue, but will flourish and inspire the lives of others.

In their quest to learn and to continue these traditions, the young weavers play the role of both student and teacher. As they watch their family members weave and as they study complex textiles to learn new techniques, they are students. Every day of their lives the young weavers strive to learn more, to discover more, and to expand their understanding of the complex textile world they were born into. Once they have mastered a new design or technique, however, students become teachers as older siblings help younger brothers and sisters, and friends work together to share knowledge.

Young weavers today are facing many challenges due to globalization, but what they learn about their weaving traditions and practices will stay with them. These young weavers may continue to weave throughout their lives, or they may return to these practices later and perhaps even teach them to others. In this way, the textile traditions will be carried forward for at least a few more generations.

As we embarked on yet another book, the young weavers were also our teachers. They brought us into their world and guided us over warp and under weft. As they talked about the tricks to get unruly threads to cooperate, their passion for their heritage and culture shone through their eager explanations. The basis of this book is the young weavers' enthusiasm and energy for carrying forward the knowledge of their ancestors.

In the pages of this book, the young weavers will be your teachers. They chose to share what they have learned with you out of the hope that it will help you develop a deeper respect for the complex patterns of knowledge that are contained in each method of manipulating fiber into a finished form. This book, by necessity, is but a brief glimpse into the textile traditions of the Cusco region. No book would ever be able to contain everything there is to know about this complex world, nor should it. Andean textiles are a living art, and to understand them fully they must be lived. The young weavers helped to show us what this truly means.

CENTRO DE TEXTILES TRADICIONALES DEL CUSCO

The CTTC is a nonprofit organization that was founded in 1996 by indigenous weavers of the Cusco region and their supporters in the United States. Its mission is to "promote the empowerment of weavers through the sustainable practice of Peruvian ancestral textiles in the Cusco region. Through workshops, opportunities, and the promotion of their textile art, the CTTC enables weavers to maintain their identity and textile traditions while improving their quality of life." Since 1996, the CTTC has partnered with ten communities in the Cusco region: Accha Alta, Acopia, Chahuaytire, Chinchero, Huacatinco, Mahuaypampa, Patabamba, Pitumarca, Santa Cruz de Sallac, and Santo Tomas. In each community, the weavers work toward strengthening and preserving the many traditions, styles, designs, and techniques that are unique to each.

The last two decades have been devoted not only to empowering the weaving communities, but also to building a museum; developing a permanent collection of textiles; researching, documenting, and publishing information about the textile traditions; creating a catalogue of the designs of each community; and developing a fair-trade market for traditional textiles, among many other goals. The CTTC hopes to focus future work on gaining recognition for Andean weavers as global artists and assuring the continuity of ancestral textile practices. In pursuit of this, the organization hopes to see its Education Department take the lead in inspiring new research, conservation, publications, educational events, and more in the field of Cusqueñan textiles. A great deal of work remains to be done so that traditional textiles are valued and treated as living art rather than simply as commercial goods for tourist markets. The Education Department hopes to promote in-depth investigations into textile traditions in order to promote the re-evaluation of this ancient way of life.

—*Nilda Callañaupa Alvarez*
Founder and Director

THE EDUCATION DEPARTMENT

The Education Department at the Center for Traditional Textiles of Cusco encourages interaction between weavers and the public through a variety of programs. Each year the department holds events for the weavers, the young weavers, and the general public to teach about textile traditions and to inspire greater respect for them. For the adult weavers and young weavers this includes activities such as annual weaving competitions, classes on ancient Peruvian textiles, and workshops to revive pre-Columbian techniques. For the general public, the Education Department has organized everything from weaving classes at local elementary schools to local and international exhibitions of the weavers' work.

Currently, the Education Department at the CTTC manages a library, publications, and a permanent collection of textiles, and conducts a broad range of investigations into textile traditions, such as recovering the natural dying process. The Department also organizes the international conference *Tinkuy: Gathering of the Weavers*, and works with the Young Weaver Groups. Out of all of this, it is the work with the young weavers that is most important. They are the future of Cusqueñan textiles, and with them rests the fate of this ancient way of life.

THE GUIDING THREAD

The Young Weaver Groups began in Chinchero in the early 1990s before the official establishment of the CTTC. At this time, the weavers met informally, working toward a future for their textiles. A group of children and adolescents also formed under the support of Elizabeth and David VanBuskirk, who were instrumental in later forming the CTTC. The group called themselves the Jakima Club as they learned to weave *jakima*, narrow bands used to teach basic techniques and designs. At the end of each year, the VanBuskirks would buy all of the jakima the children made, not because they needed yet another bracelet or band, but to encourage the young weavers to keep learning. The children used this small income to buy school supplies, or like many children, to buy sweets and trinkets. Above all, though, the money they earned by weaving helped teach them the value of this traditional art and motivated them to keep learning more complex techniques and designs.

Over the years, the Jakima Club grew. While most of the original members were children of the adult weaving group, families from more distant communities began to send their children to learn how to weave, realizing it was a valuable life skill that could provide them with a future. The group not only grew in size, but also in talent. From weaving just jakima in the most basic designs, the young weavers advanced to weaving more complex patterns in *chumpi* (belt), scarves, *ch'uspa* (a bag for coca leaves), and eventually

the traditional blue and red Chinchero *lliqlla* (shawl or carrying cloth). The quality of their weaving also improved, but most importantly, the young weavers learned to value and take pride in their textile traditions. They began to dress in the traditional clothing from Chinchero, leading the way for the adults to also feel comfortable in proclaiming their identity through their textiles.

When the CTTC was formally established and began to grow, the Jakima Club served as an inspiration and guide for other communities to establish groups for their youth. The Jakima Club name was changed to Young Weaver Groups because the term jakima is specific to Chinchero, and other communities use different names for this textile. All ten communities now work with a group of child weavers. Each group functions under its own leadership and elects a president, vice president, and other functionaries every two years. Today, there are more than 200 children and adolescents in the Young Weaver Groups, whose ages range between six and thirty. (Youths are not considered adults until they marry and establish their own household, so while the majority range in age between five and twenty, there are a handful of young weavers in their twenties as well.)

The groups have grown so large that many divide themselves into categories: First, Second, and Third. First Category is composed of the best weavers, those who have mastered all or nearly all of their community's techniques and designs. Second Category contains intermediate weavers, while Third Category is composed of beginner weavers. In many of the communities, members of the First Category share duties on a rotating basis to help teach the Third Category. In addition to their structure of self-organization, each Young Weaver Group also counts on the help of a Coordinator, a weaver from the adult association who helps instruct the children.

Participation in the Young Weaver Groups also serves as preparation for becoming a member of the adult weaving associations. Like any group of young people, the children and adolescents face the difficulties of learning to work together, share, and problem solve. On top of this, they must deal with the challenges of supporting members of their group who are orphans, abandoned, or come from abusive families and extreme poverty. In teaching the basics of community organization, the Young Weaver Groups help prepare the children for the future task of running specialized associations of textile artists who are often called on to assume many different roles in their communities.

Today, the young people are far advanced on the path of becoming master weavers like their parents and grandparents. Unlike many of their older family members, however, this generation has greater access to modern education. Whereas many adult weavers may be illiterate or were only able to access schooling up to sixth grade, in many cases the young weavers are now able to finish high school. With this education and their experiences in

the Young Weaver Groups, many are assuming leadership positions in the adult weaving associations, often as secretaries. Others have organized new groups of weavers to start other textile centers and associations.

In addition to completing high school, there are a number of young weavers who are taking advantage of opportunities in the city of Cusco to pursue higher education. Many seek degrees in anthropology, archaeology, and tourism at universities, while others follow technical degrees at institutions. From the community of Chinchero, two young weavers have already graduated from institutions with degrees in the tourism industry, while four others continue to study at the university. Two young weavers from Pitumarca are close to finishing university degrees, while a number of young weavers from Chahuaytire are just starting their studies in Cusco.

Many of these young weavers have found it difficult to move to the city and follow a path of higher education. They often miss their families and try to return home each weekend to visit, despite the long bus rides and travel expenses. With their classes and jobs, it's even harder for them to remain active in community life. Festivities for different traditions such as Carnival, saints' days, and anniversaries often take up many days, even weeks. The young weavers who choose to study in Cusco find it almost impossible to continue dancing and singing in these celebrations because they can't take off the time to return to their communities to participate. Some, like Yanett Soto Chuquichampi, have joined musical groups in Cusco that seek to recover old songs and dances. While Yanett would still like to continue dancing and singing in Pitumarca for Carnival and other festivities, she now has the opportunity to learn older songs and share her traditions with the public of Cusco.

Continuing in the Young Weaver Groups is also a challenge for these young people. Many university classes, especially those for tourism majors, take educational trips on Saturdays. Rosa Pumayalli Quispe explains that during her time at university "It was a little complicated, as I was still in the Young Weavers Group (which meets Saturdays) and there were school trips on Saturdays at times." Despite the conflicting schedules, she says that her time with the Jakima Club in Chinchero helped her immensely with her tourism degree. While her classmates from the city or less traditional backgrounds had to learn everything from the beginning, Rosa already had a deep understanding of textiles and other traditions.

Despite their current challenges, these young weavers hope that one day their degrees will help them to achieve their dreams. They often talk about what they would like to do in the future, and the numerous plans they have. Many talk wistfully about having the time and funds to return to their communities and conduct further investigations into their

textiles and traditions. Some hope to write books, and others dream of opening museums in their communities where they can teach visitors about the beauty and power of their people.

All of the young weavers, from the youngest to the oldest, and not just those pursuing higher education, are highly conscious of the future and the role they will play in it. They know that the continuity of their traditions depends on them, and they talk with pride of this responsibility. They also know the challenges they will face as they strive to balance a life of tradition in a world that is quickly modernizing. They already face the challenge of balancing their weaving education with a modern one, and the unique difficulties and opportunities this presents. Jeny Flores Layme, a young weaver from Accha Alta, was ten years old when she spoke for all the young weavers, saying, "We really like weaving in the center of weavers in our community. From Monday to Friday we study in our school and Saturday and Sunday we weave. We would like to weave and learn even more, this is our passion, and although we might enter professional careers, we will never stop weaving." It is this passion that drives the young weavers toward their future, and this passion that sustains them through difficulties and challenges.

As they look toward the future, the young weavers are above all hopeful. In their textile traditions, they have found the guiding thread that will lead them to their futures. The thread of each young weaver may lead in a different direction. Some will follow their threads to take up leadership positions in their communities and associations, while the threads of others will pull them to the city to study. As their lives overlap, these threads will weave together a future not just for the young weavers, but for their communities and for their textile traditions as well. While these threads of tradition extend far into the past, they are pulling the young weavers forward into the future as well. While it is not always clear where they will lead, the young weavers follow eagerly, hearts and minds filled with the designs and techniques of their people.

—*Sarah Lyon*
Education Department Coordinator

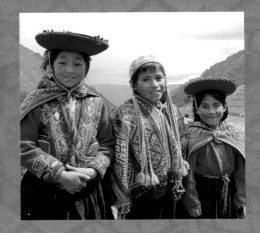
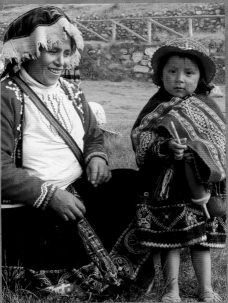

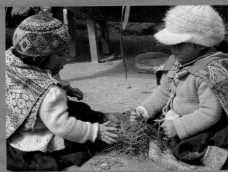
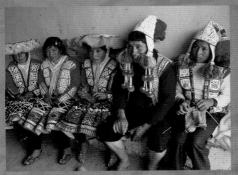
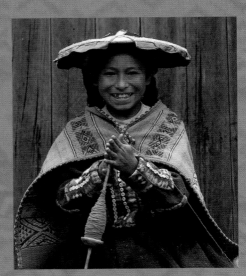
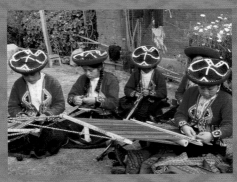
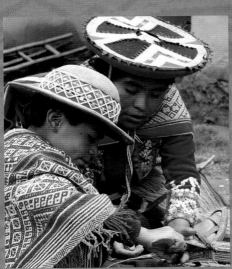

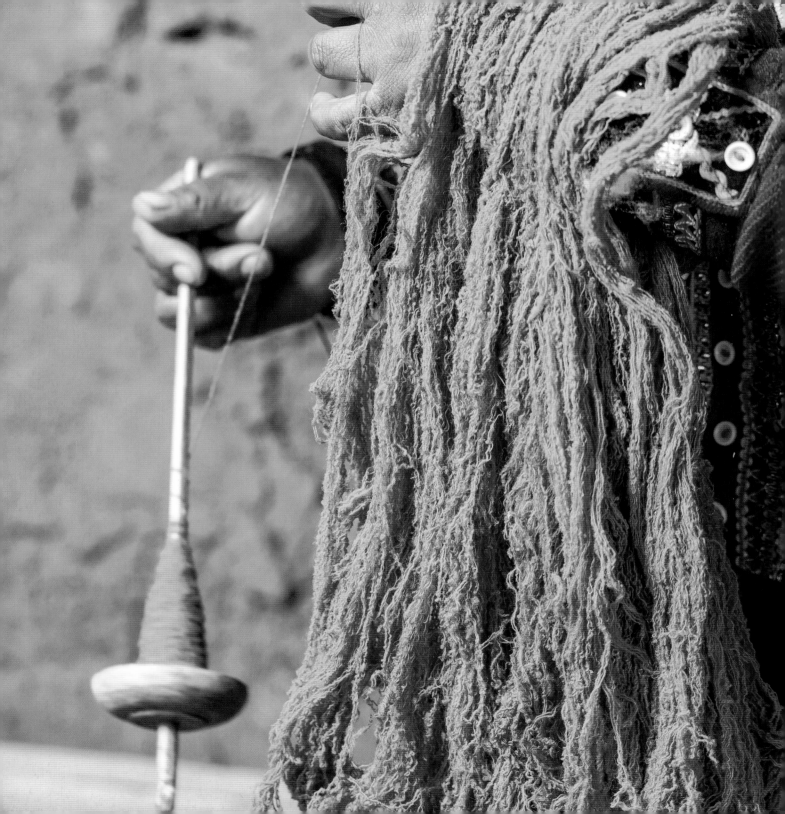

THE SPINNING LIFE

In the Andes, spinning is the most fundamental activity in the creation of any textile, and it is timeless. For thousands of years, people have been turning camelid fibers and sheep's wool into thread using the simplest of tools: the *pushka*, or hand spindle. Every new textile requires vast quantities of thread. Spinning is a never-ending pursuit and pushkas are the constant companions of idle moments. Over the course of a lifetime, spinning frames a spinner's world between two hands that are never at rest but always teasing fiber into thread.

Learning to spin is an organic process. From birth, children watch family and community members spinning. Peering out from their cocoon of blankets on their mothers' backs, babies are mesmerized by whirling spindles. Toddlers pick up pushkas and put them in their mouths, poke them in the dirt, use them as playthings. By the time a child is about five or six years old, she tries using a spindle for its true purpose.

For children in the Andes, the pasture is the original classroom. Children are put in charge of their families' flocks of alpaca, llama, sheep, and other animals, and with time to spare and little else to do, they play and experiment with spinning. Oftentimes groups of friends work together while elders and neighbors point out mistakes and offer suggestions for improvement. The first threads

LEFT TO RIGHT: Andrea Chura, Presentación Huaman, and Lourdes Chura Gutierrez, all from the community of Accha Alta enjoy the centuries-old tradition of spinning together.

APU: mountain god

BAYETA: plain-weave cloth

CHICHA: fermented corn beverage

COSTAL: handwoven sack

GUANACO: wild camelid

KINTU: an offering of whole coca leaves usually presented in a group of three leaves

LLIQLLA: (Quechua) a specific term for a type of women's shawl or carrying cloth

MANTA: (Spanish) a general term for any type of shawl, handwoven or machine made, including lliqlla

MISHMI / MISHKUY: a short stick used to twist llama fiber

PACHAMAMA: Mother Earth

PAÑA LLOQE: S-spun yarn plied in the Z direction

PLYING: twisting two or more strands of yarn together to make a stronger thread

PUKHU: spinning using a small ceramic bowl for support

PUSHKA: hand spindle

ROVING: length of prepared fiber

SKEINING: one method for winding yarn off of the spindle

VICUÑA: wild camelid

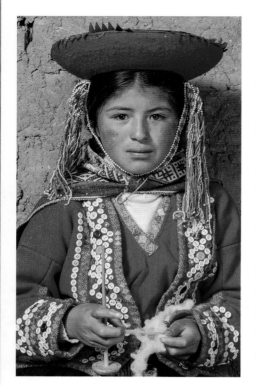

children produce are usually destined for use by their family except that which they keep for themselves to practice and experiment with as they begin to weave their first projects. By the time they are nine to twelve years old, depending on how much practice they put in, children can produce thread fine enough for any weaving project their family needs.

While children play with spinning in highland pastures, they often meet elders who are spinning masters, elders whose hands are so gnarled from long years of work that they look like the twisted roots of an old tree. These hands, however, produce the finest, most beautiful yarn imaginable and children become enamored with all the different types of pushkas and fiber these elders have tucked away in their carrying cloths. Each day these older community members will spin from dawn to dusk while tending their animals, producing a pushka full of thread or more, always with an intended purpose in mind. One day they spin for a neighbor while another day they may spin for the family's use. They are so efficient and so confident, children look at their hands and dream of one day becoming as knowledgeable and wise.

Today in villages closer to urban hubs and major roadways, fewer and fewer children go out to pasture animals and spin. Instead they focus more on modern schooling and modern activities. In remote communities where traditions are preserved more strongly, children continue to pasture their family's herds and learn spinning in the centuries-old way.

If childhood is dedicated to spinning, adolescence is dedicated to weaving, while married women and men spend the majority of their time caring for their family and making a living. Although adults do not leave off spinning entirely, they simply do not have the time to create the huge amounts of thread that they did before. Spinning, however, always remains a part of daily life. Community members are judged for their spinning ability, and people always chatter about who is a good spinner and who is a *waylaka* (lazy good-for-nothing) who cannot produce quality yarn.

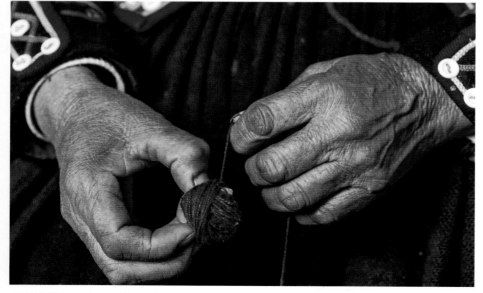

ABOVE: Thirteen-year-old Lourdes has been spinning since she was seven. She practiced spinning sheep's wool for one full year before she began to spin the much finer, and much more difficult, alpaca. BELOW: Santusa Huaman from the community of Chinchero winds plied yarn onto a stone to form a tidy ball.

As community members grow older, many return to spinning as to an old friend. It takes strength to work a *chakra* (field) and strength to use a backstrap loom. Many elders find that their aging bodies, arthritic hands, and deteriorating eyesight are no longer up to the challenge. Picking up their old pushkas, they return to a well-known activity that can support them both economically and mentally through their old age. Even the blind are able to spin by feeling the texture of the yarn.

Elders will spin for their families and community members. In exchange, they are gifted with animals, food, coca leaves, money, and other useful items. Spinning can become a valuable means of economic support and even survival if an elder has no remaining family members to care for her. Spinning allows older people to remain independent while contributing in a meaningful way to their communities.

Spinning also provides emotional support to older community members. The repetitive motions of whirling the pushka between their hands, letting it drop and spin, winding it up, and beginning the process over again establishes both a physical and mental rhythm that is relaxing for people of all ages. Many people explain that spinning is a form of meditation, a way to forget personal problems. Producing a well-crafted ball of yarn to share with family or to gift to friends is an added allure.

While children and elders typically are the ones to dedicate themselves to spinning, some people choose to dedicate their entire lives to the pursuit of creating high-quality thread. Not all spinners are weavers; some choose instead to focus only on the creation of yarn. Rather than weave their own textiles, they send out their yarn to be woven for them.

Whether you are a child just beginning or an elder revisiting a loved activity, spinning is a special process. It is a community-wide language that everyone understands. People come together to chat and spin, to walk and spin, to work and spin. It is also a personal language that individual spinners use as they sit for hours in personal contemplation. The true beauty of spinning is that it does not require physical strength, or space, or expensive materials. Spinning requires only some fiber, a desire, and the patience and willingness to do it.

While today industrially spun yarn is readily available in every type and size, it will never replace handspun yarn in the emotional, cultural, and physical role that it plays in the life of a community. Handspun yarn represents an individual spinner and her family, as each thread is as unique as the spinner who created it. Handspun yarn takes on such importance in the lives of spinners that they will save yarn from the different periods of their lives, bringing it out later to recall memories and past experiences. Yarn is passed throughout a community, traded or gifted between family members, neighbors, and friends. People will save balls of yarn

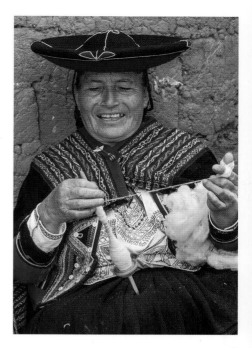

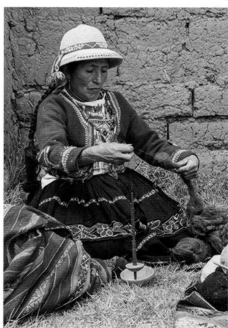

ABOVE: Engracia Quispe Castro from Chinchero has been spinning since she was ten years old. BELOW: Victoria Condori de Tinta from Acopia spins with a supported spindle.

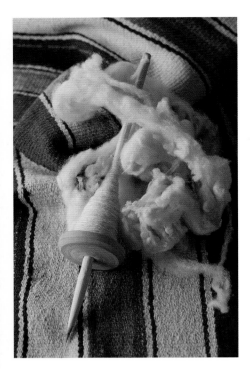

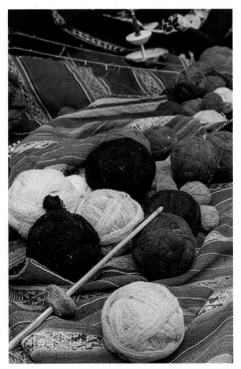

from the best local spinners, proud to own a piece of history, culture, and identity. Physically, each handspun yarn is unique in texture, fineness, and strength, lending these qualities to the textile it will become. Finely crafted balls of yarn are the true wealth of a spinner and her village.

FIBER VARIETIES IN THE ANDES

Historically, many types of fiber were available to the people of the Andes: llama, alpaca, guanaco, vicuña, and cotton. Cotton, a plant fiber that originated on the warm coast of Peru, was traded in ancient times by the people of the coast with the people of the sierra; today it is used only in some parts of the coast and in the jungle.

The most common fiber in the Andes is protein fiber that comes from animals rather than plants. The llama, alpaca, guanaco, and vicuña are all members of the camelid family and are native to the Andes. While the alpaca and llama have been domesticated, the guanaco and vicuña are wild and roam the altiplano freely to this day.

Vicuña naturally populate the altiplano of the Andes, especially just to the south on the high plains surrounding the city of Arequipa. Vicuña produce the softest, most luxurious animal fiber in the world, making it highly sought after and extremely expensive. Illegal poaching and shearing, in which hunters killed the animals in order to quickly remove their fiber, put vicuña on the endangered species list in the mid-twentieth century. Intensive conservation efforts that worked jointly with local governments and communities, however, helped to restore their numbers. Today legally sheared vicuña fiber is available on the market, but in small quantities and at a high price; the vast majority is exported to foreign companies. The guanaco's natural habitat is far south of Cusco in the southern Andes in what are today Argentina and Chile. This protected species has fiber second only to the vicuña in fineness and softness.

FIBERS TODAY

Today the people of the Cusco region use three types of fiber in their textiles: alpaca, llama, and sheep's wool. Alpaca fiber is very soft and comes in a wide variety of colors from whites and creams to blacks, grays, browns, and tans. Alpaca is used for important textiles such as *lliqlla* (shawl) or ponchos. Llama fiber is coarse and short. As they are larger and stronger than alpacas, llamas are generally used as pack animals and their fiber is used only for thick, rough textiles such as ropes and sacks. The third fiber readily available to the people of the Andes today is sheep's wool. Sheep were introduced to South America by the Spanish in the 1500s. Their fiber is softer and finer than that of llamas, but coarser than alpaca. The advantage of sheep's wool is that it takes dye better than alpaca, and weavers often prefer the brighter colors they can obtain in dyed sheep wool.

SHEARING

Many families own herds of alpacas, llamas, and sheep that may number from just three or four animals into the thousands. Shearing always occurs at the beginning of the warm, rainy season between November and April. Without their protective fur, animals would risk falling ill during the cold winter months that begin in May and extend until September. Shepherds also prefer to shear during this season because the rain helps to wash off animals before shearing, leaving cleaner fiber and less preparation work for the spinner. If the fiber must be washed after shearing, the rainy season fills low areas with fresh lakes and streams that would otherwise be dry during the winter months.

In order to spin a strong thread on a hand spindle the fiber must be long enough to work with. To obtain the appropriate staple length for handspinning, shepherds shear their alpaca, llama, and sheep every two years. If they plan to sell the fiber to be machine-spun in a factory, they will shear their animals once a year, as shorter staples are preferred for machine-spun thread. Before selling the fiber to factories, some shepherds pick out the highest quality fiber to save for themselves, selling the rest of the short fibers to be machine-spun.

Shearing is a lot of work, and typically a whole family will organize together to shear their flock. Oftentimes neighbors and friends will be called in to help as well and the family will gift them with fiber as a form of thanks. If one wants fiber for spinning, going to help shear is a good way to procure more material.

Once a date has been chosen and the shearing activity organized, shepherds select a wide, grassy, fairly clean location. Women, men, and children help to shear animals. While women can handle sheep by themselves if necessary, men will always help with alpacas, and mostly men will work with llamas, as they are very large and strong. To cut the fiber from the animal, shearers use both knives and thick scissors.

The ceremonies and traditions that surround shearing in the Andes are tied into giving thanks for the fiber harvested and prayers that each animal should regrow thick, luxurious fiber for the next year. Shearers will offer *kintu de coca* to the *apu* (mountain gods), thanking them for the fiber they will shear that day. In the Andes the coca leaf is sacred and used in many offerings. One of these offerings is the kintu, in which a person places three coca leaves together in his hands and gently blows on them. His breath sends the essence of the coca leaves to the deity. After the shearers offer kintu to the apu, they will bury the coca leaves and may sprinkle *chicha* (a fermented corn beverage) on the ground as well as an offering to the *Pachamama* (Mother Earth). After removing the fiber from the animals, shearers may paint the animals red as a blessing and in hope that they are recognized and protected by the apus, ensuring that the fiber grows back soft, long, and strong. The red represents a color of earth that comes from the altiplano.

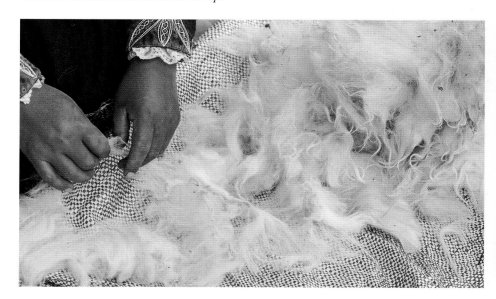

The locks of a llama fleece are pulled open and picked clean prior to forming the roving.

Traditionally, people from the communities of Chinchero and Patabamba used the grated or crushed root of *sacha paraqay* as a natural soap to clean fiber, textiles, and hair. In communities that grow quinoa, people use, as a soap, the foam that results from washing quinoa to separate the grain from the husk. Knitters from Huacatinco sometimes use a high-altitude plant called *chuki* to wash fiber and thread; some people even use fermented urine. Today, though, most people use laundry detergent to wash fiber and textiles. Detergent will strip the fiber, especially if it is sheep's wool, of any grease and help it accept dye better. If you want a softer option, wash your fiber or thread with shampoo. Shampoo will not strip away as much of the natural oils, leaving your fiber softer.

PREPARING THE WOOL

It is important to prepare fiber before spinning; otherwise it will be more difficult to produce an even, strong thread. Alpaca and llama fiber are not naturally greasy, and spinners do not need to wash it before spinning. They will wash it after they have spun it and formed it into skeins. If fiber is very dirty, however, washing it beforehand will help to remove much of the debris.

All fiber, washed or unwashed, must be picked through to remove large pieces of plant debris. Spinners remove all the sticks, grass, and other unwanted particles in the fiber, including all of the short, matted clumps of fiber that cannot be spun. Spinners in the Andes do not card their fiber.

PREPARING THE ROVING

Forming your roving, or length of prepared fiber, is very important as the quality of your thread will be determined in this step. Beautiful, strong, uniform thread is created from a well-prepared roving.

The key to forming your roving is to gently pull open the locks of fiber as you pull out debris. Pulling open the fiber also allows you to pick out the small debris you wouldn't otherwise get to.

As you open the fiber, gently extend it out without breaking it. Once you have a sizable length of opened fiber, fold it in half. Pull it out slightly again. If it is thin and weak, fold the length of fiber in half again.

Hold one end of the roving in your left hand and the other end in your right hand. Keep your left hand still as your right hand gently twists the bundle of fiber. This helps

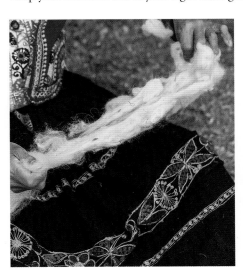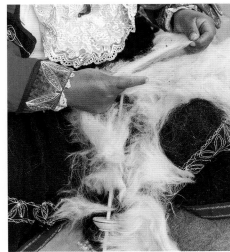

to keep the long fibers together in your roving; otherwise they easily stick to clothing and pull free. Once you have slightly twisted your roving, wrap it around your left hand, forming a small skein. Either store your roving for future use or start spinning.

If a spinner knows that she will be sitting in one place to spin, she may clean the fiber and prepare roving as she spins. If she knows that she will be walking around and moving, she will clean the fiber and prepare roving the night before in order to be able to spin constantly as she walks.

THE PUSHKA

Nearly all handspinning in the Andes is done with the pushka, or hand spindle. Most families have pushkas of all different sizes and weights, as the quality and thickness of yarn depends greatly on the pushka as well as the fiber.

Pushkas are very simple tools. Today they are made with a wooden shaft pushed through a wooden disk. Archaeological finds show that in the past the Inca and other pre-Columbian cultures used very fine wooden shafts and small disks made of stone or ceramic, often painted in elegant designs.

As pushkas are so simple, they are inexpensive and are easy to fix should they break. If the disk falls apart, spinners might poke the rod through a potato, carrot, or any other ready material to provide a quick fix—even a broken roofing tile that they bore a hole through. When they buy a pushka in the market, spinners look for old ones that have already been worn smooth. Used pushkas sit more comfortably in the hand and don't have any rough spots that could catch and worry fiber.

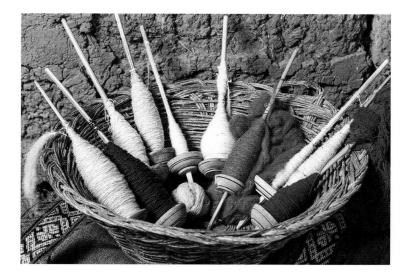

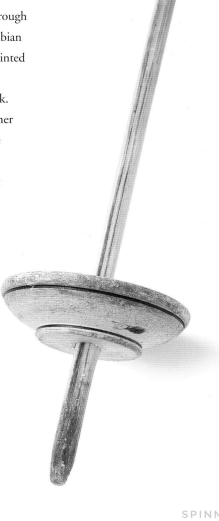

Spinning with a pushka can be done sitting, standing, and even walking about. When spinners need to use their hands for something, they tuck their pushkas under their arms until they are ready to keep working.

Most weaving and knitting yarn in the Andes is spun clockwise, or in spinning terminology, is Z-spun. Two strands of Z-spun yarn are then plied together in the opposite (counter-clockwise), or S direction. Many communities, however, also produce *paña lloqe* (right-left) yarn, spun in a counter-clockwise, or S-spun, direction and plied in the Z direction, for special uses. Lengths of this type of yarn are tied around the wrists and ankles of pregnant women and newborn animals in order to achieve balance and protection, and to provide energy to the mother and child. In some communities, such as Chahuaytire, this type of thread is used in the edges of blankets, and ponchos as it helps prevent corners from curling up. Alternating sections of Z- and S-spun yarn can produce the look of a twill structure in the finished textile because of the way the light reflects on the opposing twists of the yarns.

STARTING TO SPIN

In order to start spinning you must first create a leader thread to tie to your pushka. If you are right-handed, place your roving either around your left wrist or tuck it under your left arm. If you are left-handed, then you will want to place your roving around your right wrist or under your right arm. Our following instructions will assume that you are right-handed.

Note: *If you feel more comfortable tucking the roving under your arm but find that the fiber sticks to your clothes, then put your roving in a plastic bag. As you spin you can also let the spin reach up into the roving slightly, tightening fibers so that they are less likely to stick to clothing and peel away from the roving.*

1 Find the end of your roving and pull out a length of prepared fiber.
2 Place the tip of your pushka in the fiber.
3 Pinching the roving in your left hand, use your right hand to twist the pushka in a clockwise direction, which will twist the fiber between the tip of the pushka and the pinch in your left hand.
4 Pull gently on the roving, twisting until you have enough beginning thread to loop two or three half-hitches. Remove the tip of your pushka from the end of the now-formed thread.

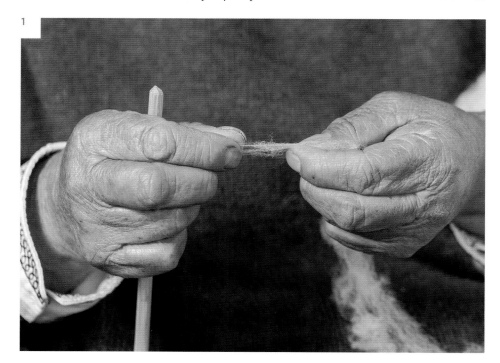

1

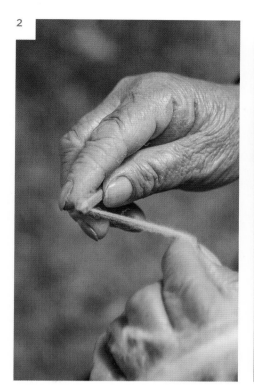

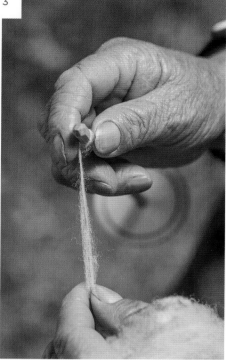

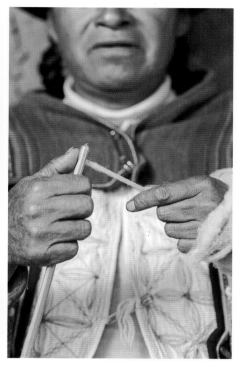

Luisa Quispe Huaman from the community of Mahuaypampa prepares a leader thread.

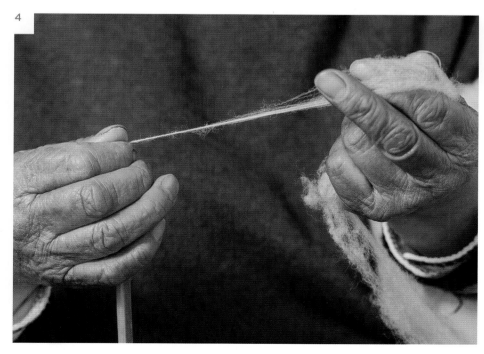

5 With the beginning thread, loop two or three half-hitches around the tip of the pushka shaft.

 Note: *There are a number of ways to loop half-hitches onto your pushka. Use the method that feels the most comfortable for you.*

 > Slowly and gently pull out fiber from your roving as far as your arms will reach. Slightly twist your pushka with your right hand so that this length of fiber becomes twisted.

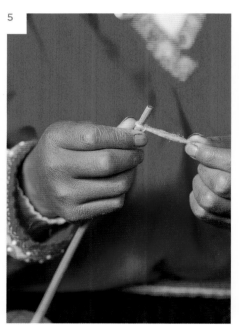

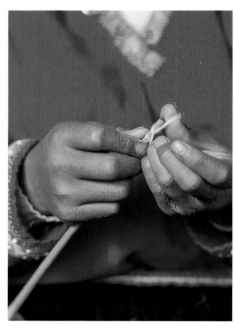

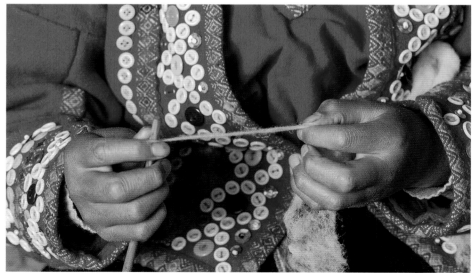

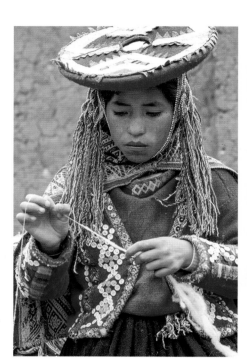

Twelve-year-old Presentación pulls fiber from her roving.

6 Using your right hand, give your pushka a gentle clockwise twist and let it drop and spin. Your left hand should be pinching the fiber as your right hand spins the pushka. After giving it a gentle spin, move your right hand up to take the place of your left hand pinching the fiber. The pushka will only spin the fiber between the half-hitches and the pinch in your right hand.

6

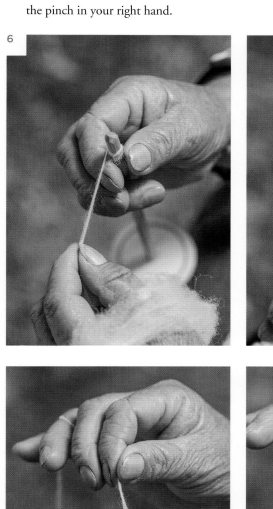
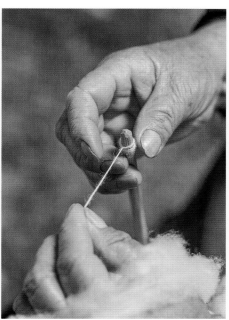
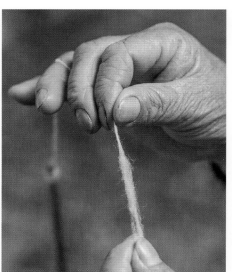
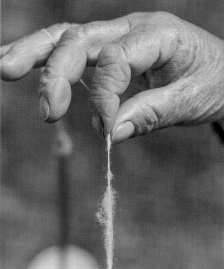

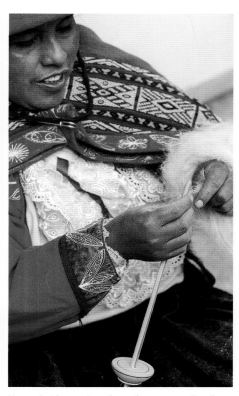

Nemesia Lloque Arce from the community of Patabamba begins to spin llama fiber. This strong, coarse yarn will be used for thick textiles, such as *costales* or rope.

7 Use your left hand to pull out more fiber and adjust thickness by pulling out clumpy areas. Once this length of fiber has been spun, slip the half-hitches off the end of the shaft.

7

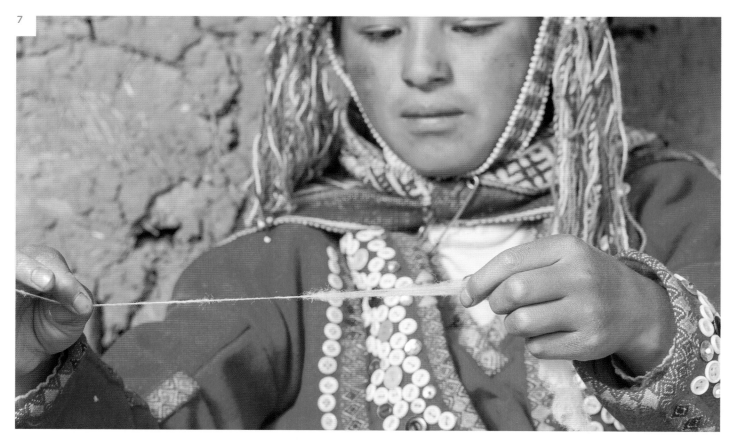

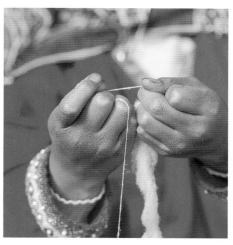
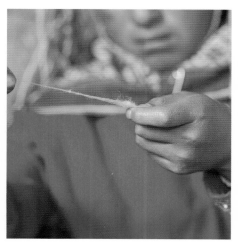
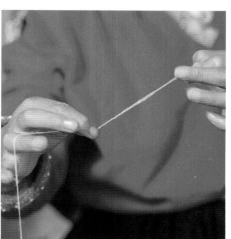

8 Wrap the beginning of your thread around the base of your pushka, wrapping it up the shaft to the top, leaving just enough yarn free to loop another two or three half-hitches.

8

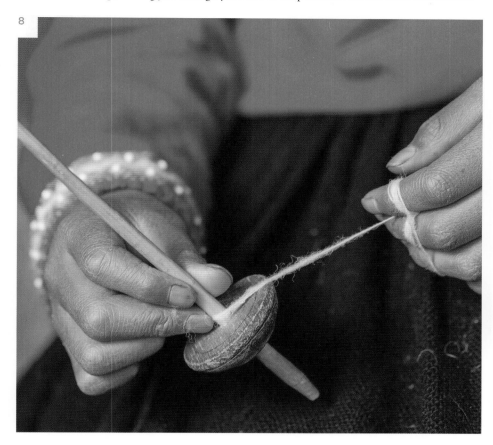

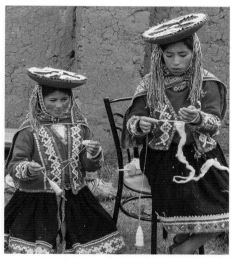

Lourdes and Presentación both from the Accha Alta Young Weavers Group spin together.

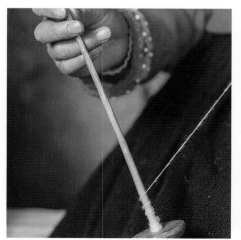

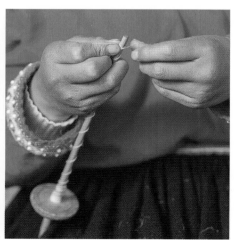

9 Pull out more fiber from your roving, pinching it in your left hand as your right hand gently sets the pushka spinning. Move your right hand up to take the place of your left hand pinching the fiber. The spinning motion of the pushka will twist the fiber between the slipknot and the pinch in your right hand, turning the fiber into thread.

> It is important that you do not remove your right hand from its pinched position on the fiber as you spin. Your right hand should remain fixed but flexible while your left hand is free to move. As the pushka spins, use your left hand to gently pull out uneven clumps in the fiber that is to be spun.

Note: *If you forget to pinch the fiber with your right hand or slip up, the spinning fiber will twist past your right hand and up into the roving that is controlled by your left hand. Should this happen, all you need to do is let out a sizable length of fiber from the roving with your left hand. The twist that got into your roving will move up this fiber and spread out, making the twist looser. You will now be able to pull out the fiber and any clumpy parts, adjusting the twist to produce even thread.*

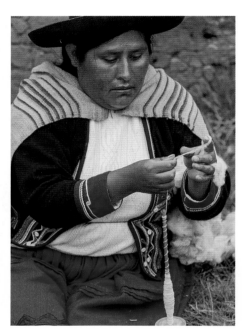

Martina Nina Quispe from the community of Mahuaypampa pulls fiber from the roving while spinning.

9

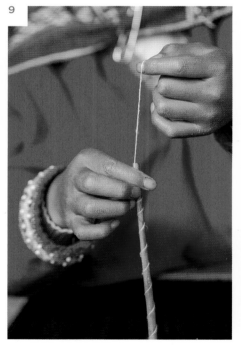

10 After you have spun so much thread that you can no longer comfortably suspend the pushka above the floor, wrap up the spun thread around the fingers of your left hand in a figure-eight pattern.

Note: *There are many ways to wrap up the thread around your fingers in a cross pattern. Many spinners prefer to use just their index and middle fingers while others may use different fingers.*

10

 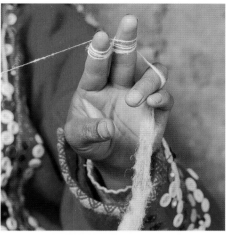

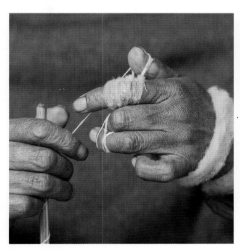 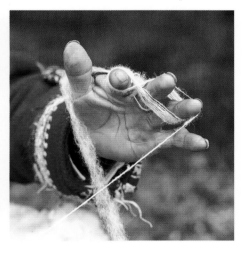

Pull off the half-hitches on the end of the spindle and wind the thread around the bottom of the pushka up to the top. Tie another two to three half-hitches and repeat the process.

Note: *Tie as many half-hitches as you need to prevent them from coming undone as you spin. Each spinner varies in the number of half-hitches she uses. Some tie just one onto the end of their pushka while others tie two or three.*

CHOOSING THREAD THICKNESS FOR BEGINNERS

For beginners it is easier to spin thin threads than very thick threads. This is because to spin a thick thread you need to use a larger, heavier pushka. Due to their weight, heavy pushkas will lose forward momentum and begin to spin the opposite way, and unspin yarn, faster than a lighter pushka. To avoid letting your pushka spin backwards, you must go through all the motions of spinning quickly in order to finish your thread before the heavy pushka begins to spin backwards. This makes thicker threads harder to form for beginners who are not yet accustomed to quickly going through the motions of spinning. Beginners ought to start with a small, light pushka forming thin thread.

CHOOSING A FIBER: ALPACA VS SHEEP

Alpaca fiber is smooth and slippery and breaks easily, which makes controlling it harder for beginners. It also means that you must work faster in order to keep up with the shifting fiber. Sheep wool is not as slippery, and many first-time spinners find it more manageable to work with.

OTHER SPINNING TECHNIQUES

PUKHU (SUPPORTED SPINNING)

This variation on spinning with a pushka comes from the Acopia region to the south of the city of Cusco. Rather than letting the pushka drop in the air as they spin, spinners sit on the ground and rest the base of the pushka in a small ceramic bowl. While drop spinning can be done standing or walking about, *pukhu* is only done while sitting, as the pushka must remain balanced in the container. If a ceramic bowl is not available, spinners will use whatever is at hand, including bits of terra cotta roofing tiles. Pukhu is only used for spinning and never for plying and over-spinning. Spinners who become practiced at pukhu can spin faster than with the drop-spinning method because they tire out less quickly in a seated position. Additionally, pukhu skips a step of the process: half-hitches are unnecessary in this technique, which means spinners can work faster.

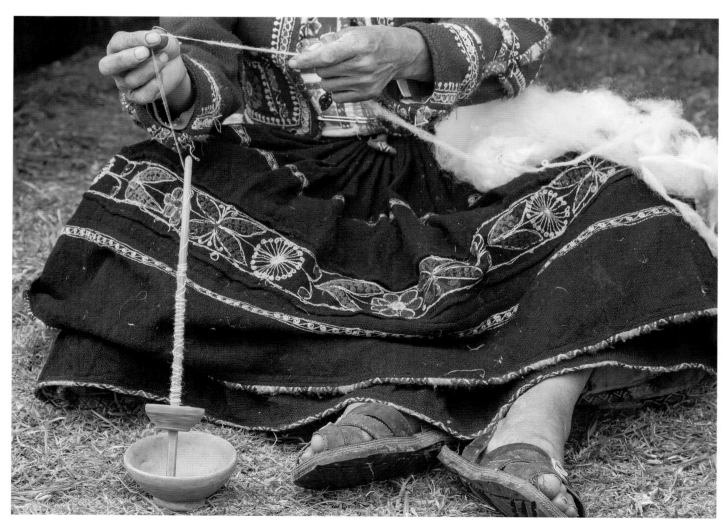

MISHMI / MISKUY (SINGLE STICK SPINNING)

Another way that people create thread in the Andes is with a technique called *mishmi* or *miskuy*. Mishmi consists of a single stick, like the pushka but without the wooden disk. Unlike the pushka, however, mishmi is only used to create thick, rough yarn for ropes and *costales* (handwoven sacks). Multiple yarns are often plied together with mishmi to create three- to four-ply yarns that are braided together for thick rope. Llama fiber is traditionally processed with mishmi as it is too coarse and short to produce fine thread. Mishmi is a technique used by men and occasionally widows; although, today the tradition is dying out.

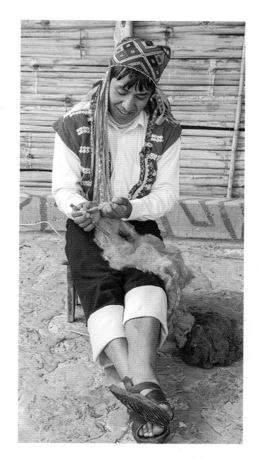

1 Fiber is prepared in the same way as for spinning with a pushka, by cleaning the fiber and creating roving. The roving for mishmi should be large and thick.

2 Start the thread by pulling out a length of fiber from the roving and inserting the tip of the stick into the end of the fiber.

3 Twist the stick around and around, winding the fiber into a thick yarn.

4 Remove the tip of the stick from the now-formed thread and wrap the thread around the middle of the stick several times.

5 Continue to twist the stick to form more thread. The left hand pinches the fiber while the right hand turns the stick. The fiber twists into thread between the stick and the pinch in the left hand.

> Continue to wrap the thread around the middle of the stick.

Note: *If your pushka breaks but you want to keep spinning anyway, you can spin fine, thin thread with alpaca or sheep in the mishmi technique as well; it just takes considerably longer.*

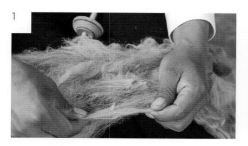

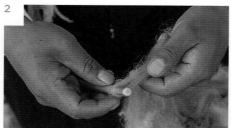

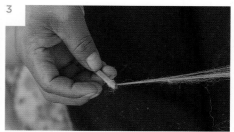

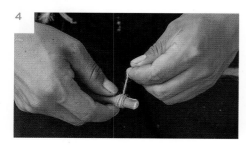

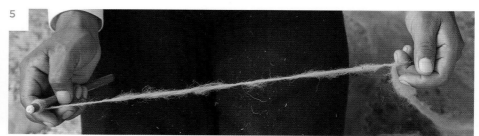

SKEINING

Once you have finished spinning your yarn, you must decide what you will use it for. This will determine which type of skein will be most appropriate for what you intend. Creating a skein from yarn wound around a pushka can be a delicate process. You do not want to tangle the yarn and turn all of your hard work into a snarled mess. Andean spinners have invented a number of clever skeining techniques to accommodate what purpose the yarn will later serve.

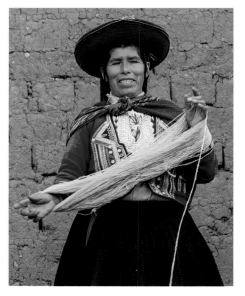

If you intend to wash and dye your yarn, you will need to create a skein that is well organized but open enough to allow water and dye to penetrate the yarn. Making skeins that will be washed and dyed is relatively straightforward.

ARM SKEINING FOR WASHING AND DYEING

This is the simplest and most common way of forming a skein that you can wash and dye.

> Before beginning, prepare three to four lengths of strong auxiliary string that will not break or take dye during the washing and dyeing process. Nylon threads or ribbons are good for this. The length of these will depend on the size of your skein.

> Stick the end of the pushka in the ground or secure the pushka upright in another manner. Stand just behind and over the pushka.

> Hold the end of the thread in one hand. Wrap the thread from arm to arm in a figure-eight pattern. The cross of the figure eight should be between your two arms. The cross is essential for keeping your yarn from tangling.

Note: *You can also do this sitting down if you become tired, but it is easier to do standing due to the large arm movements.*

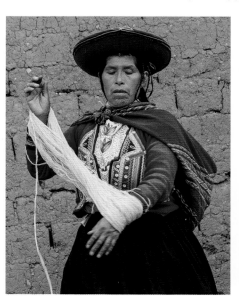
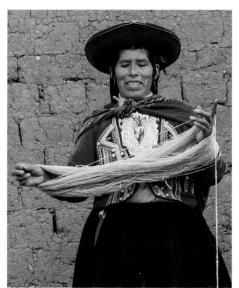

Gregoria Pumayalli Auccacusi arm skeining while standing.

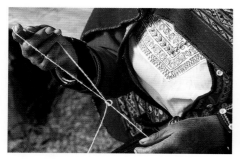
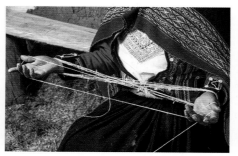
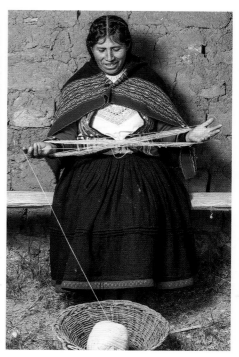

Epifania Choque Quispe from Chinchero arm skeining while sitting.

> When you arrive at the end of the yarn, you must secure the two ends together so you do not lose them. Pick up one of the auxiliary strings you prepared beforehand. Tie it through your skein where the ends meet in a figure eight. Tie the two ends of your yarn together with the ends of this auxiliary string.

Note: *Some spinners tie a strong square knot. When they go to turn their skein into a ball of yarn after washing and dyeing it, they cut out the knot and lose perhaps a centimeter of thread. Other spinners choose to tie a strong slipknot that they can easily undo after washing and dyeing in order to not lose the small amount of thread in the knot. We recommend that beginners use a square knot that they later cut out. It is not worth the risk of losing the ends of your skein to a slipknot that may untie in the washing and dyeing process.*

> At regular places in the rest of the skein, insert two to three more auxiliary strings to secure the organization of the skein and keep threads in line.

Note: *It is important not to tie the auxiliary threads tightly around your skein. The skein must be loose enough so that threads can separate and water and dye can enter. If you tie the auxiliary threads too tightly, the skein will not dye evenly.*

CHAIN SKEINING FOR WASHING AND DYEING

Many elders find that the large movements in arm skeining are too tiring for them and impossible to complete. In order to skein in a small space with minimal movements, or if a spinner suddenly decides she wants to dye a ball of yarn and needs to skein it quickly, spinners use a method called chain skeining.

Before beginning, prepare two lengths of strong string that will not break or dye during the washing and dyeing process. Nylon strings or ribbons are good for this. These strings should be about 6 inches in length, depending on the size of your skein.

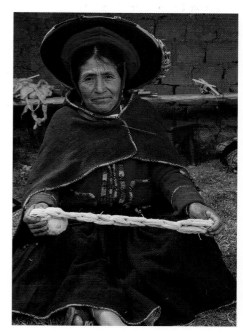

Victoria Condori de Tinta from the community of Acopia chain skeining.

1. Stick the end of the pushka in the ground or secure the pushka upright in another manner. Stand or sit just behind and over the pushka.

2. Wrap your thread into a firm, neat ball directly off the pushka. You must wrap the thread in clear sections of thirty to forty loops around the ball.

3. Pull off the first section of yarn loops. Double it upon itself by turning it into a figure eight and folding the figure eight in half to form a smaller loop of yarn. Hold this loop in your left (or non-dominant) hand, inserting your index finger through it to hold it open.

 > Remove the second section of thread loops from the ball of yarn.

4. Insert this second section halfway through the first doubled-up section of loops.

5. Fold the two ends of this second section of loops in half, making a sort of chain with the first section.

 > Remove the third section of loops and put it through the two ends of the second folded section.

6. Continue in this manner until you reach the end of the ball of yarn.

 > Once you have reached the end, place one auxiliary thread through the ends of the last folded-down section. Use the other auxiliary thread to secure the first loop in the chain as well.

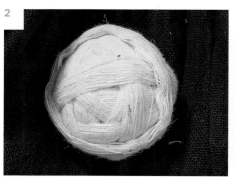

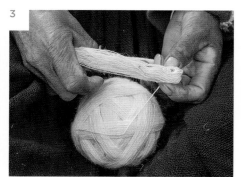

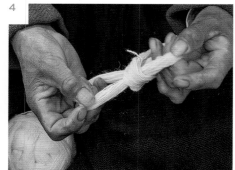

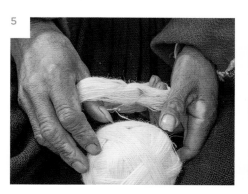

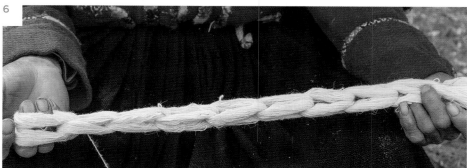

PREPARING TO PLY

If you do not intend to wash and/or dye your yarn, and instead intend to weave with it in the natural color, then you need to ply your yarn first. To create two-ply yarn, you must first create a skein consisting of two strands of single-ply yarn wound off together. Single-ply thread is not strong enough to resist tension on the backstrap loom. For weaving, yarn must be plied together into double-, triple-, or even quadruple-ply thread. Most textiles, however, are woven with two-ply thread. *Bayeta* (plain-weave cloth used for skirts and jackets) is the only exception and uses single-ply, tightly spun yarn. Creating skeins for plying is slightly more complex and requires a little guesswork about the length of thread going into the skein.

TWO-SPINDLE SKEIN FOR DOUBLING YARN BEFORE PLYING

This is the simplest method to pair two yarns together in a skein that you can later ply together on your hand spindle to create two-ply thread.

You will need two pushkas each wound with the same amount of thread of the same

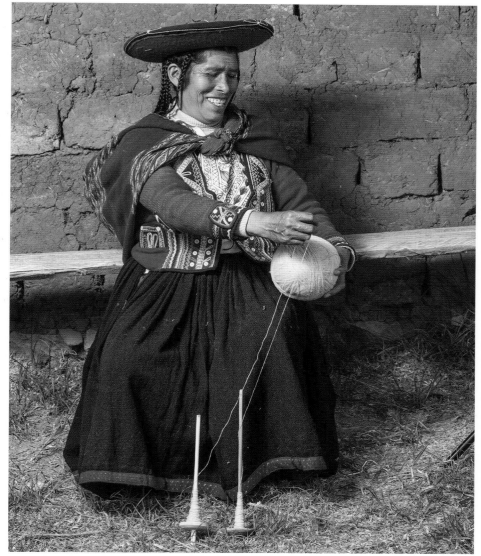

Gregoria Pumayalli Auccacusi doubling the yarn before plying. This ball has eight spindles of yarn.

grist, or diameter. You can either spin two pushkas full of yarn, or you can spin one full pushka and then transfer half of the spun yarn to a second pushka. In both of these cases you must estimate as best you can that the two pushka have roughly the same amount of yarn.

> Stick the ends of the pushkas in the ground side by side or secure the pushkas upright in another manner. The pushkas should be about a foot apart. Stand just behind and over the pushka. Match the end of each thread together and wrap them up into a firm, neat ball of yarn.

SPINDLE-TO-SPINDLE SECRET

In Chinchero and some other communities, spinners will wrap the single yarn from a spindle into a skein on their hand and then immediately ply that same skein back onto the spindle to create two-ply yarn.

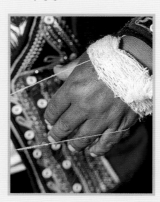

HAND SKEINING FOR DOUBLING YARN BEFORE PLYING

You can also double up the thread from a single pushka by wrapping the thread around your hand. The two methods of doing this are only appropriate for a half-full pushka. A pushka full of yarn is too much to wrap and hold on your hand.

Stick the end of the pushka in the ground or secure the pushka upright in another manner. Stand or sit just behind and over the pushka. Tie the end of the yarn around the index finger of your left hand if you are right-handed or around your right hand if you are left-handed. You can either wrap it around itself a few times or tie a simple slipknot.

1 Looking at the open palm of your hand with fingers spread apart, pass the yarn behind your index finger and thumb.

2 Pass the thread in front of your hand, across the palm, and behind your pinkie and ring fingers.

> Wrap the thread around your index finger and back the way you came: behind ring and pinkie fingers, back across the palm, behind the thumb and index finger.

> When you reach your index finger again, wrap the thread around it and repeat the process.

3 When you reach the end of the thread, untie the other end from your index finger. Match the two ends together and wind them into a ball, gently pulling the thread off of your hand.

There is another technique, which differs only in wrapping the thread around your index finger. In the first technique you change directions at the index finger each time. In the alternate method, when you reach your index finger, pass the thread in front of it, then retrace what you have done: pass the thread behind your thumb, in front of the hand across the palm, behind the pinkie and ring fingers, and back in front of the index finger again—do not change directions at your index finger but keep going around and around your hand in the same direction.

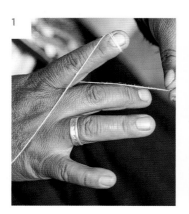
1

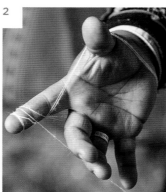
2

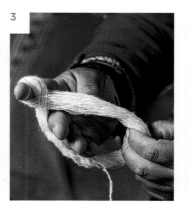
3

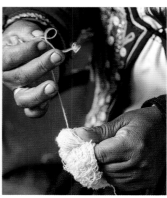

PLYING

Like spinning, plying is a never-ending task in the Andes as nearly all spun yarn must be plied together into two-ply yarn for weaving or knitting. Assuming the original yarn was spun in the usual Z, or clockwise, direction, plying will be done counter-clockwise with a large, heavy pushka. If the plied yarn will be used for weaving, the spinner puts in a tighter twist. If she will use the plied yarn for knitting, depending on the community and the intended purpose of the knitted item, she will put in a tighter or looser twist. A spinner can ply either sitting or standing.

In some communities, such as Chinchero, spinners do not wrap their skein of doubled yarn into a ball before plying it. Instead they ply directly from the skein. In other communities, such as Accha Alta, spinners will wrap their skein into a ball first and then ply from the ball of yarn.

> If you will be working from a skein, put one loop of the skein over your left arm.

> If you are working from a ball of yarn, you have a few options. You can put the ball in a bag on your left wrist or over your left shoulder. If you find the bag irritating, you can pin the ball of yarn to your clothing on the left side of your body with a safety pin.

> Tie the two ends of the threads to the tip of the pushka shaft with a few half-hitches. You will quickly learn how many knots you need in order for them to not fall out later. Most spinners put in two.

Note: *Many spinners encounter the problem of accidentally undoing their half-hitch as they roll the pushka through their hands to set it spinning. To avoid this, some lick the tip of the pushka before tying the half-hitch. The moisture helps the yarn stick to the tip of the pushka, preventing the knot from coming undone as easily.*

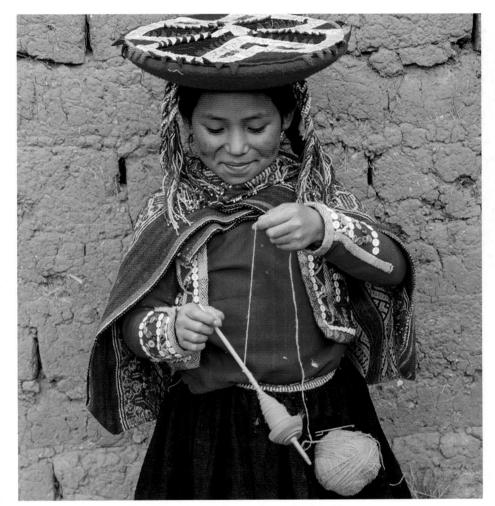

Ten-year-old Hilda Yesica Mamani Chura plies from a ball pinned to her skirt.

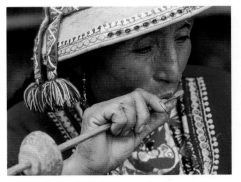

Victoria Condori de Tinta wets the tip of her pushka to make it less slippery prior to spinning.

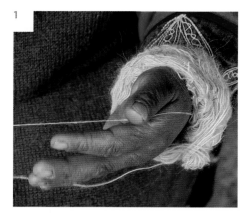

1. Let the threads run from the skein or ball through the gully between your thumb and index finger in your left hand. Allow for a few inches of slack thread.

2. Place the top of the shaft between the palms of your hands: push the top of the shaft into your left palm with the pads of the fingers in your right hand so that the shaft rotates in a counter-clockwise direction.

 > Quickly move your right hand forward and across your left hand, rolling the tip of the pushka through your palms. Let the pushka drop when it leaves your palms.

3. As the pushka drops, pinch the thread between your left thumb and index finger. Your left hand controls how much thread you let out. You must keep the thumb and index finger of your left hand pinched on the thread in order to control how much thread you are plying together at a time. The pushka will twist together the thread between the half-hitches and the pinch in your left hand.

4. In order to ply together more thread at one time, gently pick up the spinning yarn between your right thumb and index finger. Pinch it firmly. Let out more yarn from your left hand.

5. The yarn should now form a 90-degree angle running horizontally from your left hand to your right hand, where it drops vertically to the pushka near the floor.

 > Once you have let out as much thread with your left hand as you desire, use your left hand to once again pinch the thread while opening your right hand so that the thread merely runs over your thumb to the pushka below. Your right hand now functions only as a pivot in the yarn, suspending the pushka off the ground.

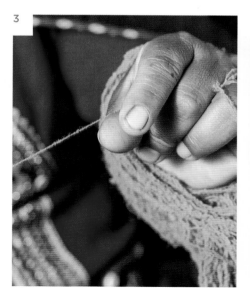

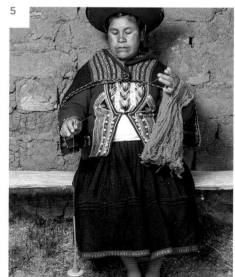

6 Once you notice that the pushka is losing speed, wrap up the plied thread around the fingers of your left hand in a figure-eight pattern.

 > If you desire a tighter spin (for weaving,) roll the pushka through your hands and let it spin once more. If you desire a looser spin (for some types of knitting), only roll and spin the pushka once.

 > After spinning and wrapping the yarn in a figure eight around the fingers of your left hand, push the half-hitches on the pushka to the lower middle of the stick or to the very base.

 > Wrap the plied yarn around the base of the pushka and up to the top of the shaft. Depending on how you tie your slipknot, you will want to do this in either a counterclockwise or clockwise direction.

7 Tie the thread to the tip of the pushka shaft with a few half-hitches.

 > Repeat the process.

These are the very basics of Andean spinning. The beauty—and the secrets—of the craft lie in its simplicity and efficiency. Andean spinners can create elegant, consistent, strong yarns of almost any size and at a high rate of production using simple tools, clever techniques, and innovation. Centuries of practice have taught them what steps are essential and what processes best achieve their goals.

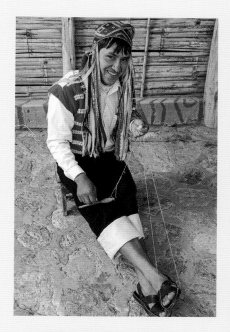

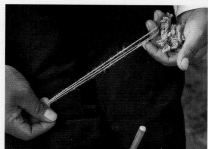

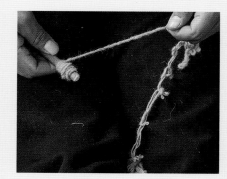

Alipio Melo Irco chain plies a single-ply yarn by hand to create a loose, three-ply strand. He then loops this loosely plied yarn back onto the mishmi and twists a very strong three-ply yarn.

6

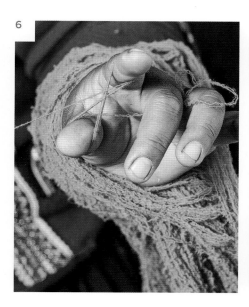

7

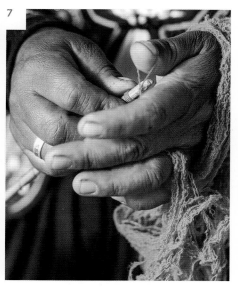

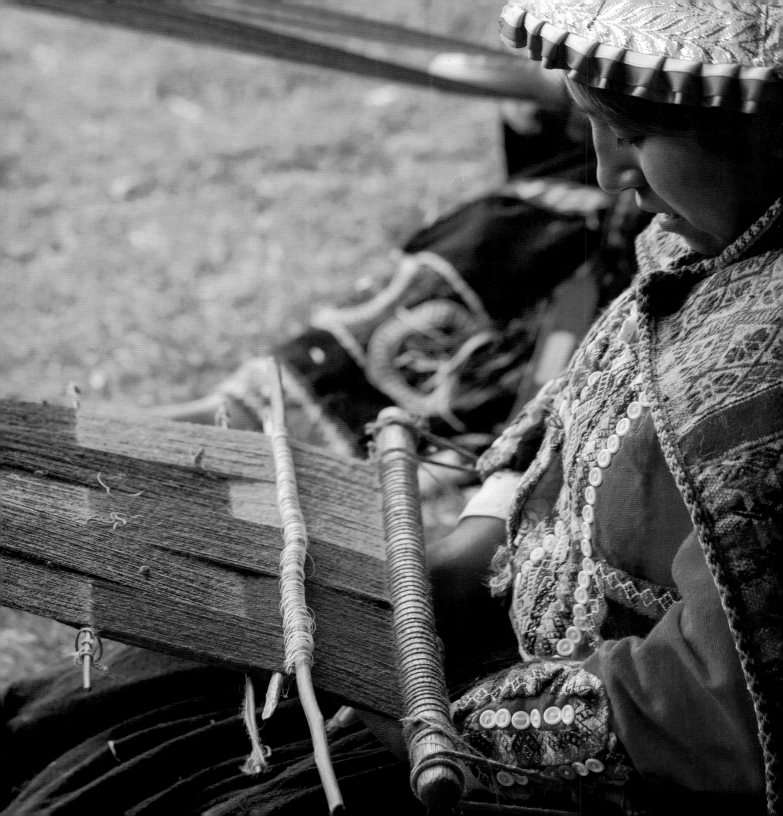

WEAVING

"Elders mention how important it was to teach their daughters or granddaughters to spin, weave, and produce their clothing. Many times a man would choose a skilled weaver's girl as a wife and mother for his children, so learning how to make the finest textiles was very important for the young girls before having families. The wealth of textiles was very much appreciated by Andean society and the skill of weavers very much respected."

— Rosa Quispe, Chinchero

Thousands of years of innovation have created thousands of techniques, styles, and designs in textiles of the Peruvian highlands. For all its sophistication, Andean weaving uses the simplest tools: a loom made of sticks and a belt for the back strap; a *ruki* or *wichuna* (sharpened llama or alpaca bone used to beat the warp and weft threads); *pallana* (a bone, sharpened stick, or bamboo from the jungle used to pick out designs in the warp); sticks of different thickness and sizes for heddle rods; and the skillful hands of the weaver. With these minimal materials, using difficult weaving techniques, Andean weavers create some of the most complex textiles in the world.

LEFT: Phetra Huayta Huanca from the community of Pitumarca weaves in an ancient technique that uses discontinuous warp. ABOVE: Weavers from Chinchero enjoy watching a weaver from Huacatinco prepare her loom.

CHAKANA: a cross design

CHICHILLA: tubular border that is woven and joined with the weft onto the edge of a textile at the same time

CHUMPI: belt

DOBLE CARA: complementary warp technique

DOUBLEWEAVE: two layers of cloth woven simultaneously

ESCALONADA: staggered-step design

GOLON: woven band sewn to the bottom of a skirt made with a weft-faced tapestry technique

HEDDLE: a set of loops that encloses the warp threads in one layer and allows them to be raised

JAKIMA: a narrow woven ribbon or band, also called *watana* or *wato*

JAKIRA: intermesh

KAULLA: shed sword

KH'ATA: plain weave

LEY: supplementary warp technique

ÑAWI AWAPA: a tubular woven border

PATA PALLAY: pebble weave

POLLERAS: women's skirts

RUKI: llama or alpaca bone used to beat the warp and weft threads and in some areas, to pick up the patterns

SHED: the space between the raised and unraised warp yarns

TANKA CH'URU: typically, the first design that young weavers learn

TICLLA: discontinuous warp and/or weft

TOKORO: a thick hollow tube acting as a shed rod

WATAY: resist dyeing yarns before weaving

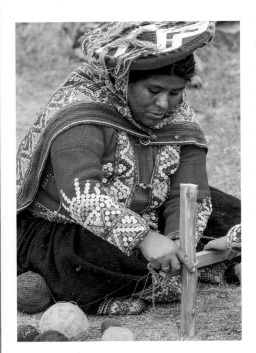

WARPING

The vast majority of textiles in the Andes are warp-faced. This means that the warp threads are so close together that the crossing threads, the wefts, are not visible. Consequently, warping is perhaps the most important part of the weaving process. It is at this moment that the weaver must decide the size of her textile, the colors, and the designs she will include. Creating good tension in the warp will determine how smoothly and easily she will be able to weave. Weaving with a backstrap loom requires strength and endurance, as the tension on the loom is critical. A weaver controls this tension with her body, leaning forward or backward depending on what she requires of her loom. For these reasons, warping is traditionally more than just the process of setting up the warp threads for weaving. Warping is a ritual, a spiritual moment of prayer in which the two warping partners ask for luck and blessing in the new weaving project. They will bury coca leaves in the holes where the warping stakes are put and will sometimes offer a libation of chicha.

There are also many beliefs and superstitions that surround warping. Some weavers say that it is bad luck for a chicken to walk over the warp or through the balls of yarn—either there won't be enough yarn to finish the process or the weaver won't be able to weave quickly and advance her project. As a chicken scratches in the dirt with its feet looking for food, so too will the weaver scratch in vain at her warp with her ruki, never advancing the weaving. Should someone meet two warping partners at work, they will place a small pebble next to their balls of yarn. Many believe that this brings luck and will ensure that the warping partners will have enough thread to finish their project.

Two people almost always work together to warp, as it is not reasonably possible to warp alone. Frequently, warping partners are found between family members, friends, and neighbors. Traditionally, young people will enter into a type of apprenticeship and work with an experienced warper to learn the details of the process. If no one in a weaver's

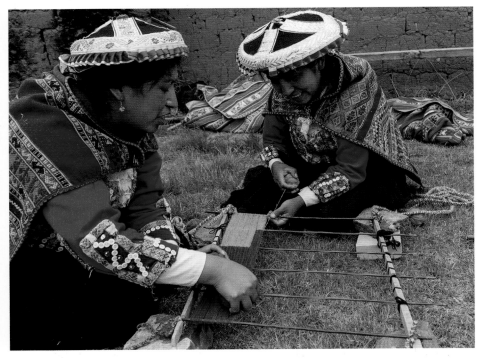

ABOVE: Andrea Chura building the loom prior to warping. BELOW: Phetra Huayta Huanca and Yanett Soto Chuquichampi warp together for the *Chakana* design.

immediate social circle is available to help warp, she may elicit the help of a neighbor through *ayni*, the tradition of reciprocal work. Today, the neighbor will help with the warping project, and at a future date, the weaver will return the favor and help her neighbor to warp.

Because warping is usually done between two people and invites comment from onlookers, it is very much a social activity. The two people warping chat and gossip as they work. Family members and visitors will watch and join in the conversation, offering advice about color combinations and design choices. They share jokes as well as food, chicha, and coca leaves. Oftentimes warping partners surprise themselves and their onlookers as they find lost threads amongst their piles of yarn, experiment with color combinations, make poor choices or wise choices, realize they've made a mistake, or realize that their tension has changed. These opportunities for variation and discovery make each textile unique and the basis of stories remembered and retold in the years to come.

The amount of time and care that warping partners put into a project will depend on what the final weaving will become. For weaving a poncho or blanket for a wedding or ceremony, the warping partners will agonize over every detail. They will discuss the quality of the yarn, the colors, the distribution of the threads for the patterns, and the appropriate size and placement of every design and color element in the textile

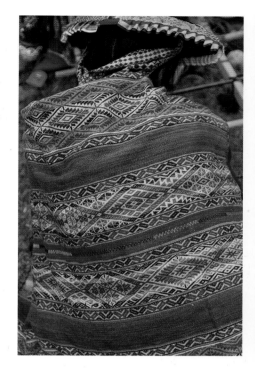

as well as the size of the textile itself. Warps for simple or everyday textiles do not solicit the same painstaking precision and care. Warps for potato sacks and thick blankets for beds, for example, can even be warped with a young child as a warping partner.

Most weaving in the Andes is done on backstrap looms, which come in different forms.

In many communities, the weaver wraps one end of the loom around her waist with a strap. She secures the other end of the loom in one of two ways depending on the community: In some communities, the weaver ties the far end bar to two posts hammered into the ground; in other communities, the weaver ties the far loom

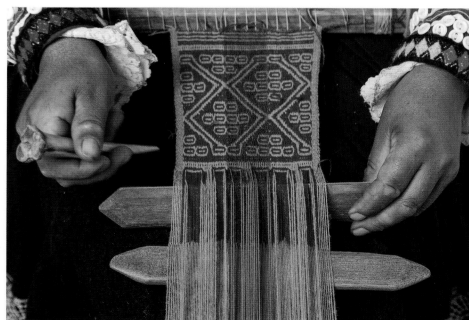

ABOVE: A gorgeous manta from Pitumarca illustrates the beauty of naturally dyed yarns woven into intricate traditional designs. BELOW: Asuna Sunta from the community of Chahuaytire uses her ruki to pick up the border for the replica shawl of the *Momia Juanita* (see page 113).

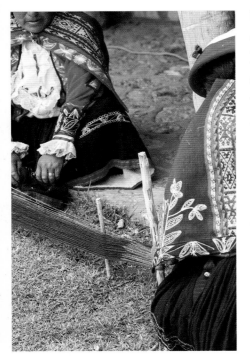

bar with a rope to a tree or post. In some communities, weavers use a third type of loom where both ends are tied to four stakes hammered into the ground. The weaver sits in front of one end to weave; she does not need to strap herself in.

There are two ways of warping for backstrap looms: vertical or horizontal. Either type of warping may be used for any of these three loom types. Backstrap looms where the far end is tied to a tree or post can be used to create textiles of any length, but are limited by width. Generally, the maximum width possible is about 27 inches. Stake looms are even more limited, and can only be used for textiles that are the size of a *ch'uspa* (small bag) or larger.

In the past, weavers wound their warp on wooden stakes. Today many prefer to use rebar, as the metal is stronger, resists being bent out of shape by the tension of the warp, and is easy to hammer into the ground. Other tools for warping and weaving, such as the *tokoro* (a shed rod), were previously bamboo or wood but are also being replaced with modern materials like plastic tubes and metal.

The color sequence and manner of warping determines the structure of the design and what is possible to weave. Many textiles will combine different techniques to create the final piece. For example, a weaver may include patterns in supplementary warp (page 57), color change in discontinuous

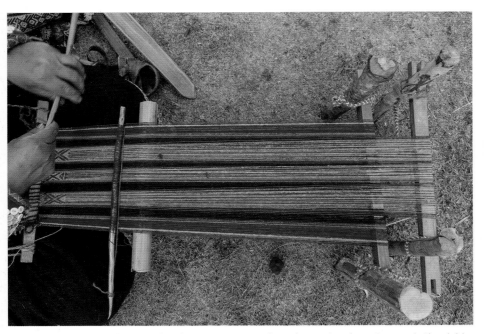

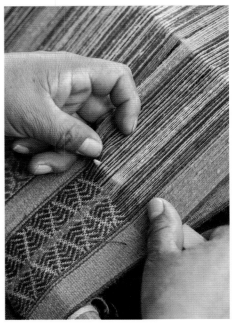

ABOVE LEFT: Weavers from Patabamba prepare a warp for a three-color chumpi woven in the *doble cara* technique. BELOW LEFT: Stake loom warped to weave a ch'uspa. BELOW RIGHT: Juana Mirma Consaya from Huacatinco picks up a complex design with a ruki. She spent one week preparing the warp and setting up the loom.

warp (page 63), and a finishing border of a tubular weave (page 56) done separately at the end, all in a single weaving. Each technique has its own necessary warping sequence which can't be changed.

The quality of a textile in the Andes is determined by a number of factors. The textile should above all be tightly woven with the warp firmly packed together. To determine how tightly woven a textile is, people would sometimes sprinkle droplets of water onto the surface of the weaving. The longer it took the fabric to absorb the water droplets, the tighter the weave and the higher the quality. In addition to tight weaving, quality is determined by rich color combinations, intricate patterns, complex

Sixteen-year-old Vilma Condori Mamani from Accha Alta begins a complex warp for a wasa watana (see page 123).

techniques, and the finishing details such as seams and borders.

All weavers learn techniques and patterns in a step-by-step fashion, beginning with the most basic and working up to the most complex. Before weavers learn how to weave a design, they must learn *kh'ata* (plain weave), working on a warp that has been made with alternate colors for pattern weaving. They do this by lifting the top warp layer, passing the weft, changing the sheds, beating down the weft, then passing the weft in the new shed, repeating this process as often as they want without picking up any pattern threads. The result is a section of weaving with alternating horizontal stripes in the two warp colors. In this early practice, they learn to keep the borders straight and to tighten the weft. Once they feel comfortable weaving plain weave, they move on to weaving a design, like *tanka ch'uru* (see page 49) or any other narrow pattern of the region. Starting with the smallest textiles, which are narrow ribbons or ties called *jakima* in the community of Chinchero and known by other names such as *watana* or *wato* in other communities, weavers learn the simplest designs in any given technique. Once they master these simple designs and understand the structure of the technique, they progress easily to weaving larger textiles, such as belts, with wider designs.

Weavers will often work together and time passes quickly as they chat and lose themselves in their looms, picking out designs and passing the weft. Visitors will stop and sit next to weavers and conversations veer from the happy moments in their lives to the sad ones. Many families have a grassy patch in their courtyard or patio with a post reserved for weaving. Here a weaver installs herself amongst an array of weaving tools: llama bone beaters and picks, different types of threads, needles of all sizes tucked into her *montera* (hat), and a lunch of boiled corn, potatoes, *moraya* (dehydrated potatoes), and fava beans close at hand as well as the indispensable coca leaves. Weaving can also be a solitary activity as many people spend hours alone in high pastures watching over their flocks. It's most common to spin during these hours, but occasionally, they take advantage of this time to weave as well.

TECHNIQUES

KH'ATA (PLAIN WEAVE)

Learning plain weave allows a young weaver to practice using the heddles and *kaulla* (shed sword) to control the weft and maintain tidy borders. The plain-weave warp for the backstrap is created by wrapping the threads in a figure eight around two widely spaced stakes. The figure eight in the center forms the cross which keeps the warp threads in perfect order.

If the textile is small, four inches wide or smaller, you do not need to use loom bars. If the textile is larger than this, you will want to position the warp on loom bars before putting in the heddles. Once you have positioned your warp and set up the heddles, you are ready to plain weave.

A traditional backstrap warp for plain weave with a cross in the center to separate the sheds.

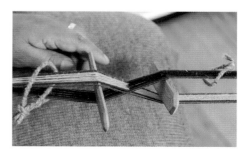

Martina Huaman from Patabamba weaves a simple *golon* in plain weave.

CREATING CONTINUOUS STRING HEDDLES

Heddles are a set of threads that loop around warp threads—or alternating warp threads based on the design—so that they may be lifted all at once. To create most textiles, weavers put in two heddles. The first heddle is just a loop of strong string tied around the top warp in the second shed formed by the cross in the warp. In wide warps, the threads in the top warp sit on a rod or hollow pipe. The second heddle is more complicated and is always put in the shed nearest to the weaver. Here's how to make a string heddle:

The heddle can be created from right to left or left to right, depending on personal preference. Our illustrations show working right to left.

Note: *It is easiest to form the heddles if you first put a shed sword in the two sheds. The two swords help separate the bottom warp from the top warp, making it easier for you to see the top warp and correctly form the heddle loops in order without mixing up warp threads.*

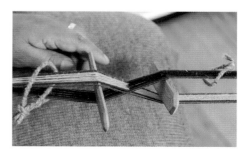

Two shed swords help separate the bottom warp from the top warp.

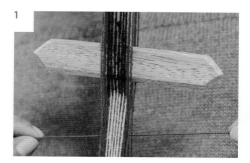

1

Open the shed closest to you and pass your heddle string through, left to right.

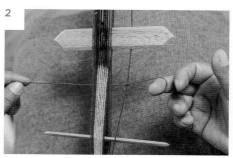

2

Tie a loop of thread about one or two inches wide in the end of this string and place it over your right index finger or middle finger.

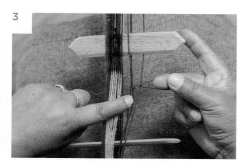

3

With the index finger of your left hand, reach between the first top warp thread and the second top warp thread on the right side of the warp.

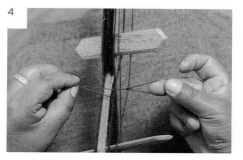

4

Pull up a loop of the heddle string.

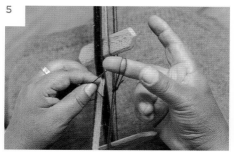

5

Loop the heddle string over your right index finger or middle finger.

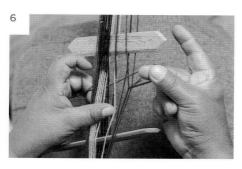

6

Adjust this second loop of string to be the same size as the first loop. You will now notice that the first top warp thread is caught up in a loop of heddle string secured to your right finger.

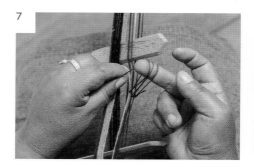

7

Continue forming loops across the warp in this manner, catching up each individual warp thread in a loop of heddle string.

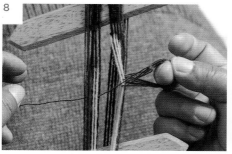
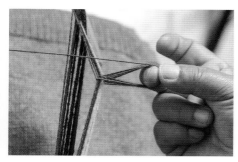

8

Make sure that you use the thumb of your right hand to pinch the heddle loops to your index finger or middle finger, so they do not fall off or pull out and in this way change size. You want all of the loops to remain the same size from beginning to end. If the warp is not wide, you will be able to hold all of these heddle loops on your right finger. If the warp is wide you will eventually need to transfer the heddle loops onto a stick as they will not all fit on your fingers. Once you reach the end of the warp and finish forming your heddle loops, you will need to secure the heddle loops. If your textile is small, two or three inches wide, you will do the following to secure the loops:

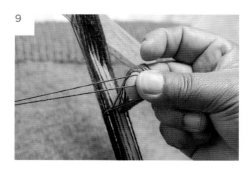

9

Pull out a length of the heddle string that is at least a little wider than the warp. Double it up (make it a loop). Place and pinch the tip of the loop between your right fingers that hold the heddle loops.

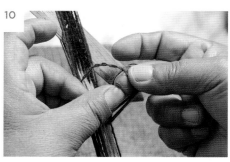

10

Pinch the tip of the loop between your right finger that holds the heddle loops and a finger of your left hand. Push the left finger through the heddle loops, pulling your right finger out the other side. In this way you will transfer the heddle loops off of your right finger and onto the looped string.Your left hand should be holding the other end of the loop so that it does not pass completely through the heddle loops.

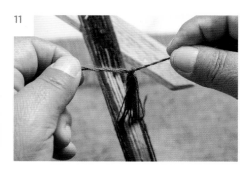

11

Fold the two ends of the loop up over the heddle loops. Tie the loop to itself firmly with multiple square knots over the heddle loops. Make sure that this knot is very tight and strong; you do not want it falling out as your heddle will then come undone.

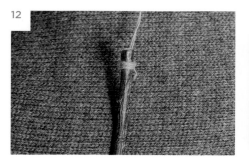

12

If your textile is wider than three inches, you will want to use a stick to secure the heddle loops: Tie another auxiliary string to the end of a stick that is slightly wider than your warp.

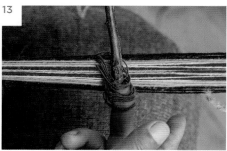

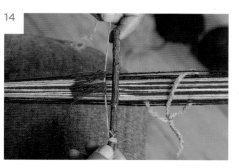

13

Pass the stick through the heddle loops so that the loops are passed onto the auxiliary string tied to the end of the stick.

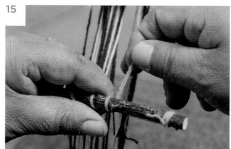

14

Hold the stick over the heddle loops. Where the auxiliary string trails out of the heddle loops, tie it tightly to the end of the stick so that the auxiliary thread lies taut along the stick. The heddle loops are now sandwiched between the stick and auxiliary thread.

15

Wrap the auxiliary thread around the stick in a spiral motion, passing it through the heddle loops at even intervals of about ¼ to ¾ of an inch. This binds the auxiliary string to the stick, securing the heddle loops and preventing them from moving.

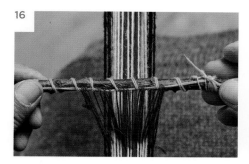

16

Tie off the auxiliary thread tightly to the other end of the stick.

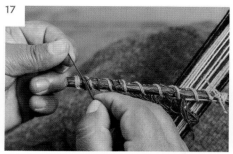

17

The end of the heddle string should also be tied to the end of the stick to secure it.

Note: *The shed formed by the main heddle is Shed 1 and the shed formed by the shed loop is Shed 2.*

WEAVING PLAIN WEAVE

18

Strap yourself into your backstrap loom. If the warp is twisted, you should unwind it so that the main heddle and shed loop are on top of the warp.

19

Insert your sword into the shed closest to you. (If you begin weaving right after setting up the heddles, your sword will already be here). We will call this Shed 1; it is formed when the main heddle is lifted. You should note which color of the warp is on top in Shed 1. Think of Shed 1 in this color. Turn the sword on edge so that it holds Shed 1 open for you.

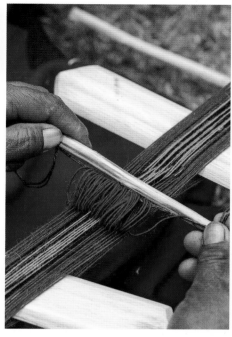

String heddle tied to a stick.

20

Pass your weft through. Leave a small tail of the end of the weft hanging out. Remove the sword.

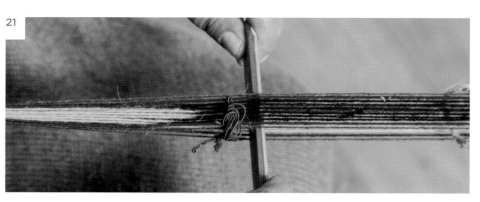

You will now change from Shed 1 to Shed 2. We will denote the shed formed by the shed loop as Shed 2. Note which color of the warp is on top in Shed 2. Think of Shed 2 as this color.

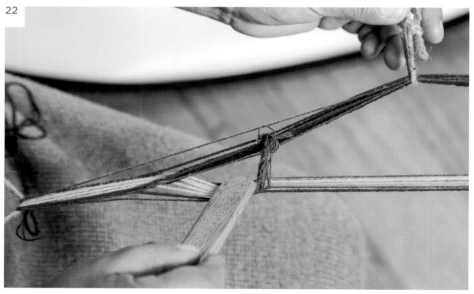

Firmly grasp the loop of thread that is your shed loop. While you pull it up with one hand, use your other hand to pull down the bottom warp. The goal is to obtain Shed 2 in front of the main heddle rather than behind it. Pulling up on the shed loop and down on the bottom layer of warp threads will make Shed 2 appear in front, or pop out.

Note: *If pulling straight up and straight down on the shed loop does not produce the desired result immediately, then place your sword in Shed 2 where it is opened behind the main heddle. Turn the sword sideways so it keeps Shed 2 open for you. Bring the sword up against the back of the loops on the main heddle. As you hold the sword in place with your fingers, use your thumbs to stroke the warp threads horizontally, running your thumbs back and forth across the warp threads from center to edge in front of the main heddle. Shed 2 will open up in front of the main heddle.*

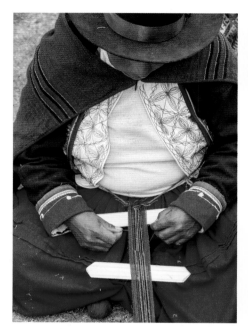

A weaver from Mahuaypampa begins to make a string heddle for a complex belt design.

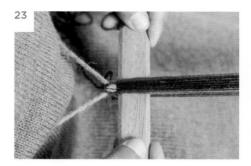

Once you have opened up Shed 2 in front of the main heddle, insert the sword in this shed. Using both hands, beat with the sword toward your waist, tightly packing down the weft you just passed through the shed.

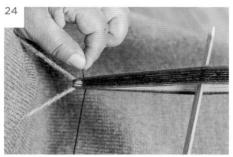

Turn the sword on edge so that it holds open Shed 2 for you. Pass your weft through the shed. Pass the tail of your weft through the shed, securing it. Remove the sword.

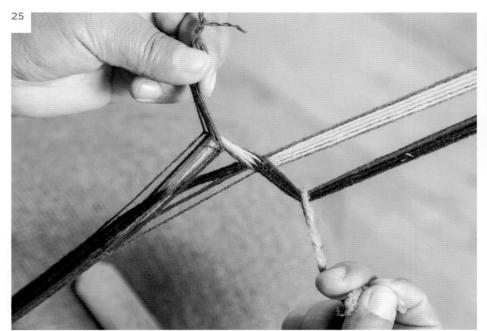

Open up Shed 1 again: pull straight up on the main heddle and straight down on the shed loop. Shed 1 will appear once again, or pop out.

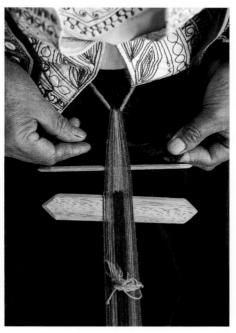

A weaver passes the warp thread through the shed while weaving a doble cara design.

Note: *It is important that you only pull straight up and straight down on the main heddle and shed loop. Many beginning weavers have the tendency to pull the main heddle back and forth in a sawing motion across the warp when they have difficulty getting Shed 1 to pop up. This sawing, while it might work in the short term, can cause problems in the long term. Either the thread loops on the main heddle will fray and break, and you will lose your heddle, or the warp threads will fray and break.*

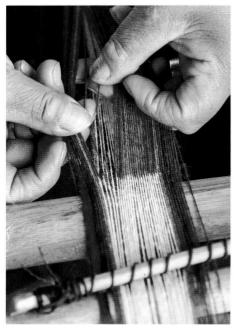

A weaver picks out a design warped for doble cara, carefully passing warp threads from one hand to the other.

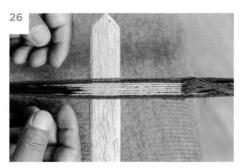

26 Insert the sword in Shed 1.

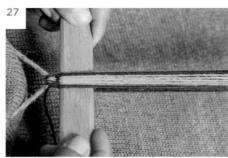

27 Beat the sword toward your waist to pack the weft in.

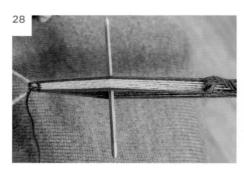

28 Turn the sword on edge so that it holds the shed open for you.

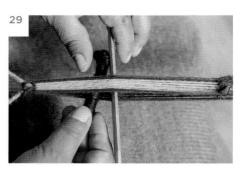

29 Pass your weft through Shed 1.

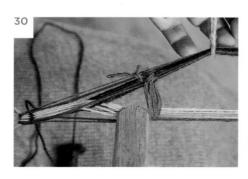

30 Open up Shed 2 with the shed loop once more and continue weaving in this manner.

31 Several rows of plain weave.

Note: *If you are having trouble getting Shed 1 or 2 to pop up, you need to look at how you are manipulating the tension on your loom. The tension you put on your backstrap loom controls how well it works. Sometimes you will want more tension, sometimes less. If you cannot get Shed 1 to pop up, lean forward slightly for less tension and the shed will pop up more easily. If you cannot get Shed 2 to pop up, try leaning back for more tension.*

CONTROLLING WEFT AND BORDERS

It can be difficult to achieve straight borders and prevent the weft from showing through between the warp threads of your weaving. Remember, textiles in the Andes are warp-faced and the weft should never appear except in a few techniques. One of the first indicators of a textile's quality is whether or not you can see the weft between the warp threads.

The trick to achieving straight borders and to preventing your weft from showing is all about tension in how you handle your weft as you pass it through a shed. When you pass the weft, do not just pass it straight through and pull it tight from the other side. This will make it harder to form straight borders and almost guarantee that the weft will show through.

Instead, before you pass the weft through, hold onto a length of it in the hand on the side it is coming from. Pull the weft tightly in this hand so that you are pulling tight the previous row you wove. Pass the weft through the shed, but keep pulling in the opposite direction on the previously woven row. Slowly pull the weft through the current shed while maintaining tension on the previously woven row. This will ensure that your weft does not show.

As you pull the weft thread through, it can pull the warp threads out of their straight line. So once you have pulled the weft completely through the new shed, gently pull horizontally on the border warp threads on the side the weft is coming from. Pulling the warp in this manner allows it to snap back into the straight position it was in prior to your passing the weft. This will ensure that your borders remain straight.

Practicing these techniques and knowing your own weaving style are the keys to achieving straight borders and hiding the weft. Some people weave tighter than others, some looser. Knowing your own innate weaving rhythm will help you control details like borders and weft.

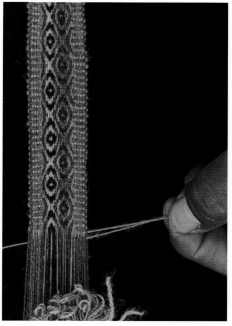

Holding onto the weft thread while passing it helps to maintain even edges.

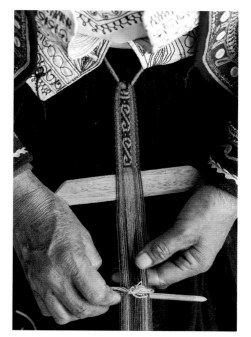

DOBLE CARA (COMPLEMENTARY WARP)

Weaving in this technique produces a two-faced fabric in which the pattern and structure are the same on both sides, but the colors are opposite. Patterns are made by picking up warp threads from the bottom layer to create a motif, at the same time dropping their corresponding warp threads from the top so that the same motif appears on the opposite side in the opposite color.

The most important aspect of understanding the doble cara technique is that the warp threads come in pairs, one light color and one dark, alternating across the warp. The upper layer of warp threads will be one color, the lower or bottom layer the other. The cross that was formed when you create the warp keeps the threads in perfect alternate order. The two warp layers change places, depending on which shed you have opened. Every single thread in the top warp has a corresponding thread of the opposite color in the bottom layer of

warp. For example, if your top warp is yellow and your bottom warp is blue, then every yellow thread on the top will have its corresponding blue thread below. If there are six yellow threads on top there will be six blue threads below.

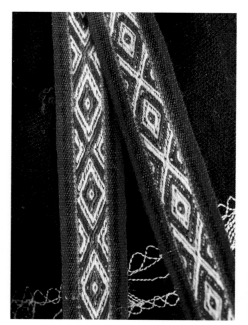

ABOVE: Weaving the *kuti* design in doble cara. Kuti means "to return" in Quechua. BELOW: The front and back of this *luraypu* (diamond) design woven in doble cara show the same motif but in different colors.

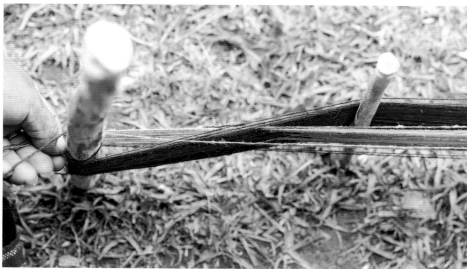

A doble cara warp for a design of three colors shows the distinct separation of the upper and lower warp threads.

WEAVING A *JAKIMA* (NARROW BAND)—A TWO-COLOR DESIGN

The very first design that young weavers learn in many communities is tanka ch'uru, also known as *el Cruz Andino*, or the Andean Cross. *Tanka* is the Quechua word for a forked branch. *Ch'uru* means snail shell or seashell. Often the simplest designs are called ch'urus. The Tanka ch'uru design represents the four regions, or *suyos*, of the Incan empire, which was known as *Tahuantinsuyo* by the Inca: *Chincha Suyo* to the north, *Anti Suyo* to the east in the Amazon jungle, *Colla Suyo* to the south, and *Cuntin Suyo* to the west. The weavers call tanka ch'uru the "mother of all designs" because it teaches all the basics of the doble cara technique that a weaver must master in order to learn more complex doble cara designs.

Traditionally, in Chinchero when a young weaver completes her first jakima, which is normally the tanka ch'uru design, she gives it to a male relative to throw into the Vilcanota River so that she may one day weave as fast as the river flows.

To form designs in the doble cara technique, you will select threads from either the upper warp or the bottom warp, depending on what colored thread is required by the design. If the color you need is in the upper warp, then you leave the upper warp thread on top and leave its corresponding bottom warp thread on the bottom. If the color you need is in the bottom warp, then you drop the corresponding upper warp thread and pick up the bottom warp thread. In other words: whatever you do to the upper warp thread you must similarly do to its corresponding partner thread in the bottom warp. The result is that you form the design on both sides of the textile but in reverse colors.

There is an important trick to realizing which bottom warp thread corresponds to which top warp thread. When you have Shed 1 open you will notice that the bottom warp threads are either to the right or left of the top warp threads. When you open Shed 2 you will notice that the bottom warp threads are now on the opposite side of the top warp thread. For example, if you open Shed 1 and the bottom warp threads are to the left of the top warp threads, then when you open Shed 2, the bottom warp threads will now be to the right of the top warp threads.

If the bottom warp threads lie to the left when the shed is open, then you can find the partner to any individual top warp thread directly to the left. It will be the bottom warp thread to the left of that top warp thread.

If the bottom warp threads lie to the right when the shed is open, then you can find the partner to any individual top warp thread directly to the right. It will be the bottom warp thread to the right of that top warp thread.

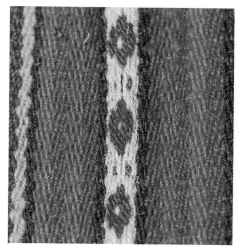

Tanka ch'uru design.

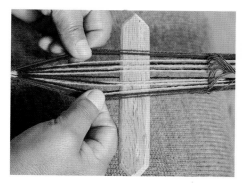

In this example, Shed 1 is open and bottom warp threads are to the right side of top warp threads.

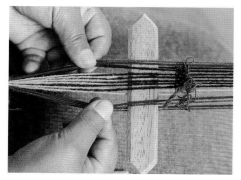

Shed 2 is open and bottom warp threads are to the left side of top warp threads.

PROPER HAND POSITION

To quickly and easily pick out the designs, proper hand positioning is a must. While each weaver varies slightly in her manner of picking out designs, we will use the most widely used hand position in these instructions, as the majority of beginning weavers find it the easiest and clearest to use.

You will use both your left and right hands to form the designs. If you are right-handed you will pick up from right to left. If you are left-handed, then you will pick up from left to right. We will consider the right-handed perspective.

You will use three fingers on each hand: your middle finger, your index finger, and your thumb. At either side of the jakima, place your middle fingers below the bottom warp. Your middle fingers will always be responsible for controlling the bottom warp.

Insert your two index fingers into the shed between the upper and bottom warps. Your middle fingers will always be responsible for controlling the upper warp.

Place your thumbs over the top warp. Your thumbs will slide warp pairs from your left hand to your right hand and will work with your index fingers to change top warp threads for bottom warp threads.

Your left hand will feed your right hand warp pairs as you move along from right to left selecting the correct upper or bottom warp threads to form the design.

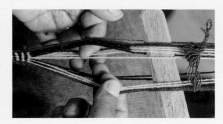

When you are first learning to weave, it is easy to confuse whether the corresponding bottom warp thread is the thread to the left or the right of the top warp thread in question. If you are keeping accurate count of your threads as you weave, however, you will realize if you've made a mistake when you reach the end of the design line you are weaving. If there is an extra bottom warp thread, or if you are missing a bottom warp thread, then you probably made a mistake in determining if the partner thread on the bottom warp was to the right or to the left.

An Andean weaver would not use a chart but would instead recall the pattern design from memory. For ease in understanding how the doble cara design is formed, we have created this chart. Read it in the same direction that you pick out each pattern row: from right to left and bottom to top. (This is for right-handed people. If you are left-handed then you will weave left to right and read the design left to right.) This chart only considers the warp threads in the design; it does not include any border warp threads.

The numbers of rows in a design are indicated in the columns of numbers along each side of the chart.

The background colors in the boxes of the chart indicate the color of the warp thread, enabling you to see the design in the chart.

The letters O and X inside of each box in the chart indicate whether the color you need (the color of the box) is to be found in the upper warp or the bottom warp. If the box has a letter O, then the correct color is in the upper warp already and you can leave it where it is. If the box has a letter X, then the color you want is in the bottom warp. This means that you will drop the upper warp thread and pick up the bottom corresponding warp thread.

10	O	O	X	X	O	O	10
9	O	O	O	O	O	O	9
8	X	X	O	O	X	X	8
7	O	O	O	O	O	O	7
6	O	O	X	X	O	O	6
5	X	X	O	O	X	X	5
4	O	O	O	O	O	O	4
3	O	O	X	X	O	O	3
2	O	O	O	O	O	O	2
1	X	X	O	O	X	X	1

Weaving the Design For this example, we will work with yellow and blue warp threads for the tanka ch'uru design. On the side of the jakima facing us as we weave, we will make the cross blue and the background yellow. On the other side of the jakima (the side we don't see as we weave) the cross will be yellow and the background will be blue.

To weave designs you need at least two swords. For plain weave, you can use just one sword. Before starting your design, weave a few rows of plain weave. Each weaver varies in the number of plain weave rows she chooses to weave before starting her design. Most weavers put in one to five rows of plain weave before starting the design, while some begin the design right away without any plain weave. We recommend that beginners weave a few rows of plain weave before the design to help adjust tension and establish borders.

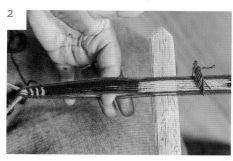

1 Once you are ready to start the design, look at your sheds. The shed that allows the blue warp to be on top should be opened closest to you. Place a sword in this shed. We will call this the Blue Shed.

2 Above the Blue Shed secured by the sword, open the other shed that allows the yellow warp to be on top. Place your second sword in the Yellow Shed.

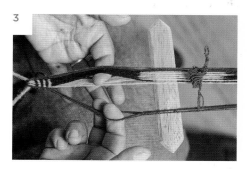

> Push the two swords up about 5 to 10 inches away from your waist. This will push the cross in the warp up and away from your waist. The amount of space you want between the cross and your waist is a personal decision that depends on your own weaving rhythm and the size and flexibility of your fingers. The larger your fingers, the larger space you will likely want.

> Pull the first sword in the Blue Shed back to your waist to rest just beyond what you have already woven.

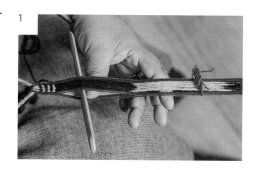

3 Place your fingers in the proper hand position to weave in the Blue Shed. Separate out the border: from your left hand, pull the bottom border warp onto the middle finger of your right hand, pull the upper border warp onto the index finger of your right hand. This will open up a divide in the warp between the right-hand border and the warp threads of the design.

> Look at the first row of the chart, reading from right to left: you need two yellow threads on top, followed by two blue threads, followed by two more yellow threads.

4 Selecting the first pair of threads: The first two yellow boxes in the design chart have Xs in them. This means that these yellow threads will be in the bottom warp. You must change the two yellow bottom warps for the two blue upper warps. To do this, slide the two blue warp pairs from your left hand and let them drop in the divide between your hands. (You can use your thumb and index finger in your right hand to pull the two warp pairs off of your left hand). See note, page 54.

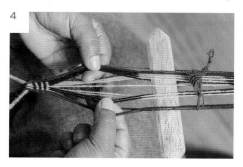

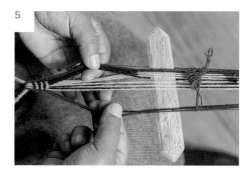

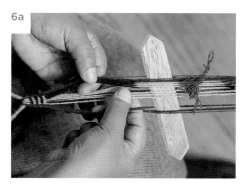

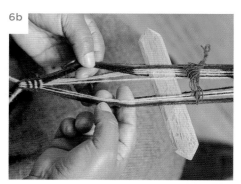

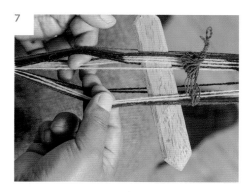

5 You will notice that the bottom yellow threads jump to the top and the top blue threads drop to the bottom.

6 a With the middle finger of your right hand, grasp the blue thread now on the bottom and lump it with the other bottom threads of the border in your middle finger. b With the index finger of your right hand, grab the yellow threads that are now on top and lump them with the other top threads of the border in your index finger.

7 Selecting the second pair of threads: The second two boxes in the design chart have Os in them. This means that the blue thread will be in the top warp. Your work is much easier now as you do not need to swap bottom warp threads for top warp threads. Instead, you merely slide the two warp pairs over, transferring them from your left to right hand.

8 a Put the two yellow threads on the bottom with the other bottom warp threads in the middle finger of your right hand. b Put two blue threads on the top with the other top warp threads in the index finger of your right hand.

9 Selecting the third pair of threads: These boxes also have Xs in them so you must drop the two blue threads in the top warp and pick up the two corresponding yellow threads in the bottom warp as you did for the first two warp threads.

> You have now finished picking out the first line of the design. Transfer the left-hand border that remains held in your left hand to your right hand with the rest of the warp.

> Take out the sword nearest to you that is holding open the Blue Shed. Place this sword in the new shed you just created—place the sword in the space where your right index finger is.

Note: *Beginning weavers will leave the sword in the shed closest to them, here the Blue Shed, in order to save that shed in case of mistakes. If you mix up the design and pick out the wrong colors, then drop all the threads held in your hands. Pull up the sword in the Blue Shed to meet the sword in the Yellow Shed, forming the correct cross in the warp once more. Pull the sword in the Blue Shed back closer to you and try weaving the line of the design again in the Blue Shed. More experienced weavers do not always leave the sword in the nearest shed, but rather remove it once they have their fingers in place to weave. If they make a mistake, they do not have the sword holding open the nearest shed to revert back to. Instead they must drop all the threads they've made the mistake in, remove the upper sword as well, and re-form the lower shed with the heddles, put in the sword, re-form the upper shed with the heddles, and put in that sword again as well. Leaving in the nearer sword saves time if you make a mistake because you don't have to re-form all the sheds again with the heddles.*

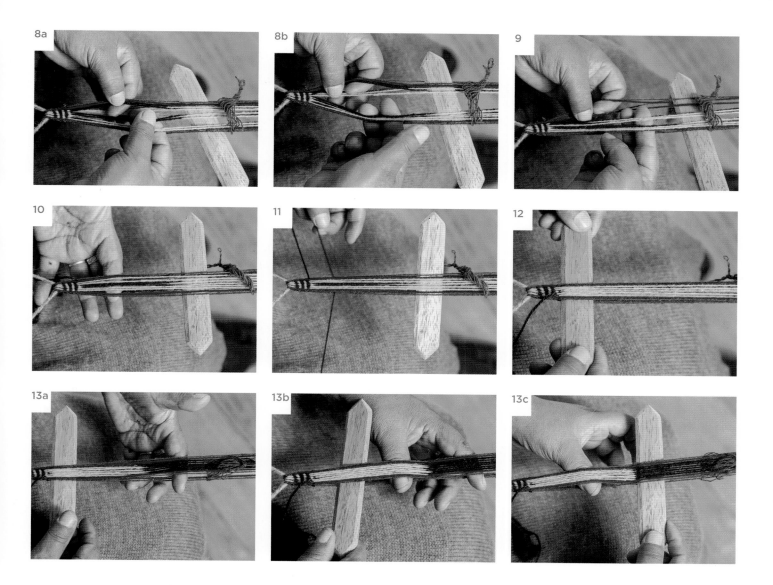

10 You may now remove your right hand from the warp, as the sword is holding the design shed you just picked out.

11 Pass the weft through the design shed held by the sword. Remove the sword.

12 Beat down the upper sword in the Yellow Shed to pack in the weft you just passed through.

13 a Open up the Blue Shed above the Yellow Shed and insert the sword. b, c Adjust the distance from the cross in the warp to your waist if necessary by pushing it farther away with the sword.

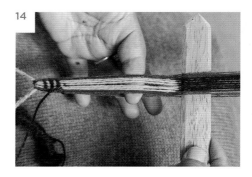

14

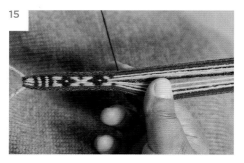

15

14 Bring the sword in the closest shed, the Yellow Shed, to your waist. Place your fingers in the weaving position in the Yellow Shed and weave Row 2 in the design.

15 Continue weaving in this manner through Row 10 of the chart. Repeat the design, starting again at Row 1.

Once you get close to the end of the warp it will be harder and harder to weave. Many weavers will revert to plain weave as they near the end because it is hard to get their fingers into the warp to pick out the design. Once it is impossible to weave any more, untie the jakima, turn it around, and braid the ends.

Note: *When you select bottom warp threads and exchange them for top warp threads it is very important that you do this correctly. Many beginners have the tendency to first pick up the bottom warp and then drop the top warp. Doing this often twists the top and bottom warp threads around each other, producing a mistake. It is important that you first drop the top warp threads between your left and right hands. Only then should you pick up the bottom warp threads that will have jumped upward. This will ensure that the bottom and top warp threads remain in perfect order and do not twist around themselves.*

THREE-COLOR DESIGNS

Two-colored designs are the simplest to warp and weave. Pre-Columbian weavers knew how to weave doble cara designs with up to six colors. Today we only know how to weave with up to three colors. Like two-colored designs, three-colored designs come in warp pairs but are arranged in a slightly different way. For the sake of explanation, we shall say that the light color is in the bottom warp and the dark color is in the top warp. For every light-colored warp thread on the bottom there are two dark-colored warp threads on the top. In many ways these two dark-colored warp threads are treated as a single unit: they are held together and controlled by the same loop of string in the main heddle, and they appear together either to the left or right of the light-colored thread depending on which shed is open. During the moment of picking out the design, however, the two dark-colored threads are not treated as a single unit but considered separately.

Three-colored designs are woven in alternating sections, or blocks, of the two dark colors. For example, if you look at the side of the textile where the dark colors form the background, then you will see one rectangular background section in one dark color followed by one rectangular background section formed by the second dark color. That is, the three colors do not appear together on the same side in the same place. Instead the light color appears with one of the dark colors at a time, alternating between the two dark colors. It is important to

A three-colored design woven in doble cara shows the two dark colors alternating against the light green color. The top design, in red, is *maki maki* (hand to hand); the second design is *chunchu* (a person from the jungle).

remember which dark color section you are currently weaving in order to correctly weave the design and not make a mistake.

Three-color designs are not particularly complex to weave but take longer as you have to work through picking out an extra set of threads in the third color and must keep mental track of which dark color you are working with on the top and bottom. In the three-color doble cara technique, weavers tend to think in terms of positive and negative space to help them remember which dark color should be on the top or bottom. In the two-color doble cara technique, weavers tend to think in terms of reciprocity: the bottom warp threads mimic the top warp threads.

OTHER DOBLE CARA TECHNIQUES

Jakira (Intermesh) Jakira comes from the communities of Patabamba, Chahuaytire, Accha Alta, and other areas to the north and northeast of Cusco. It is a complex weaving technique that forms very thick cloth. This technique requires more warp threads than are typical for doble cara. The warp threads are set up in four heddles, and the pick-up of the pattern is done with the last heddle. Due to the complexity and resulting thickness, it is generally never woven in large textiles but only in *chumpi* (belts). Men use these thick belts to support their waists and backs while they work in agriculture lifting heavy bundles.

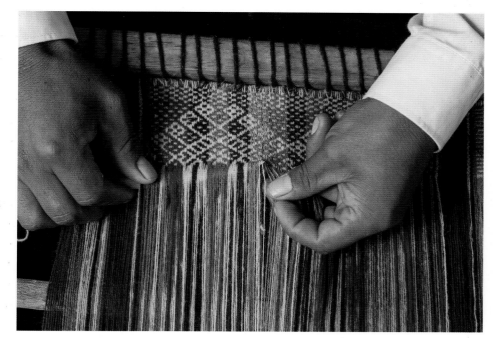

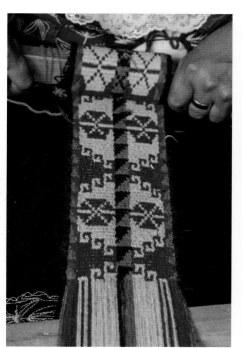

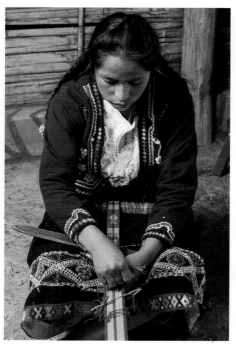

ABOVE: *Palmay ramos* complementary warp: picking up in groups. BELOW LEFT: Catarina Champi Ojeda from Patabamba weaves a *puma maki* (puma print) with roses design in jakira. BELOW RIGHT: Rebeca Sutta Huaman from Chahuaytire weaving jakira.

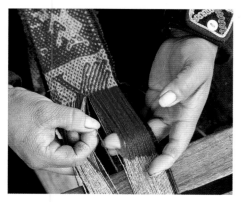

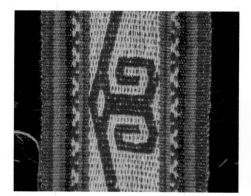

Pata Pallay (Pebble weave) Pebble weave, known as *pata pallay* in the Cusco region, is a type of doble cara pattern that alternates long sections of a solid color with checkered dots of warp pairs to form patterns. The plain-weave sections connect the checkered dots to form the design. This variation on doble cara is generally used to create more realistic, representative designs of animals and objects. For this reason it is also sometimes called animal pallay. As every other row consists of large expanses of plain weave with interceding rows made up mostly of two-by-two checkered dots, it is easy to weave designs in pata pallay and easy to invent new designs or variations on designs. When weaving in pata pallay, many weavers will string different animal figures together one after the other, switching the background color for each animal. For example, if a weaver is working in red and white, she may weave the first animal in white on a red background, and then weave the second animal in red on a white background, continuing to alternate the background and figure color from animal to animal.

In the llama design (at top left), note how the background is formed by checkered dots and the body of the llama is composed of long stretches of a solid color, the classic formation of pata pallay.

BELT BORDER

In Chinchero, Mahuaypampa, Santo Tomas, and many other communities in the Cusco region, weavers use a unique border technique to hide the weft at the edge of a textile and create the appearance of a tubular border. Most often the technique is used in belts, especially belts worn by men to support their backs as they work in agriculture and to lift heavy loads. It is generally used in textiles woven in the doble cara technique as opposed to *ley* (see page 57).

ABOVE and CENTER: Pata pallay designs. BELOW: A pata pallay variation where only one light and one dark warped thread is picked up in a row. That is, the checkered dots are not formed by a warp pair (two threads), but by half a warp pair (one thread). This is a technique used in the Momia Juanita textiles. RIGHT: The tubular belt border is composed of four woven rows in which floating and non-floating warp threads are alternated.

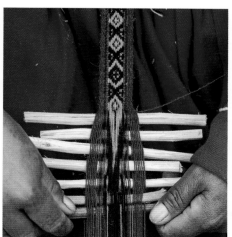

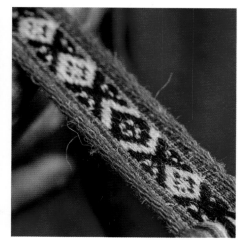

LEY (SUPPLEMENTARY WARP)

Ley is a supplementary warp technique that forms designs on one side of the textile. The background warp is usually a light color while a set of darker warp colors creates the design by floating on the top face of the weaving. In this technique, the weft will show between the light colored warp threads of the background. Some weavers prefer to use a weft that is the same color as the background so that the weft blends in. Other weavers prefer to use a weft of a different color so that the weft does show, forming a pattern of small dots in the background warp.

Due to the design structure, ley is significantly easier and faster to weave than doble cara designs, and in the past, many weavers valued textiles in the doble cara technique more highly than those in the ley technique. Also owing to the design structure, it is much easier to invent new designs in ley. A weaver can easily create any new image she can think of, from letters for writing words to realistic representations of animals and people.

As in doble cara designs, there is a light color and dark color in ley designs. Unlike doble cara, where the dark and light colors can both form the background color, in ley the light color is always the background while the dark color always forms the designs.

Unlike doble cara, the warp threads do not come in complementary pairs in the upper and bottom warps; the upper warp does not directly correspond to the bottom warp. While doble cara designs are almost always an even number of threads across (and so an even number of warp pairs across), ley designs are always an uneven number of warp threads wide. In doble cara, all threads are considered part of the pattern, but in ley only the dark colored threads are counted while the light colored threads are essentially ignored. Small ley designs may be 3, 5, or 7 dark threads wide. Large ley designs may be as many as 27 to 29 dark threads wide, or even more.

We will take as an example a small ley design from the community of Chinchero called *coco*. In total there are 21 warp threads in this design, 7 of which are dark pattern threads, making it a 7-thread design according to the logic that just counts dark threads. In Shed 1 there are a total of 10 warp threads. In Shed 2 there are a total of 11 warp threads.

In our example the dark color (DC) warp threads are purple and the light color (LC) warp threads are pink. The DC warp threads and LC warp threads are arranged in this way in each shed:

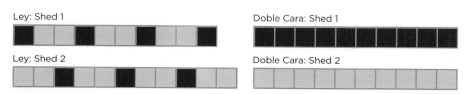

Ley: Shed 1

Ley: Shed 2

Doble Cara: Shed 1

Doble Cara: Shed 2

In ley, the two colors alternate in both sheds. Notice that the LC warp threads come in pairs but that the DC warp threads do not.

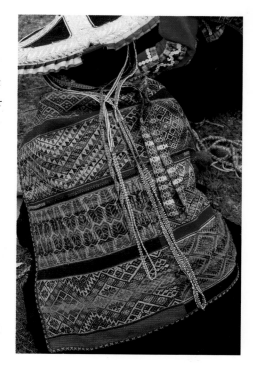

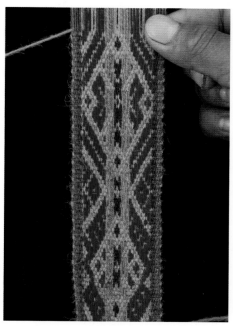

ABOVE: An exquisite manta from the community of Pitumarca is woven in ley. BELOW: A narrow band woven in ley.

When you weave a ley design, you only work with the DC warp threads. That is, you only have three actions that concern you:

1. Keeping a DC warp thread on the top warp.
2. Dropping a DC warp thread from the top to bottom warp.
3. Picking up a DC warp thread from the bottom to top. When you drop or pick up DC warp threads, you do not pick up or drop any of the LC warp threads as you did with doble cara.

Note: *In a few special cases, mostly in large, wide designs, the weaver will sometimes work with the DC and LC threads to form the design in ley, but we will not touch on this advanced technique here. In the vast majority of ley designs only the DC threads form the pattern.*

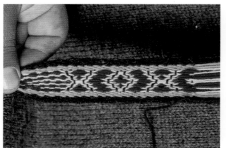

It is possible to pick out the designs in ley in two ways: with your fingers or with a ruki. Generally weavers tend to work on smaller textiles with their fingers, and larger textiles with a ruki.

If you choose to work with your hands, the hand position is the same as with doble cara designs. If you choose to work with a ruki, hold the bone in your right hand. Use the point to pick out the DC warp threads from right to left. Use your left hand to help guide the picking up and dropping of DC warp threads.

Ley can also be woven in designs of three colors. Like ley of two colors, ley of three colors is also a supplementary warp weave where the second dark color is additional supplementary warp. The two dark colors always come together in the warp and are sometimes treated as a single unit, and sometimes treated as separate threads. There are two ways to create three-colored designs. In the simpler way, the design is only seen on one side of the textile. In the more complicated technique, the design is seen on both sides of the textile.

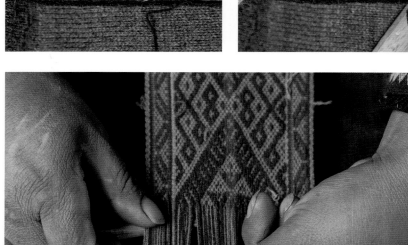

ABOVE: In ley, the background warp is usually a light color while a set of darker warp colors creates the design. CENTER LEFT: The back side of the ley design coco from Chinchero. CENTER RIGHT: The front side of the coco design. BELOW: In this *tika organo* design woven in ley, the lighter color forms the background and the dark color forms the motifs.

WATAY (RESIST DYEING)

Watay is the Quechua term for *ikat*, or resist dyeing. In this technique, the weaver tightly wraps up sections of her warp before dyeing it. When the warp is dyed the dye cannot penetrate the wrapped sections and they remain undyed. After the weaver mounts the warp on her loom and begins to weave, the dyed and undyed sections of warp create the pattern as she weaves it in plain weave.

The community of Santa Cruz de Sallac revived this technique from near oblivion, with much of the credit going to the hard work and perseverance of Leonardo Quispe who nearly single-handedly recovered the working knowledge of watay. In the Andes, resist dyeing can be traced to the pre-Columbian Nazca and Huari cultures. The technique practiced by the Nazca and Huari is more similar to what we would recognize as tie-dye, or shibori in Japan, where the already woven textile is tied in intricate patterns and then dyed. After dyeing, the tied parts of the textile are untied, leaving un-dyed patterning. This dyeing technique was frequently used in combination with *ticlla* (see page 63) to create very intricate patterning. The weaver would first create multiple textiles with ticlla. Each textile was then tie-dyed in distinct colors. After dyeing, each textile was disassembled following the ticlla divides. The different color sections were then mixed and matched together in highly complex patterning. The loose warp ends from the ticlla technique were then dovetailed to connect pieces while horizontal slits were sewn together.[1] Today Santa Cruz de Sallac is one of the very few communities, along with the Ccatcca area, in the Cusco region that still maintains the watay dyeing technique in their traditional textiles.

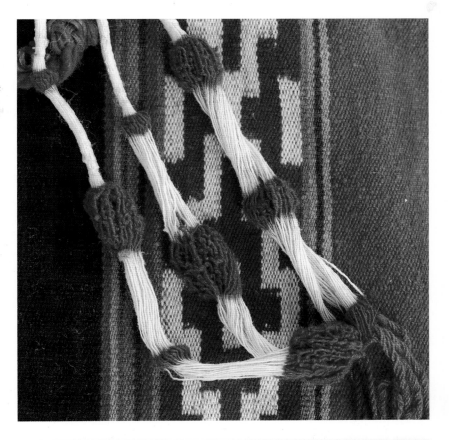

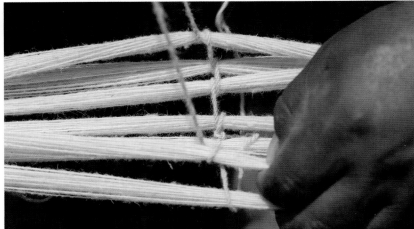

ABOVE: These threads, dyed with great precision, will be warped on a loom and woven into the chakana or cross design shown on the fabric beneath. BELOW: Weavers use a highly complex system of organizing the warp threads in order to tie the resists.

[1]Rebecca Stone-Miller. *To Weave for the Sun: Ancient Andean Textiles.* New York: Thames and Hudson, Inc., 1995, p. 101.

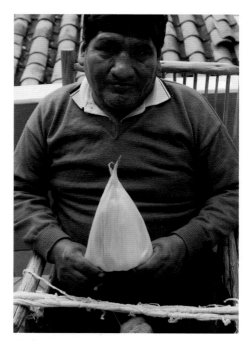

Rigoberto Puma Mayta of the Santa Cruz de Sallac weaving association holds a corn husk used to wrap the warp threads prior to watay dyeing.

Preparing the Warp for Dyeing All of the most complicated work in the watay technique comes in the moment after warping when two people must work together at all times with a warping board or with three sticks in the ground to arrange and rearrange the warp. This rearranging is a means of keeping the threads organized for tying the resists and forming the correct design. The warp is begun the same as for plain weave in doble cara or ley, but two separate sections of warps are formed, each consisting of seven warp sets that are tied off individually. The two warp sections are then combined until only four warped sets remain. Later, after dyeing the threads, the warp is arranged on the warp beams for weaving or is replaced on the warping board or stakes to augment more warp for plain weave or for designs.

Wrapping the Warp At this point it is not necessary for two people to work together, although it makes the processes go faster with two sets of hands working at wrapping up sections of the warp. Usually men wrap the warp because of the strength required, but now women also participate in the wrapping.

> For wrapping the warp you will need:

A cup of water

Many lengths of thread that you will wrap around the warp

Corn husks or plastic (from plastic bags, for example), or heavy packaging tape

> If you are working with corn husks, the traditional material, they need to be damp. If they are completely dry they will crack and fall apart. Today most weavers use plastic from plastic bags, as it is easier to work with. The process for tying each warp section is as follows:

Cut the damp corn husk to the desired length. Dampen the length of thread you will use to wrap with.

Place the corn husk around the section of warp that you will wrap up.

3

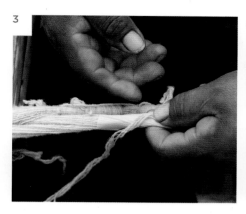

Tie the damp thread around the corn husk and completely wrap the length of the husk twice with the string.

4

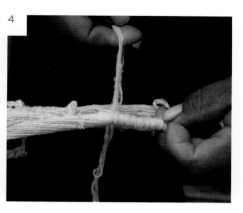

You should wrap as tightly as you possibly can, completely covering the corn husk with the wraps of thread. The tighter you wrap up the corn husks around the warp, the less likely that dye will get inside when you dye the warp.

5

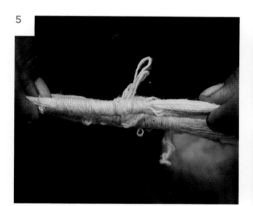

Tie off the end of the thread.

6

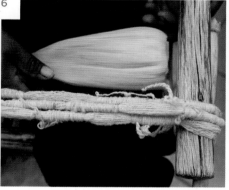

Warp wrapping completed and ready for dyeing. Detail below.

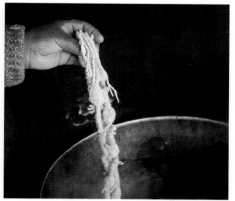

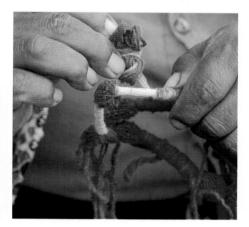

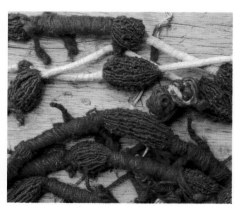

ABOVE: The wrapped threads are placed in a cochineal dye bath. CENTER: The threads are carefully unwrapped after they have been dyed and dried. BELOW: Unwrapped sections reveal the white threads that will form the outline for the Chakana design.

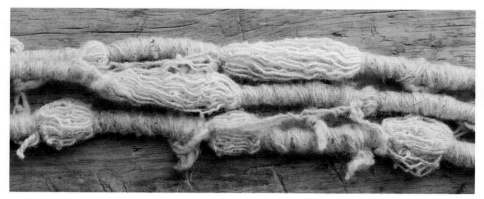

You should wrap the warp in sections according to the diagram below. The light gray indicates the four warp sets. The green sections indicate where you should place a corn husk and wrap up the warp. The general wrapping pattern is a zig-zag with a dot at the center of each triangle formed by the zig-zag. Due to the manner of arranging and rearranging the warp in sets, when this is dyed and later woven, the weaving pattern will be a chakana, or cross. Once you have finished tying each section, you untie the sticks from either end of the warp. The warp is now ready to dye.

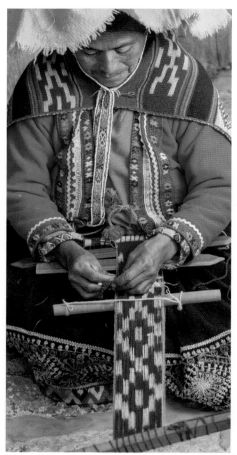

ABOVE: Nicolasa Quispe Huaman from Sallac weaves the chakana design, which some believe represents the Southern Cross constellation.
RIGHT: The warp threads reveal the precision in all aspects of the dyeing and warping processes.

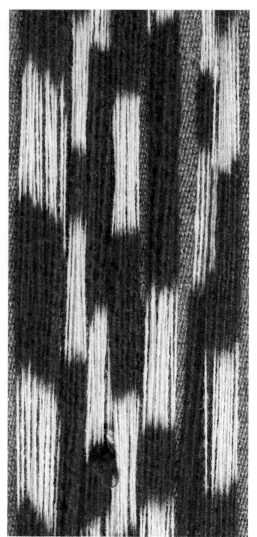

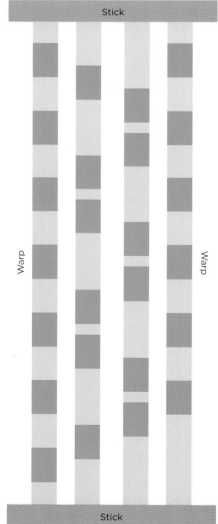

TICLLA (DISCONTINUOUS WARP)

This is an ancient and complex technique that was only maintained in the community of Pitumarca. Weavers draw their designs from examining old pieces woven by earlier generations as well as from ancient pieces found in museums and collections.

Discontinuous warp allows the weaver to change the color of her warp. This is achieved by inserting different sticks in the warp and warping different colored sections between the different sticks. Where a stick is inserted, the two colors of warp interlock around each other to form one continuous textile in the different colors. Ticlla can be woven either with plain weave or with patterning in ley. The colors and designs are determined during the warping process. The loom is set up with heddles in each warp section, as each warp section is woven separately. A weaver typically decides to include from two to three changes in warp color, but in a complicated piece will use many more: the only limit is her imagination and skill. When the weaver approaches the end of the first section of ticlla, she will turn the loom around and weave from the opposite end of that section to meet what she had previously woven in that section. The last few inches are finished with a needle as it is impossible to fit fingers and weaving tools in the small space left in the warp. Before this needle weaving begins, the weaver removes the shed rod and continues to use the heddle so that she only

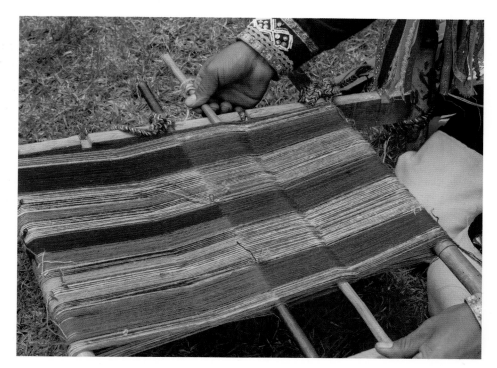

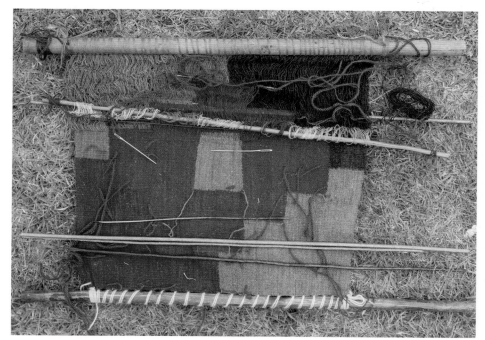

ABOVE: A completed ticlla warp ready to be woven in ley. BELOW: A partially woven chakana design in discontinuous warp.

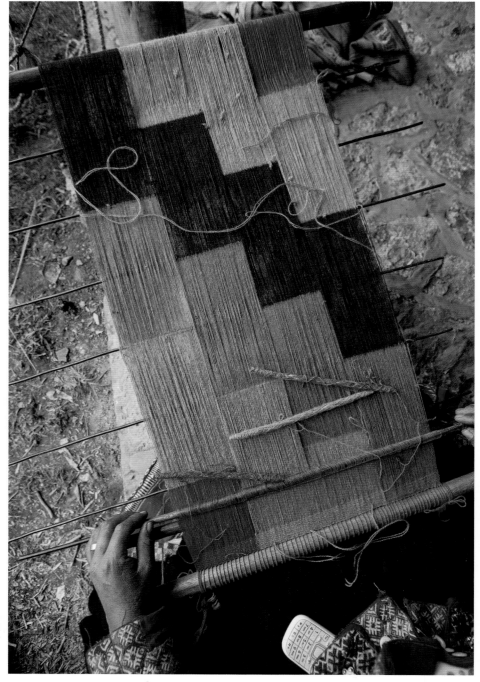

needs to needle weave one of the two sheds. Eventually, the heddle must also be removed. Historically weavers used bone needles before they had access to metal needles, and some still use needles made of bone, cactus spines, bamboo, or wire. Once the weaver finishes the first section, she will then weave the other sections in the same way.

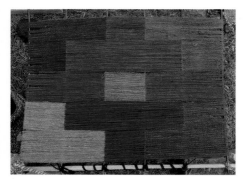

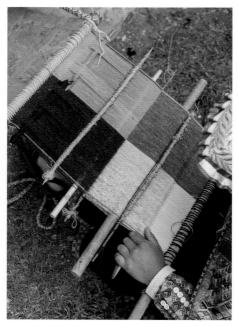

ABOVE: *Escalonada*, the staggered steps design, is woven in discontinuous warp. ABOVE RIGHT: Chakana, cross design, fully warped and ready to weave. BELOW RIGHT: The backstrap loom is set up with heddles in each warp section to weave the *ticlla unkuña*. The design, the simplest using this technique, represents the four regions of the Inca empire.

DOUBLEWEAVE

Doubleweave is an ancient technique widely practiced by pre-Columbian cultures that fell out of use and was eventually forgotten by nearly all modern weavers of Peru, although there are still weavers living and working on the border with Bolivia and in Bolivia that practice the technique. After analyzing ancient textiles, scholars were able to divine the structure of the technique and re-create it. An important turning point was Adele Cahlander's 1985 book, *Double Woven Treasures from Old Peru*, that renewed interest in this technique. During the international weaving conference, Tinkuy 2013: Gathering of the Weavers, organized by the *Centro de Textiles Tradicionales del Cusco* (CTTC), Jennifer Moore held a workshop to teach the doubleweave technique. After much hard work, the weavers that work with the CTTC are now recovering this ancient technique that was once lost to Peru.

The structure of doubleweave is exactly as the name suggests: multiple sets of heddles control the warp in order to create two layers of cloth, one on the top and one on the bottom. The weaver is essentially weaving two planes of cloth, each a different color, at the same time. These two planes of cloth intersect each other at specific points to form the design on the top and bottom in reverse colors.

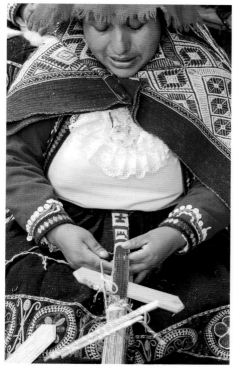

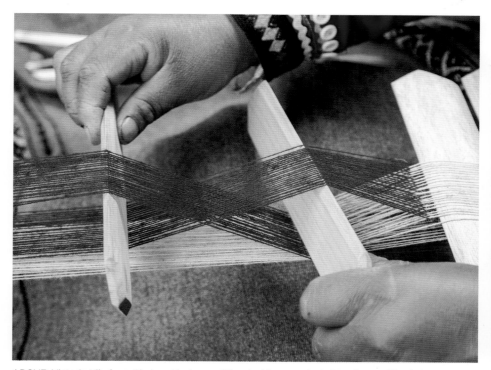

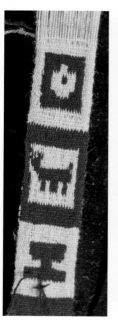
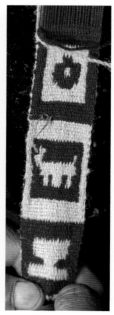

ABOVE: Victoria Ylla from Chahuaytire learned the doubleweave technique from a friend. BELOW LEFT: Placing multiple shed sticks in a doubleweave warp. The weaver is essentially weaving two planes of cloth. BELOW RIGHT: The same doubleweave piece, side by side, showing opposite colors on front and back.

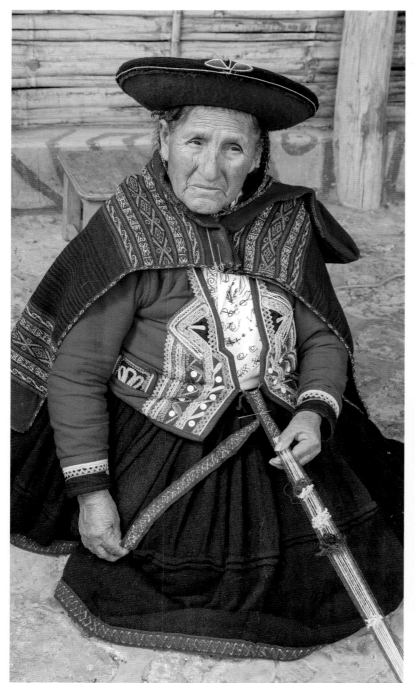

GOLON (WOVEN BAND)

A *golon* is the woven band sewn as a decorative element to the bottom edge of *polleras* (women's skirts). The technique is an interesting combination of tapestry joins and pattern sheds lifted with string heddles. Unlike other weaving we've described, golones are weft-faced—that is, the weft forms the visual design, and the warp is hidden.

All of the work in weaving a golon comes at the moment of forming the pattern heddles. A weaver puts in a set of heddle loops to control each woven row of the design. When she is weaving the golon, she does not need to pick out the warp threads to form the design; instead she merely pulls up the correct heddle set and passes the correct weft color.

Different styles, sizes, and designs of golon can be found in many communities from around the Cusco region. Golones range from very simple with few colors of weft, to very complex with many colors and many pattern heddles.

ABOVE: Rosa Quispe de Pumayalli weaves a traditional Chinchero golon. The golon sewn to the bottom of her pollera is the same design. CENTER: The white threads, tied to ten string heddles, create the design as the heddles are shifted in the proper sequence. RIGHT: Warp threads consist of several white threads framed on either side by two pairs of red threads.

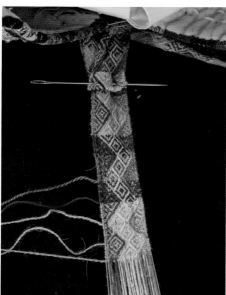

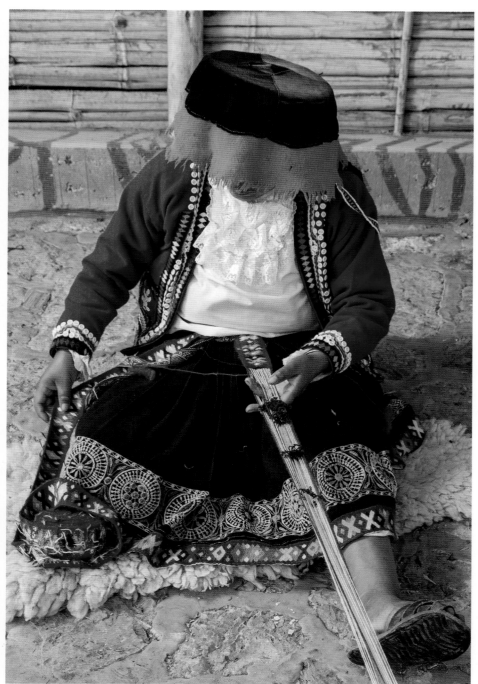

ABOVE LEFT: A very complex Huacatinco golon. BELOW LEFT: A Pitumarca golon woven with as many as sixteen string heddles to create the intricate pattern. RIGHT: Asunta Suta Puma weaves a Chahuaytire golon—the same design sewn to the bottom of her pollera.

FINISHING

There are two ways to finish a larger piece of weaving. The traditional way is harder and more time consuming. The new way of finishing a textile arose out of a need to quickly finish pieces for the tourist trade.

In the traditional method, the weaver will finish weaving every last inch of her warp, creating a textile that has four selvedges. When she nears the end of her warp, she will flip her loom around and begin to weave from the other side. As she advances her weaving bringing the two woven sides closer to each other, it will become harder and harder to weave using the heddles and sword.

Then the weaver will thread a needle with the weft thread and, thread by thread, pick out each line until she connects the two sides of her textile. In this way the textile has four selvedges and is not cut from the loom.

The quality of a textile is partly determined by whether the weaver finished her textile in this method or not. You can tell if a textile was finished in the traditional method because near to one end there will be a number of horizontal lines, such as you see in plain weave, interrupting the designs. This is where the weaver connected the two sides of the textile with her needle and weft thread.

The importance of this finishing technique in Andean cultures traces back to the belief that textiles were sacred objects. Pre-Columbian weavers went out of their way to invent techniques to achieve the styles and end results they desired without the need to cut the textile or thread and violate its sacred nature.

In the simpler way of finishing, a weaver cuts her warp from the end loom bar. Once she reaches a point where she cannot use the heddles to form sheds and keep weaving, she cuts the

ABOVE: A weaver finishing his piece in the traditional way by weaving to the very end of the warp, rather than cutting it from the loom bar. RIGHT: Picking up the warp threads of a ley design with a needle.

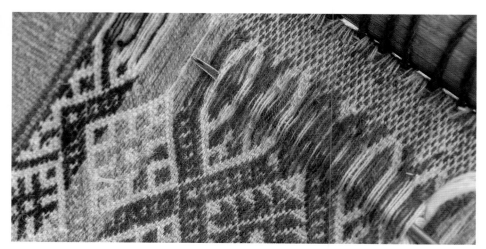

warp from the end loom bar close to the bar. She then sews off and secures the edge of the textile at the last row she wove. It is best to use a sewing machine for this in the zig-zag stitch. The weaver trims off the tails of the warp from the end of the textile. To hide the ugly machine stitch securing the end of the textile, she will finish the textile with the woven border *ñawi awapa* (see page 99), or with a similar border technique, such as *chichilla* (see page 111), or sew a jakima around the edges of the textile.

The advantage of this finishing method for the marketing of textiles in the tourist trade is that a weaver can finish the textile quickly. Tourists do not know how to differentiate between the two finishing methods and do not know that a textile ought to be properly finished without cutting the warp from the loom. Furthermore, when tourists see the plain-weave rows interrupting the design section they do not understand that this indicates that the textile was finished in the traditional manner. Instead, they believe the weaver made a mistake in the design as the design is interrupted by "ugly" lines. Ironically, tourists are more inclined to pay a lower price for the higher quality, traditionally finished textile because they do not understand the intricacies of textile techniques in the Andes.

Centuries of Andean weaving have produced an impressive array of techniques and designs developed through ingenious practicality and creativity. The sacred rituals of warping and weaving endure—a devotion to tradition, to community.

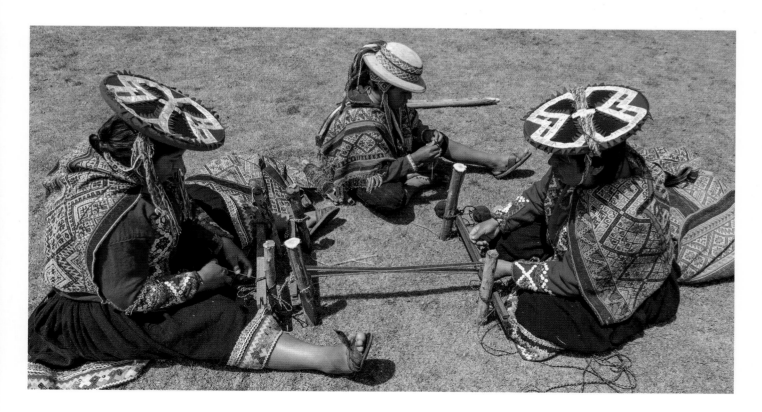

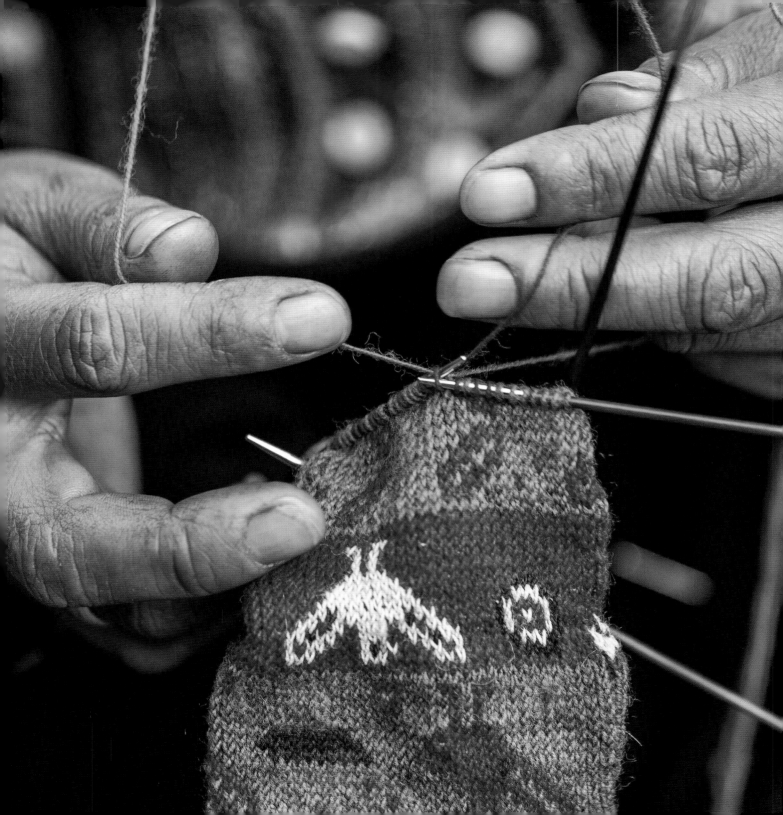

KNITTING

We don't know exactly when knitting was introduced into the Andes, but it was likely brought by the Spanish during the sixteenth century. Some say the Spanish adopted knitting from the Portuguese, and indeed, the knitting methods in some parts of Portugal today resemble the Andean style of knitting. The pre-Columbian Wari and Tiahuancaco cultures, however, were very skilled in constructing textiles with complex looping techniques worked with a needle. Analysis of ancient textiles from Nazca and Paracas reveal the skilled use of intricate needle-looping techniques similar to nålbinding. Since the Spanish conquest, Andean communities have become highly skilled knitters, specializing in making *chullos* (hats), *maquitos* (protective arm warmers or sleeves), and *ch'uspas* (small purses used for carrying coca and coins, or to be worn while dancing).

YARNS AND NEEDLES

Knitters use very fine, tightly twisted yarn and create knitting as fine as 18 stitches per inch or more. The yarn is usually handspun and tightly plied, in contrast to normal commercial knitting yarn, which usually has a relatively slack twist. If Andean knitters use commercial yarn for their personal work, they add some twist to it,

using a hand spindle. If they are knitting for the tourist trade, they use softer, more loosely twisted yarns. In Huacatinco, knitters work very quickly, and they can sometimes finish a chullo in one day. In Chinchero, on the other hand, knitters put much more twist into their knitting yarn than most other communities and are known for the tight spin of their chullos. Due to the tightly plied yarn and extremely tight knitting, it takes longer to knit a chullo in Chinchero than it does to weave a blanket.

Knitting is done in the round on five needles, four to hold the work and one to transfer the stitches. The needles are usually handmade from wire, but sometimes bicycle spokes are used,

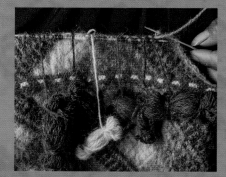

ABOVE: Outside view of a Chahuaytire knitter's orderly yarn management while carrying multiple yarn colors for knitting a chullo. LEFT: A ch'uspa from the Pitumarca region with two pockets knitted into the body of the purse.

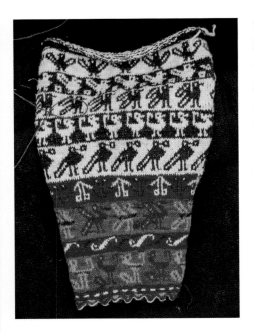

though the latter are more often used for knitting sweaters. In the past, knitters in Chinchero used the long and very thin spines of a certain cactus that grows in the area, high in the hills, as needles. Today it is hard to find cactus spines long enough for knitting. The needles are pointed on both ends in Chinchero, but in many other places in the Cusco area, one end of each needle is hooked to pull the yarn through the tight loops. Double-pointed needles are now available for purchase in the Cusco region, and about two years ago, some knitters began to use circular needles for the first time.

HIGHLAND TECHNIQUES

Most Andean knitters work from the inside of the piece with their working yarn tensioned around the neck. Consequently, the work is almost entirely purled rather than knitted, according to the North American or European definitions of the terms. This technique makes color changes easier, and often the work goes very rapidly. Multiple yarns of different colors are twisted around each other with every stitch so that there are no long floats on the fabric. If the twist is always made in the same direction, the yarns get increasingly twisted; therefore, it is necessary to change the direction of twist on

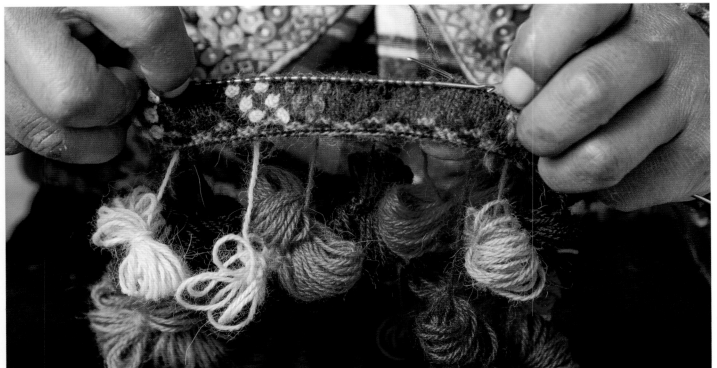

ABOVE: A maquito from Chinchero knitted in traditional multicolored motifs on the cuff and black and white for the arms. BELOW: Multiple increases are knitted together in one stitch in alternating colors to create the q'urpus (bobbles) for this child's chullo from the Pitumarca region (see page 74).

a regular basis. The usual practice is to change directions whenever there is a color change in the pattern. If the yarns still get too twisted, the knitter just stops knitting and untwists them. The needle is inserted into the stitch before the threads are twisted. To twist the threads, the color to be thrown and purled is in the center, and the other two colors are switched with each other above the thread to be worked, using the thumbs. Then the center thread is put over the needle to create the stitch. The left thread can be held by the lower fingers while the thumb and first finger put the yarn over the needle. The right thread continues to be held by the thumb. In some communities, such as Acopia, some knitters have begun to work with the front side facing out, in the American style.

Decreasing is often done by binding off an occasional stitch concealed within a plain ground area and when the design is closing or ending. Increasing is done by picking up a stitch from the previous row and purling it. Increases are done mainly in a line between rows of a pattern.

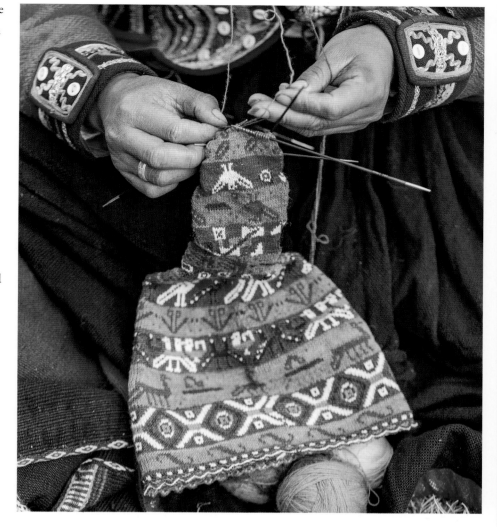

 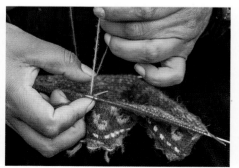

ABOVE: Knitting the chupan on a Chinchero chullo. LEFT to RIGHT: Tensioning and twisting the three colors of yarn from inside the chullo while knitting the complex wave design.

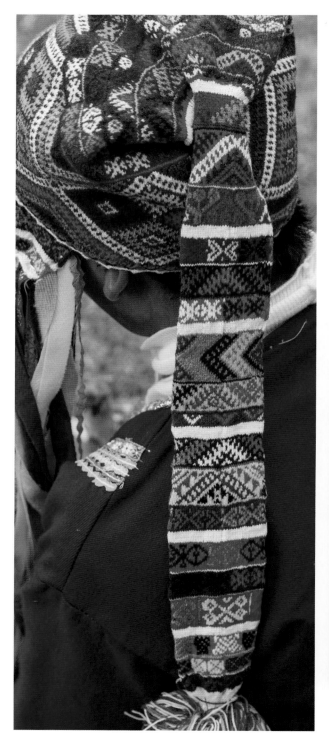

THE CHULLO

Chullo, *ch'ullu*, and *verete* are Quechua terms from the Cusco region, all referring to the knitted hats worn only by men and children. *Lluchu* is the term from the Aymara language used in the region south of Cusco, in the Lake Titicaca area. Men knit hats for their sons. Women knit hats for their families or for sale. Young men knit extremely intricate hats often to attract young women. The chullo is an identity piece and men take great pride in their quality and designs. The chullo for babies in some regions are different from men's, especially in the use of *q'urpus* (bobbles) that are decorative and

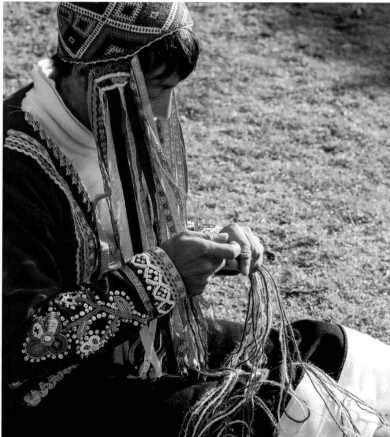

LEFT and ABOVE: Alipio Melo Irco wears a chullo with a long *chupan*, or tail, and streamers flowing from the square earflap, a characteristic of chullos from his community of Pitumarca.

also are thought to provide protection. In some communities throughout the region, both women and men knit; in other communities, only men or only women knit.

Each region determines or adapts its own version of the chullo. The color combinations used, the shape of the hat, the style and complexity of the earflaps, short or long top tassels, *puntas* or *picas* (scallops), fringe, ties, and other embellishments vary from community to community. The trend is toward even greater embellishment and today young men in some areas knit increasingly elaborate chullos heavily decorated with beads.

Many chullos now are knitted from softer, heavier yarn, especially if they are knitted for the tourist trade. The same is true of leg warmers, gloves, shawls, and socks, which were not knitted traditionally in the Andes. From time to time knitters vary the materials used in the chullos from handspun and home-dyed colors to factory-produced alpaca or acrylic yarn.

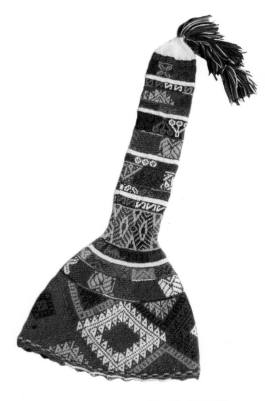

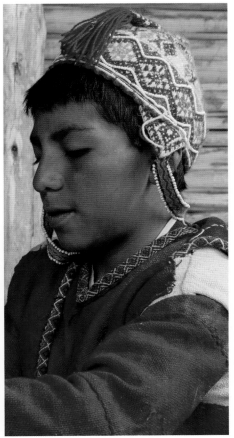

LEFT: Jaime Condori Huaman, a knitter from Pitumarca, wears a vibrant chullo he knitted incorporating traditional motifs and finished with multiple tassels. CENTER: Thirteen-year-old Ronaldo Condori Layme from Accha Alta wearing a chullo his father knit for him. ABOVE RIGHT: A Pitumarca chullo.

CHULLO
SECRET

One of the secrets for knitting a chullo, practiced in some communities, is to work a round right to left, as usual, but then to avoid having a color jog in the pattern, the knitter will work the next round left to right, by purling the stitches in the opposite direction. (See Andean Mirror Knitting page 80).

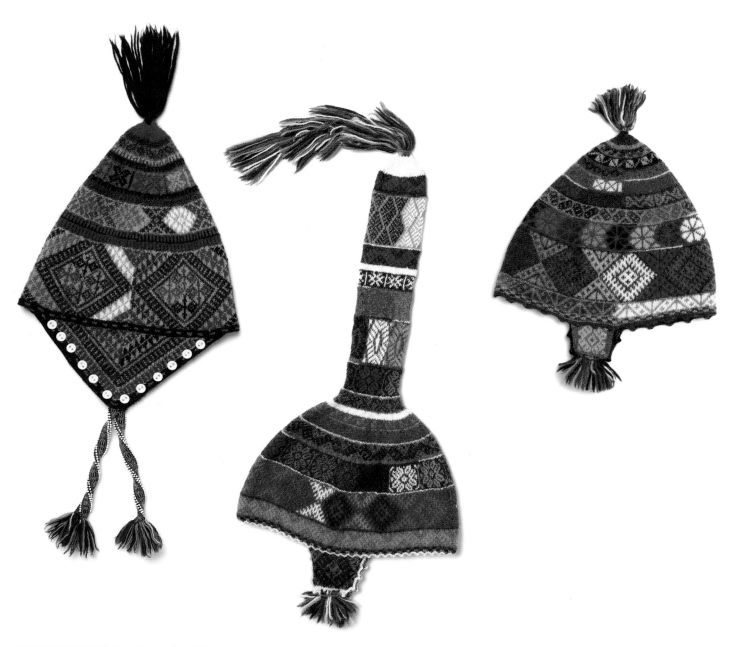

THIS PAGE LEFT: Chahuaytire chullo with buttons sewn to the edge of the earflap and woven ties with beads, and a short, modest tassel on top. Chahuaytire chullos are narrower and more pointed at the top than in other communities. CENTER: Pitumarca chullos have wider shapes, often with a long *chupan* (tail) and square earflap. RIGHT: A variation of a Pitumarca chullo without the chupan.

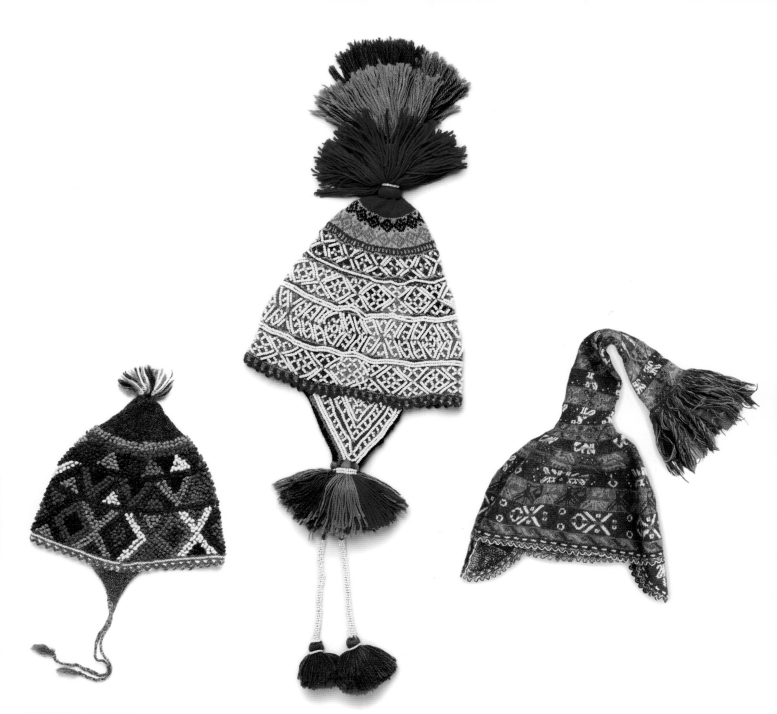

THIS PAGE LEFT: Child's chullo with q'urpu from Accha Alta. CENTER: A heavily beaded chullo from the community of Huacatinco. RIGHT: A Chinchero chullo with five-color scallop border, several bird motifs, and three knitted tubes under long fringe attached at the top of the wide chupan.

SCALLOP CAST-ON TECHNIQUES FROM THREE COMMUNITIES

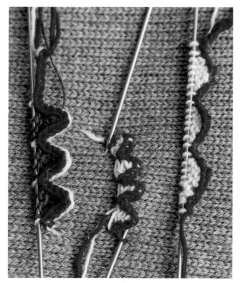

Scallop techniques from left to right: Chinchero, Accha Alta, and Patabamba.

Historically, most Andean cast-on methods serve to make a decorative scalloped edge for a chullo. There are many techniques, ranging from very simple to very complex. Scallops can be made of varying sizes, and you can adjust the size by adding to the number of stitches in each scallop. Scallops for children's hats are typically smaller.

PATABAMBA CAST-ON IN TWO COLORS

Making the Chain

1a With the Border Color (BC), create a crochet chain with enough stitches for your project. You can "crochet" by hand by first tying a slipknot and then pulling the loop of thread through your initial loop until it's tight. **1b** Repeat this until your chain is long enough for your project: you will need one chain for each stitch needed. Make sure you keep your tension even. You do not want your stitches too loose or the scallop will not be well defined. Pull the last loop so that it is 1 to 2 inches long and don't cut the thread so that you can create more stitches if necessary or create the scallops as you go. Identify the smooth face and the spine of your chain. The spine is the side with the bumps. **1c** Hold the chain with the bumps facing up.

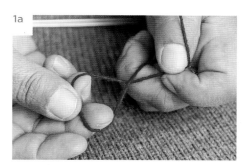

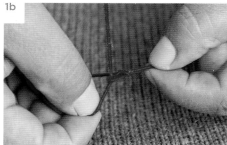

Creating the First Scallop

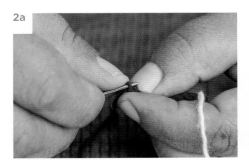

2a

Tension the Scallop Color (SC) around your neck. Begin to pick up stitches from the chain, working right to left. Insert tip of right-hand needle into the first bump.

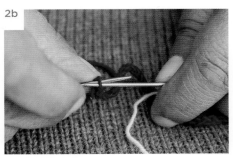

2b

Insert left-hand needle through the back loop of the stitch.

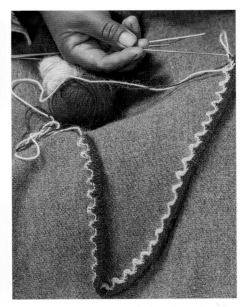

A length of the Patabamba scallop cast-on.

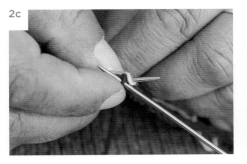

2c

Purl with the SC, placing stitch on right needle.

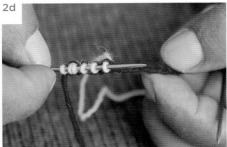

2d

Repeat until you have 5 stitches on right needle.

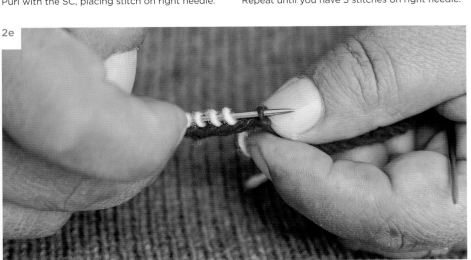

2e

Skip two bumps. This will become the point of the scallop. You can skip only 1 bump if you want a sharper point. Pick up the next bump, purl, making one more stitch with the SC.

ANDEAN MIRROR KNITTING
SECRET

When working in stockinette, rather than purling back a row after you've knitted a row, you can knit the stitches from your right needle onto the empty left needle. Put your left needle through the back loop of first stitch on right needle, wrap yarn counterclockwise, and pull the needle through the stitch. The first stitch from the right needle will now be on the left. Continue to the end of the row. It is possible to wrap the yarn clockwise, but this requires you to knit through the back loop on the return row.

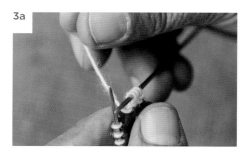

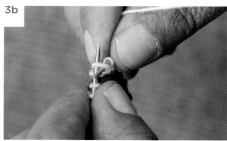

Pull the SC yarn tail behind right needle, then place left needle through the back loop of the first stitch—the last stitch that you just made.

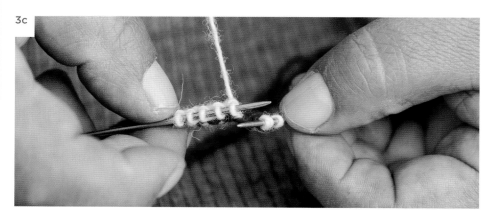

Knit 3 stitches in Andean Mirror Knitting. Alternatively, you can turn the knitting, and purl 3 stitches.

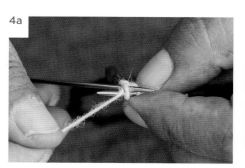

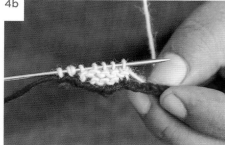

Pull the SC yarn tail to the front and purl 3 stitches.

If you turned and purled, then turn and knit 3 stitches. Do not turn.

5 Place right needle through the next bump and make 1 stitch.

6 Pull the SC tail behind right needle. Then Andean Knit 5 stitches. Alternatively, you can turn the knitting and purl 5 stitches.

7 Pull the SC to the front and purl 5 stitches.
 (If you turned and purled, then turn and knit 5 stitches. Do not turn.)

 Repeat Steps 2–7 until you have the required number of scallops for your project.

ACCHA ALTA CAST-ON IN TWO COLORS

Tensioning both yarns around your neck is extremely helpful in this clever technique as the secret is in carrying the yarns to the appropriate side to create the stitch. After you create the first stitch, the remaining stitches will be formed on the left needle. It must be done on double-pointed needles.

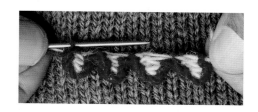

Making the Border

1

Tie one Border Color (BC) and one Scallop Color (SC) yarn together in an overhand knot.

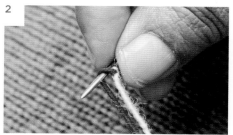

2

Bring the right-hand needle from behind and between the two strands of yarn—the knot will be to the right. The BC yarn will drape over the top of the needle, front to back.

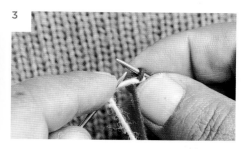

3

Cross the SC yarn tail over the top of the BC yarn tail and with the left-hand needle, make a loop with the SC yarn by bringing the yarn from back to front over the needle.

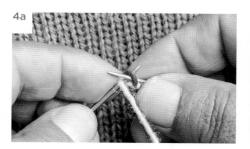

4a

Insert the left needle through the back loop of BC yarn on the right needle.

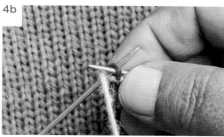

4b

Cross SC yarn tail over top of BC yarn, left to right.

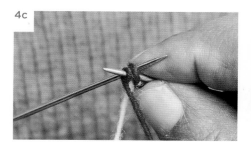

4c

Purl with BC. Pull the SC yarn tight to secure the stitch.

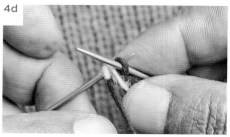

4d

Now you'll have one BC stitch on the right needle and one SC stitch on the left needle.

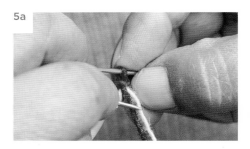

5a

With the SC yarn tail to the right of the BC tail, make a second loop with SC on left needle.

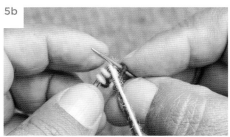

5b

Insert left needle through the back loop of the first BC stitch on right needle. Cross SC yarn over top of BC yarn, left to right, purl with BC. Now you will have 2 SC stitches on left needle and one BC stitch on the right needle. SC stitches are shaped from the loops on the left needle and closed with the BC yarn from the right needle.

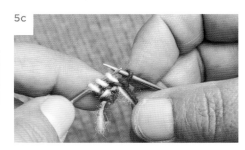

5c

Repeat Step 5 until you have 3 SC stitches on left needle and one BC stitch on right needle. You can create more stitches for a larger scallop, but for this technique, adding stitches will make it longer, not wider.

Making the Scallop

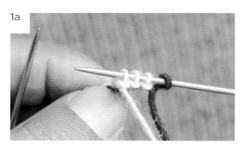

1a

Purl 3 stitches with SC yarn, so that you have all 4 stitches on the right needle: 1 BC stitch and 3 SC stitches.

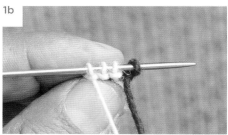

1b

Push your stitches to the other end of the needle. Hold this needle in your left hand.

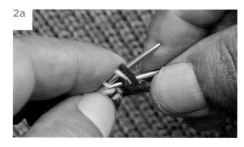

2a

Purl 2 stitches together with BC yarn. Slip this decreased stitch back onto left needle.

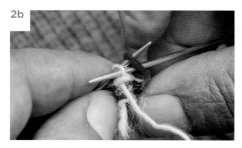

2b

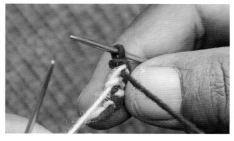

Repeat decreasing in this way, always with 1 BC stitch and 1 SC stitch, until you have just 1 BC stitch on right needle. Pull SC yarn tight.

2c

The SC yarn should be to the left of the BC yarn. This completes the first scallop.

Repeat Steps 3–5 of **Making the Border** and Steps 1–2 of **Making the Scallop** until your scalloped edge is the desired length for your project.

CHINCHERO CAST-ON IN THREE COLORS

These instructions are for making scallops with three colors—white, red, and green.
Many knitters from Chinchero also knit a five-color variation of this cast-on technique.

Making the Chain

The first step is to make a two-color chain. Tie all three yarn colors together in a single overhand knot. Alternatively, tie only the two colors to be used for the chain and add the third color later.

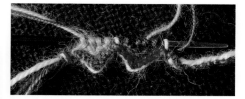

ABOVE: Three-color Chinchero scallop. BELOW: Five-color variation.

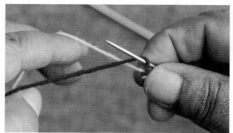

1

Drape Border Color 1 (BC1, red in sample) over the right-hand needle from front to back (the knot should be to the right). Pass Border Color 2 (BC2, white in sample) under the BC1 yarn.

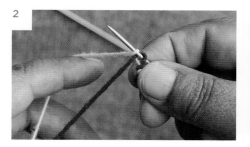
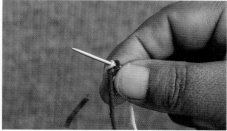

2

Drape BC2 yarn over the needle from back to front, to the left of the BC1 loop. Pass the BC2 yarn under the BC1 yarn, holding it in your right hand.

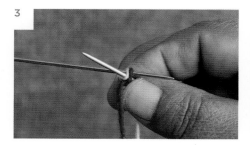
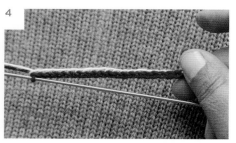

3

Insert left needle into the back of both loops on right needle and make a purl stitch with the BC1 yarn, pulling through both loops. Pull gently on both yarns. Do not pull too tightly on the BC2 yarn or it will be too difficult to pick up stitches later.

4

Repeat Steps 2–3, until you have a total of 10 stitches for the first scallop. For the remaining scallops, you will only need to make 9 stitches. You can make a long chain first for making many scallops or make stitches for one scallop at a time.

Knitting the Scallop

To begin knitting a scallop, pull the last loop so that it is 1 to 2 inches long and remove the needle. This loop is left so you can make additional stitches as needed.

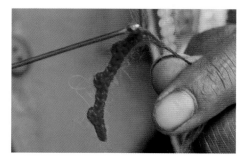

While complex knitted scallops are most traditional, some knitters choose to crochet a simple scallop cast-on, then pick up the stitches with a knitting needle.

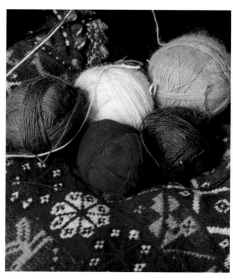

Balls of tightly plied, handspun yarn in traditional colors.

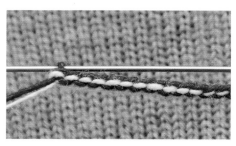

Orient the chain so that a row of non-overlapping BC2 loops is framed by BC1 loops.

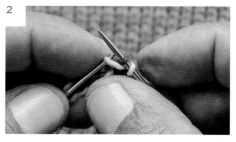

With the Scallop Color (SC, green in sample), pick up and purl 5 stitches into the BC2 bumps.

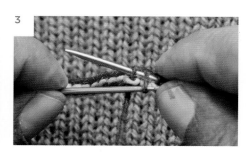

Pass the second stitch over the first stitch on the right needle (decrease 1 stitch). Pick up and purl 1 stitch.

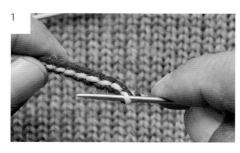

1

Beginning at the opposite end of the large loop, insert the right needle, from back to front, into the first BC2 stitch (back to front) and leave it on the right needle.

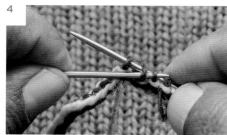

3 ... **4**

Pass the second and third stitches over the first stitch on the right needle (decrease 2 stitches). Pick up and purl 1 stitch.

5

Bring SC yarn to the back of the work. Place the left needle into the back of the first SC stitch on the right needle. Andean Mirror Knit (see page 80) 3 stitches. Alternatively, turn and purl 3 knit stitches.

6

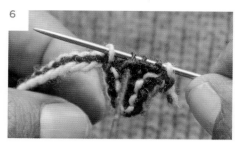

Bring SC yarn to the front, and purl the same 3 stitches. (If you turned and purled, then turn and knit 3 stitches. Do not turn.) Pick up the next BC2 stitch with the right needle, but don't work it.

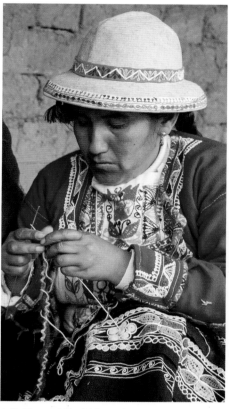

Julia Mamani Sumiri from the community of Acopia begins a scalloped edge for a chullo.

Repeat Steps 1–6 until you have enough scallops for your project.

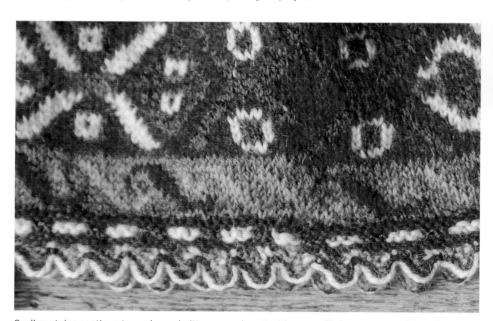

Scallop styles continue to evolve as knitters experiment with more efficient ways to achieve the traditional appearance of the chullo border.

THE STRIPE AND CHECK BORDER

After the scallops have been knitted for the chullo, the next step for many traditional chullos is to knit the "stripe and check" border. These border designs may vary from community to community, but they typically include a few rows of vertical stripes and a checkerboard.

Checkerboard Knitting Chinchero Style

The straight edge of the cap begins with a design called *ñaccha* (comb) or *k'utu* (bump, looped). First divide the scallops onto four needles. Hold the finished work in the secondary hand and transfer one stitch at a time to a needle held in the primary hand. It is not necessary to count the stitches, just distribute the work so it looks like about the same number of stitches on each needle.

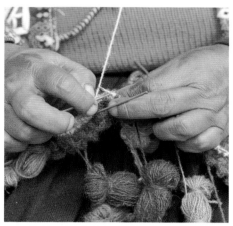

A knitter from the community of Huacatinco manages multiple colors of yarn while knitting a chullo.

1 Using the red yarn and with the inside of the hat facing you, purl all the way around the cap. (When all the stitches have been transferred to the new needle, move them to the middle of the needle before moving on to prevent them from slipping off.)

2 With the same red yarn, knit a row. To knit with a single color, move the red yarn to the back of the work and place it over the left index finger. Insert the first needle behind the second one, in the back of the stitch. Because the previous row has been purled, it may be hard to insert the needle behind, so you can insert it in front first, and then move it through to the back.

3 The next two rows alternate 2 blue and 2 white stitches. Tie on the blue yarn. To purl the first row of blue and white, these yarns must be moved to the inside of the work: put the balls through the square made by the needles. Drop the red yarn and tension the blue and white yarns around your neck. Hold both colors in the left hand and proceed to purl 2 blues, 2 whites, repeating until the end of the row. When changing colors, no special maneuver is needed, but when purling the second stitch of the same color, after the needle is inserted, cross the two colors before throwing the yarn, so that the unused color is held down.

4 Knit the next row. After knitting the 2 blue stitches, move the blue yarn to the inside of the work, and move the white yarn to the outside in order to knit those 2 white stitches. Then move the blue back inside and the white outside. This will create 2-stitch-long floats of each color on the back, which is facing you.

5 Before purling the next row of red (as in Step 1), twist the red with the blue and white. After starting the row, cut off the blue and white and tie the ends together in a square knot.

6 Knit another row of red (as in Step 2). This completes the border.

MOTIFS

Usually the motifs in knitting are the same as those found in woven textiles. Some younger knitters have begun to create charts for the motifs, though most knitters carry the patterns from memory in the traditional way. The patterns are learned by counting the stitches in a previously knitted garment. Soon, the knitter knows them well enough to be able to work each row solely with reference to the previous one. Endless possibilities exist for design work in chullos, from simple or complex geometric shapes to ancient Inca symbols and innovative animal and bird designs. The use and combinations of motifs vary from community to community and no two chullos are ever the same, reflecting the individuality, preference, and skills of its maker. Below are charts for several designs common in chullos from many communities.

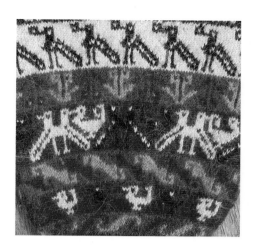

Twined grass rope or simple wave, *kuti q'iswa*. Kuti means "to return" in Quechua. Q'iswa is a rope made of q'uya, a strong grass from the highlands; it also means "twisted." There are many variations of the kuti motif in weaving. ■ MC ■ CC1 ■ CC2

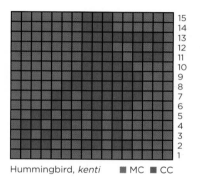

Hummingbird, *kenti* ■ MC ■ CC

Star, *chaska* ■ MC ■ CC

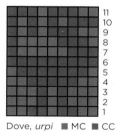

Dove, *urpi* ■ MC ■ CC

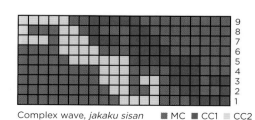

Complex wave, *jakaku sisan* ■ MC ■ CC1 ■ CC2

BORDERS AND FINISHING DETAILS

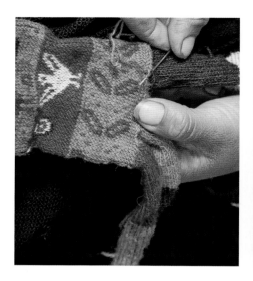

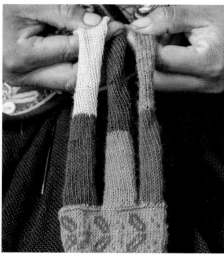

LEFT: Philipa Marca sews three knitted tubes to the top of her hat. The tubes will be concealed underneath layers of fringe to make the fringe appear more robust. Philipa learned to knit in her early twenties by watching her friends knit. At age twelve she became a member of the original Jakima Club and continued in that group for eight years. At thirty, she is now teaching her own daughter to knit and weave.

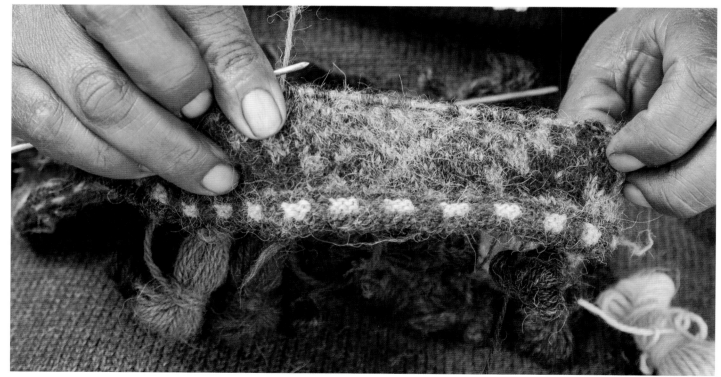

ABOVE: Demetria Cchicche Huaman from Chahuaytire begins with a traditional checkerboard border design and will add on the scallop edging after she's finished knitting the chullo.

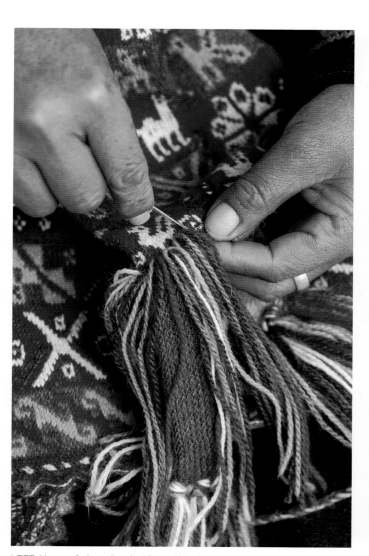 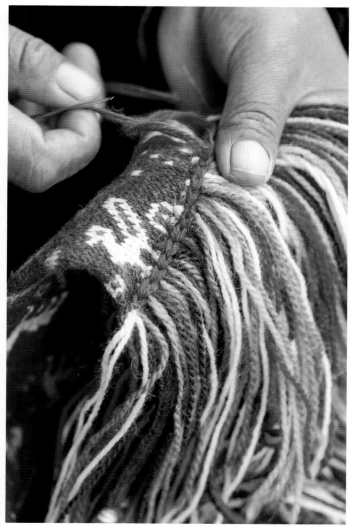

LEFT: Norma Quispe Condori from Chinchero adds fringe to the ends of knitted tubes and then adds fringe at the top of the chullo to cover the tubes.
RIGHT: She then applies a decorative edging over the fringe where it joins with the chullo.

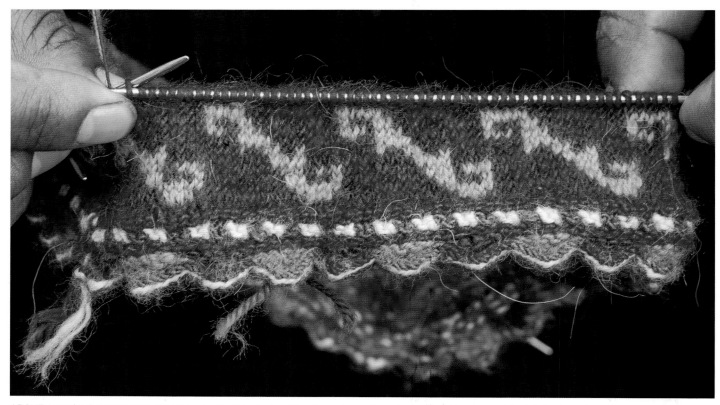

ABOVE: Leandra Gutierrez from Chinchero begins this chullo with a five-color scallop, checkerboard border, and the jakaku sisan (complex wave) motif.

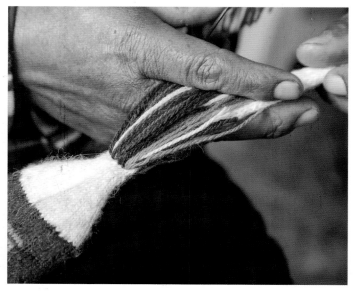

LEFT to RIGHT: Jaime Condori Huaman sews tassels to embellish the single narrow tube at the tip of this chullo.

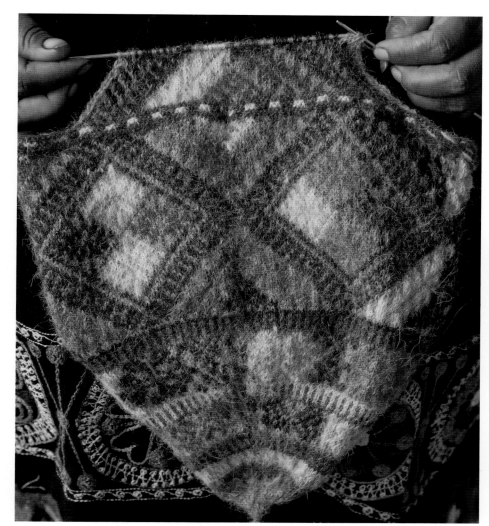

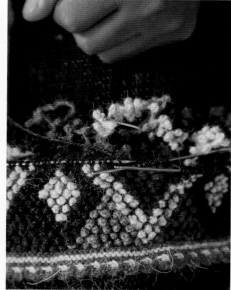

LEFT: Yolanda Perez Puclla from Chahuaytire knits earflaps from the body of the chullo. BELOW: Strings of q'urpu are knitted into a child's chullo (see page 92).

LEFT to RIGHT: Timotea Quispe Auccocusi from Chinchero knitted the earflaps with the urpi (dove) motif and stitches it to the chullo after the body is knitted. Then she knits a scallop border and sews it to the earflaps.

Q'URPU CHULLO BOBBLE HAT

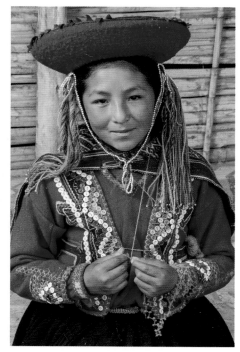

Q'urpu are small popcorns or bobbles knitted into the hats of babies and small children. These hats, q'urpu chullo or wawa chullo, were thought to provide children with protection against harmful spirits. Unfortunately, in recent years, these baby hats with the bobbles are disappearing from daily use in the communities, though they are still made for the tourist trade. Today, the hats are primarily knitted in the community of Accha Alta. Also for the tourist trade, adult beanie-style q'urpu hats are now available.

There are a few techniques for making q'urpu: those that are pre-made on a string of yarn and either knitted into the hat or pulled through with a hooked needle afterward, and those formed from working several stitches into one loop to form a bump. Knitting with the string of q'urpu is the most common method.

Q'URPU ON A STRING

There are two ways to work with q'urpu. The string of q'urpu can be treated as a pattern yarn and carried along the knitting as you would a second yarn color. Each q'urpu is worked in between stitches based on the design. The other way is to knit the entire chullo in regular flat knitting, and then go back and fill in some of the colored pattern motifs (usually diamonds) by pulling the q'urpu through the fabric with a crochet hook or hooked needle. It will take a young knitter about three days to make the several hundred q'urpu necessary for one chullo.

Making the Q'urpu

1 Make a slipknot. Tighten to create a loop which is the first loop in your chain.

2 Pull a second loop through this first loop from the yarn tensioned around your neck. Pull tight, just as if you're finger crocheting (see Patabamba Cast-On, page 78). Make 4 to 5 chains depending on the weight of yarn and size of q'urpu you'd like. Jeny makes 4 chains, her cousin Ronaldo makes 5 for his q'urpu.

3 Pull the last loop you've made over the chain of 4 to 5 stitches and pull the loop tight to shape the q'urpu. Jeny calculates the distance between each q'urpu by half of her thumb tip (about ¼ inch).

Twelve-year-old Jeny Flores Layme from Accha Alta tensions the yarn around her neck and holds it under her arm. She wraps the finished q'urpu around her left wrist as she continues to work.

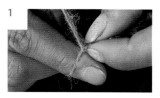
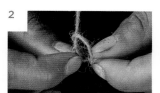
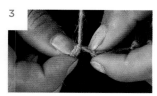

Q'urpu Knitted from Stitches in the Chullo

For this q'urpu technique, you work multiple increases in one stitch and then knit them together. It is helpful to use very pointed needles or a needle with a hook at the end.

Q'urpu Stitch: Knit into the front and the back of the stitch 4 or 5 times, depending on the size of the q'urpu that you'd like. Transfer the 4 to 5 stitches that you've just created onto the left needle and purl all the loops into a single stitch, forming the q'urpu, pushing it through to the front face of the chullo.

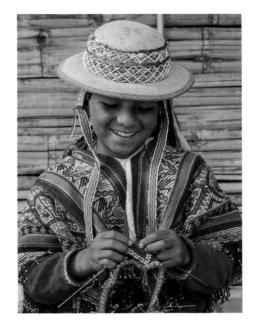

ABOVE: Ronaldo Condori Layme knits the string of q'urpu in his chullo. He purls, working from the inside of the hat, feeding the q'urpu through to the front side between stitches. He tensions the yarn around his neck, but keeps the string of q'urpu off to the side as he works. Ronaldo learned to knit from his father when he was nine years old. LEFT: Multiple increases in a single stitch create the q'urpu in this child's chullo from Pitumarca.

KIPU (KNOTS)

Kipu is the Quechua word for knot and was also a record-keeping system used by the Incas from about 1400–1532. Kipus were made of long textile cords with a varying number of additional suspended cords. Along the cord's length were a complex series of knots. These were either single overhand knots, knots where the cord was wrapped around itself two or more times, or figure-eight knots. Each knot was made in one of two different orientations, resulting in a different slant, like S and Z spinning and plying directions. With no written language, the Inca created this tool for recording the movement of people and goods. The color of the cords and knots also was used to convey information. Long viewed as a complex accounting system, scholars now believe it is highly likely that kipu functioned as an early form of linguistic expression as well.

Many of the knitting techniques in the Peruvian highlands have been practiced for more than four hundred years. This practice has given way to innovation and expansion. While traditionally the chullo, ch'uspa, and maquito were the primary knitted items, now knitters of the CTTC also make sweaters, wrist warmers, socks, and a variety of other garments, carrying the skills of their ancestors forward with ingenuity and pride.

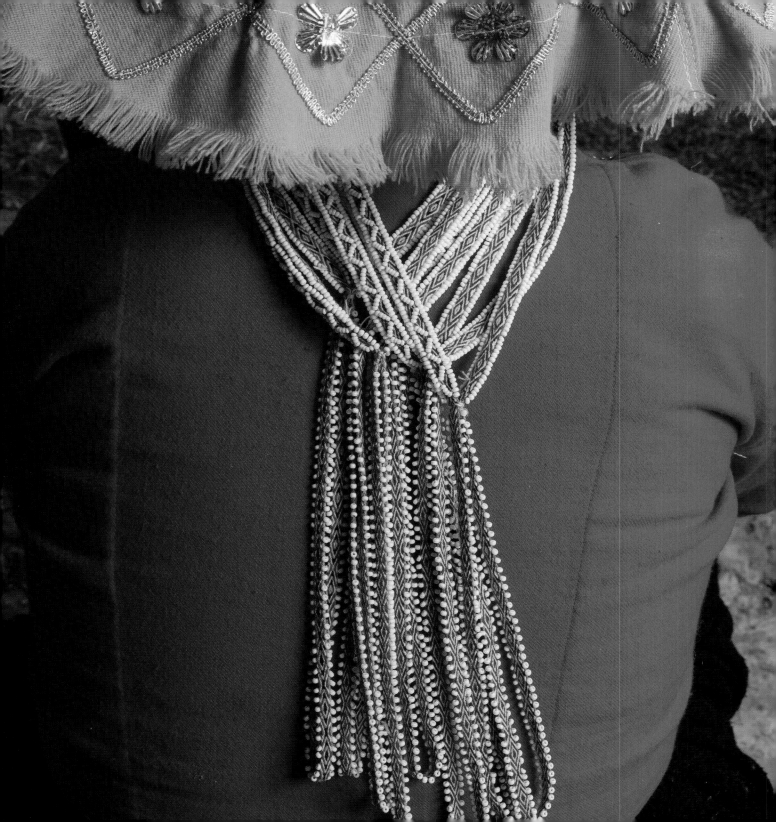

FINISHING DETAILS
AND OTHER TEXTILE TECHNIQUES

Much of what makes Andean textiles so wonderful is the care and attention that go into the finishing details. These include textile borders, embroidered seams where fabrics are joined together, decorative fringes, and tassels. There is a saying that if you have made a poor quality textile, then you want to hide your warping and weaving mistakes with very fine finishing touches. Alternatively, if you have made a very fine textile, you don't want to ruin it with a poor finishing. Many weavers in the Andes look forward to the finishing touches they will put on their textile and much scrutiny attends this aspect of a weaving. While some of this commentary can stray into the extreme, it also helps push weavers to constantly strive for improvement, especially for younger weavers.

Finishing details not only lend grace to the final textile, they are also eminently practical. Seams hold textiles together while borders and fringes prevent edges from fraying. They extend the life of a textile by many years, and as textiles are so often the symbolic and actual wealth of a weaver and her family, this is very important. When border, fringes, and seams wear through, a weaver will carefully take them out and put in new ones, preserving the textile for years to come. The used yarn from the finishing details is also given another life in the form of small textiles for children or for horse and donkey pads. Today these used textiles are sold as antiques or vintage pieces to tourists who mistake the extremely worn-out appearance as an indicator of great age.

The life of a textile is not limited only to this world. When a weaver passes away, her family will gather all of the textiles they believe she will need to take with her. They burn these textiles so that she can take

LEFT: Elaborate layers of beaded watana cascade from Leonarda Merma de Gonzales's montera. ABOVE: A sling braid used in ceremonial dances incorporates several designs and a flourish of tassels.

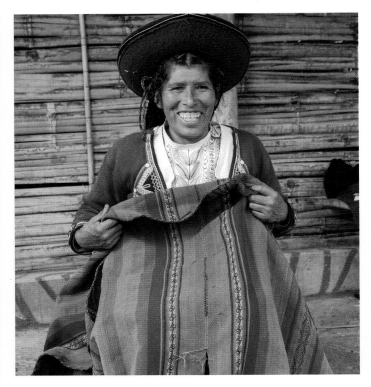

them with her spirit. No matter in what way, old textiles are always repurposed and reused either in this world or the next.

Each region has its own techniques and styles for finishing details. Often weavers from one region will laugh about how weavers from another region choose to finish their textiles. Of the entire population, however, it's young, single men and women who create the most beautiful and intricate finishing details in their clothing and textiles. These details are often what marks the difference between married and unmarried people. Unmarried

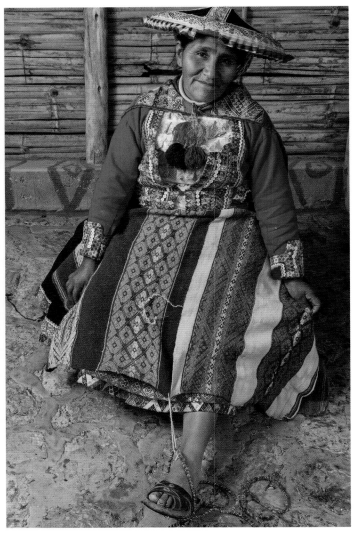

ABOVE LEFT: Gregoria Pumayalli Auccacusi holds two halves of a manta she has seamed together with the *q'enqo* design. BELOW LEFT: The top of a wasa watana (narrow band) where several intersecting bands are woven through the central band. RIGHT: Susana Huaman joins together two pieces of fabric with an invisible *chukay* (seam).

men and women have the requisite time needed to dedicate to the labor-intensive work of finishing a textile. Often these finishing details can take even longer than the weaving of the piece itself. Single men and women are judged and valued by their attention to detail; it indicates their ability to be a good future husband or wife, father or mother. Young people gain respect in their communities for the work on finishing details, and younger generations look on with jealousy at the patience of their older siblings to create these painstaking details.

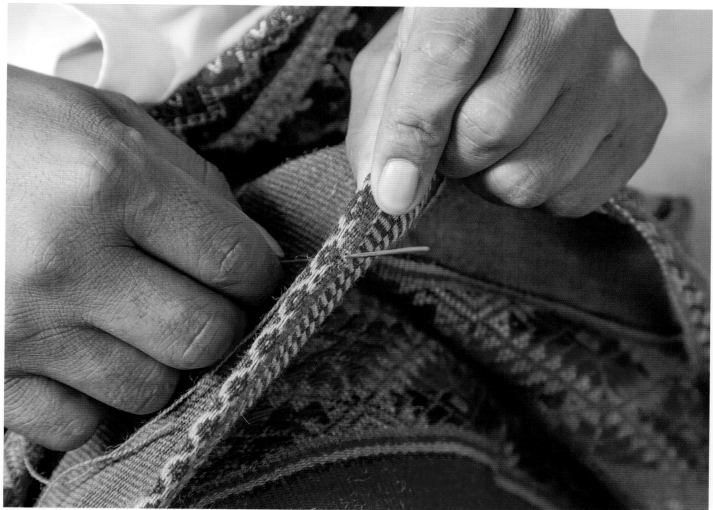

ABOVE: Beaded watanas embellish Lourdes Chura Gutierrez's montera. BELOW: A weaver finishes a textile by sewing a woven band to the edge.

AWAPA AND *CHICHILLA* TUBULAR BORDERS

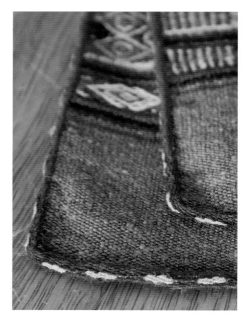

Tubular borders are a unique and creative way of giving textiles a professional, finished look while also protecting them from wear and tear. While many communities in the Cusco region weave slightly different variations on the technique, the basic structure remains the same. Weavers create narrow warps, normally about as wide as a small band, which they weave and sew onto the edge of a textile at the same time. The weft is held on a needle, and after passing the weft through the open shed, the weaver sews the weft through the border of the textile using the needle. This ensures that the weft always finishes on the same side of the warp that it started on, pulling the warp around the edge of the textile to form a tube. The outer side of the tube forms a design. The other side of the textile, the inner side of the tube which remains unseen, is a tangle of floating warps that do not form a pattern.

These tubular edgings not only protect the textile from physical wear, preventing fraying and unraveling and hiding the uneven edgings, they also are said to protect the textile spiritually. Most tubular edgings come in some variation of an eye pattern and many weavers explain that these borders watch over or protect the textile from befalling some future harm.

CHINKA CHINKA

The simplest tubular borders can be found in Patabamba and other communities from the same area. In this edging, called chinka chinka, the weaver warps a small edging all in plain weave. The edgings may be one or more colors. The center color, which forms the design, is also warped as plain weave.

When the weaver weaves the edging to her textile she drops or picks up the central color to form dots between the border colors. Chinka chinka means to appear and disappear, which is what the central warp threads do.

For example, a weaver might warp her edging in plain weave with the following colors (diagram shows upper warp only):

The green and the red are the edging. The white forms the design. The weaver will completely drop or keep the middle white warp to make the white dot appear and disappear against a red background, which is really part of the edging warp.

ABOVE: Chinka chinka attached to the edge of the fabric. BELOW: Another variation of chinka chinka woven separately. The four white warp threads in the center create the eye framed by red and blue border warp threads.

ÑAWI AWAPA (EYE BORDER)

Ñawi awapa is a unique border finishing technique that originated in the community of Chinchero. This ancient technique serves as both a beautiful finishing to textiles and as a practical protection to prevent fraying edges. In Quechua, *ñawi* means eye and *awapa* means border. While ñawi awapa physically protects a textile from daily wear, as with other borders, weavers believe that the woven eyes protect the textile it surrounds from harm. The technique is woven without a heddle. The weft goes in a continuous circle around the lower threads of the warp and through the shed. The back side of the weave is a tangle due to crossing warps, but this side is hidden inside of the tube and only the eye design is seen on the outside.

Ñawi Awapa Warp There are three main parts, or groups, of threads in ñawi awapa. The border threads, the eye threads, and the zig-zag threads. In our example warp, the border threads are red, the eye colors are yellow, black, and blue, and the zig-zag is orange.

Your loom is warped with 20 threads from left to right—thread distribution shown in the chart at right (the same number of threads are in the lower and upper warp).

To maintain the cross in the warp, a *tanka* (forked stick), or two sticks tied together, is inserted in the warp. An auxiliary stick is also inserted in the warp to help form the sheds while weaving.

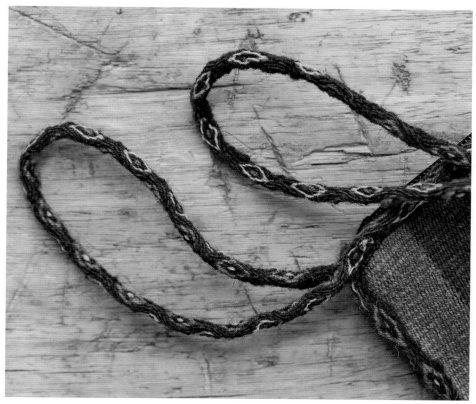

Ñawi awapa eye border on a handbag.

# OF THREADS	COLOR OF THREAD	THREAD GROUP
2	RED	BORDER
4	YELLOW	EYE
4	BLACK	EYE
4	ORANGE	ZIG-ZAG
4	BLUE	EYE
2	RED	BORDER

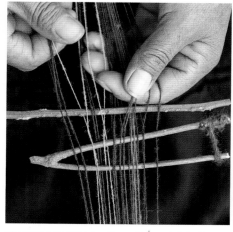

The tanka and the auxiliary stick maintain the cross and create an alternate shed.

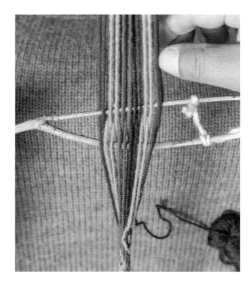

Weaving *Ñawi Awapa* If you are right-handed, you will work from right to left and will always pass the weft from left to right. If you are left-handed, you will work from left to right and will always pass the weft from right to left. Always pick up from the bottom and drop from the top, as in weaving doble cara.

Note: To ensure tight weaving, always pull up and down on the warp after picking out a new shed as this tightens the weave. When passing your weft, always pull it upward then across to ensure a tight weave and to make eyes pop out.

Yellow Eye

At the forked stick, place your finger in the pick-up position.

> Row #1 Yellow Eye

1

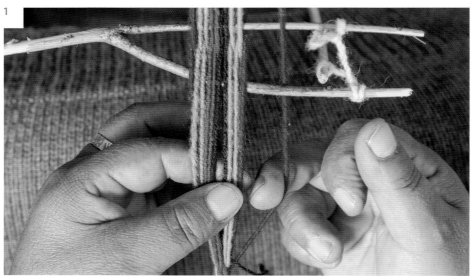

Border: Pick up 1 red from bottom and drop 1 red from top.

2

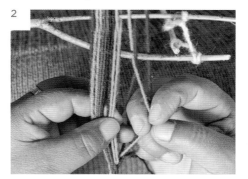
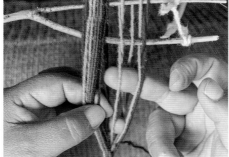

Eye Border: Pick up 1 bottom yellow, drop 2 top yellows together, pick up second bottom yellow.

Ñawi awapa may appear to be an impossibly complicated technique, but it is actually relatively simple—as any Andean weaver will tell you. With a little practice, soon you will become comfortable picking up and dropping the threads and will have a visual sense of how the warp threads form the design. The youngest weavers in the Andes master this technique easily and so can you.

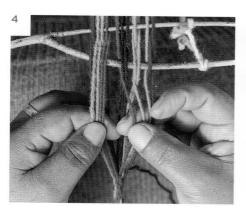

Eye Interior: Drop 2 blacks.

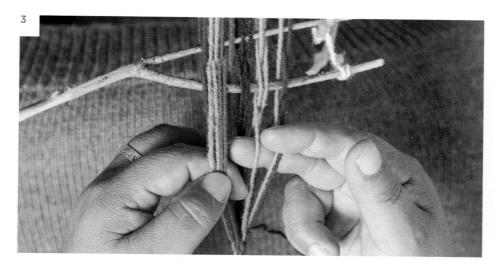

Ñawi awapa with yellow and blue eyes.

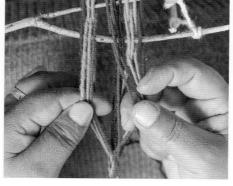
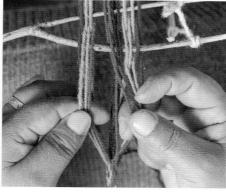

Zig-zag: Drop first orange on the top and pick up the first orange on the bottom and repeat.

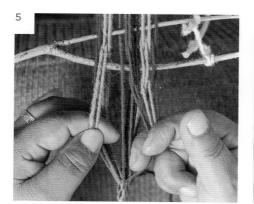

Eye Center: Drop 2 blues.

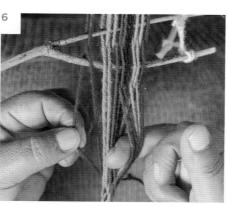

Border: Drop 1 red and pick up 1 red from the bottom.

ÑAWI AWAPA SECRET

This border can be woven separately from the textile or it can be stitched to the textile as it's being woven. The weaver passes the weft through the ñawi awapa warp and then passes the weft through the edge of her textile with a needle so that the weft always finishes on the same side it started on, ready to pass through the warp in the same direction once more.

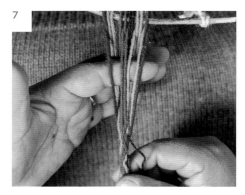
7

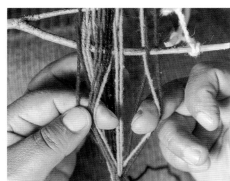

Return to the first eye and open it between two fingers.

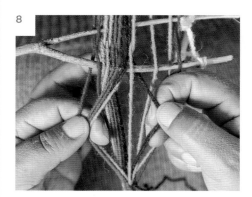
8

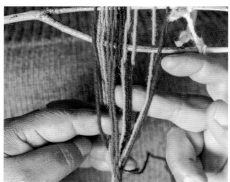

Between 2 center dropped yellows, pick up (or bring up) 2 floating blacks (from the bottom threads).

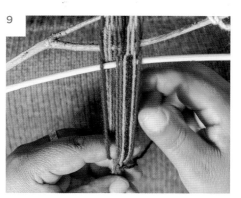
9

Beat. Beating for this technique is not the same as for flat weaving. Pull top threads with one hand in groups while pushing down hard with one finger from the other hand. Place auxiliary stick in pick-up shed.

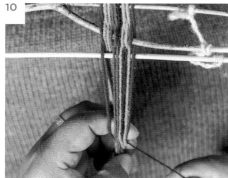
10

Pass weft.

> Row #2 Yellow Eye

Use the auxiliary shed.

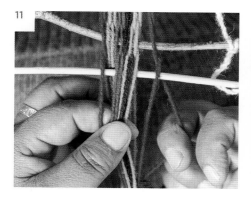

Border: Pick up 1 red from the bottom and drop 1 red from the top.

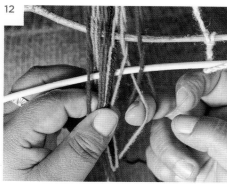

Eye Border: Pick up 1 yellow.

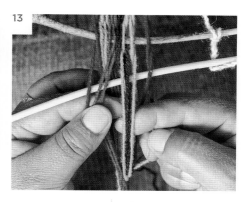

Drop 1 yellow, drop 2 blacks and drop 1 yellow from the top.

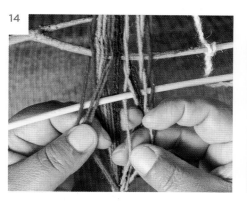

Pick up 1 yellow.

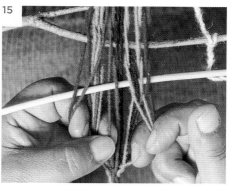

Zig-zag: Drop 1 orange and pick up first bottom orange and repeat.

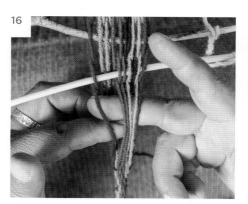

Eye Center: Ignore all the blues. **Border**: drop 1 red and pick up 1 red from the bottom.

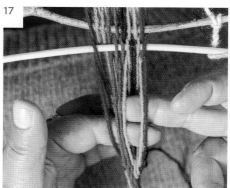

Return to the eye.

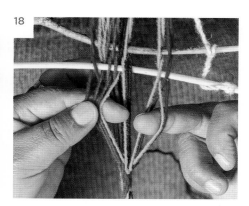

Open it.

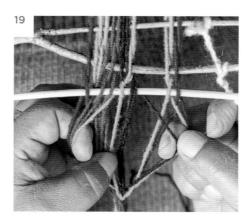

19

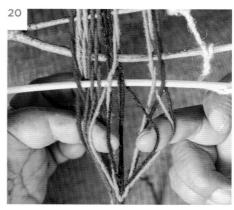

20

Pick up 1 black to the right of 2 dropped central blacks.

Pick up other bottom black to the left side of the dropped central blacks.

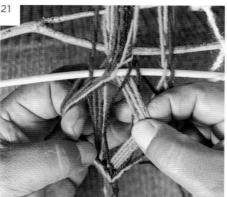

21

Keep the eye open (1 yellow and 1 blue on each finger). From the center of the dropped blacks (which are on top of auxiliary stick), pick up all 4 blues.

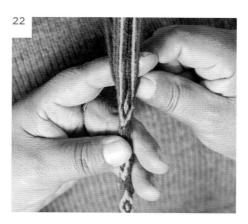

22

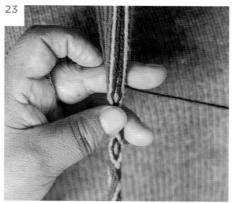

23

Beat.

Pass weft and pull tight.

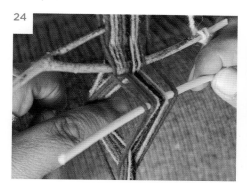

Replace auxiliary stick with finger.

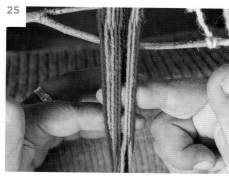

Beat. Pass weft and pull tightly (until the Yellow Eye shows).

> Row #4 Yellow Eye

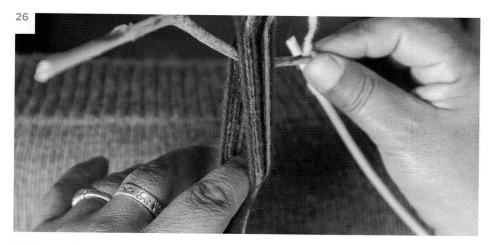

Put finger at shed made by cross (front of the stick).

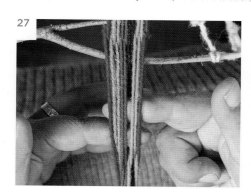

Beat.

Pass weft.

Blue Eye

At the crossed stick, place your finger in the pick-up position.

> Row #1 Blue Eye

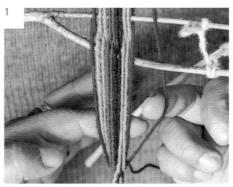

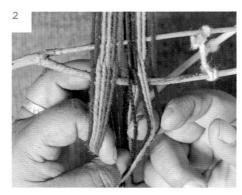

Border: Pick up 1 red from bottom and drop 1 red from top.

Eye Interior and Center: Drop 2 yellows and 2 blacks from top.

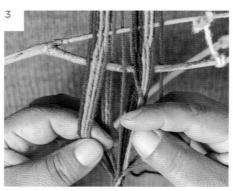

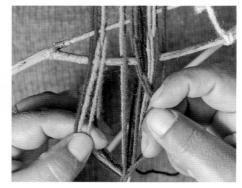

Zig-Zag: Pick up first orange from the bottom and drop first orange from the top and repeat.

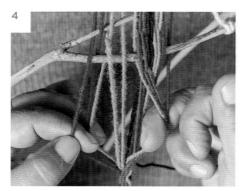

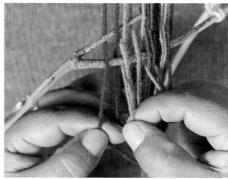

Eye Border: Pick up first blue, drop 2 top blues, pick up second bottom blue.

Ñawi awapa in finer yarns of different colors.

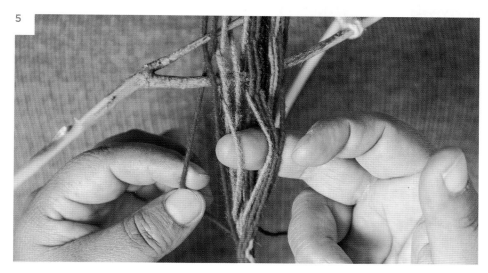

Border: Drop 1 red and pick up 1 red from the bottom.

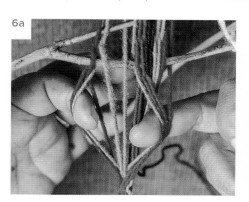 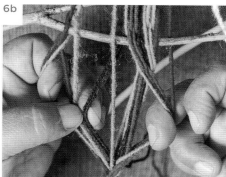

6a Return to the Blue Eye and open it between two fingers. **6b** Between the center of 2 dropped blues, pick up 2 floating blacks from the bottom.

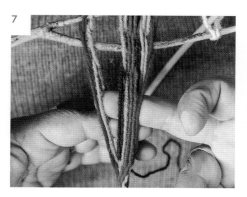 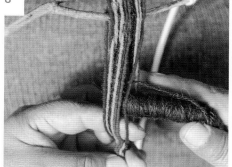 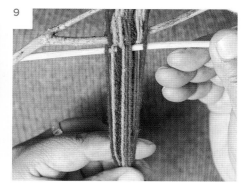

Beat.

Pass weft.

Place auxiliary stick in pick-up shed.

> Row #2 Blue Eye

Use the auxiliary shed.

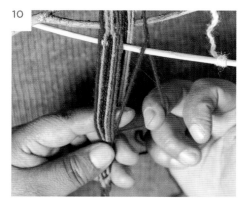
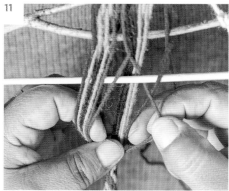
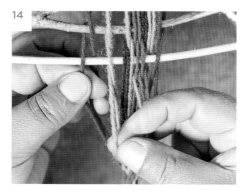

Border: Pick up 1 red from the bottom and drop 1 red from the top.

Zig-Zag: Pick up 1 orange from the bottom and drop 1 orange from top and repeat.

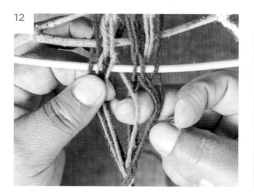
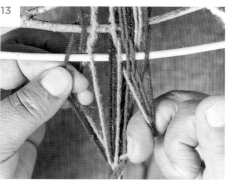
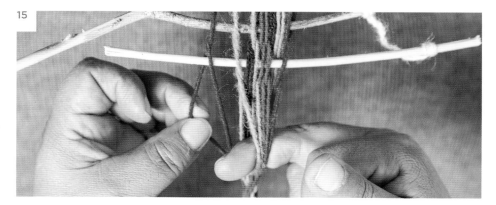

Eye Border: Pick up 1 blue.

Drop 1 blue, drop 2 blacks, and drop 1 blue.

Pick up 1 blue from the bottom.

Border: Drop 1 red and pick up 1 red from the bottom.

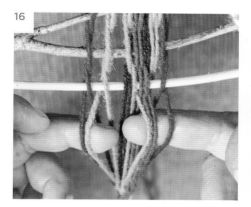

16

Return to the Blue Eye: open between fingers.

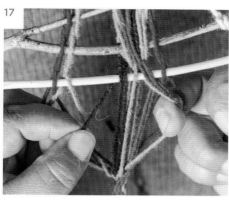

17

Pick up 1 black to the left of the 2 dropped central blacks.

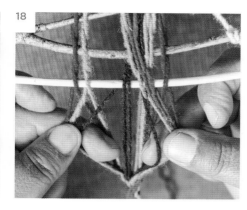

18

Pick up other bottom black to the right side of the dropped central blacks. Keep eye open (1 blue and 1 black on each finger).

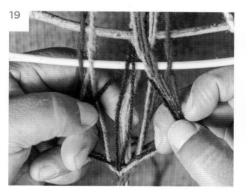

19

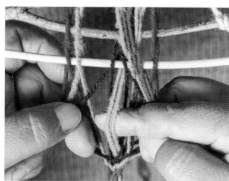

From center of dropped blacks (which are on top of auxiliary stick), pick up all 4 yellows.

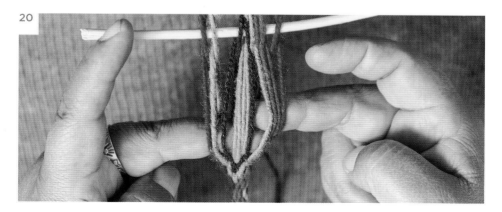

20

Beat. Pass weft and pull tight.

> Row #3 Blue Eye

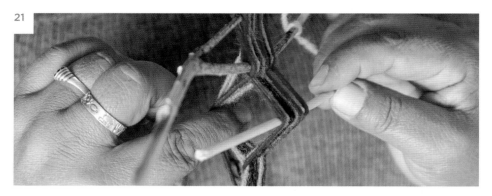

Replace the auxiliary stick with finger.

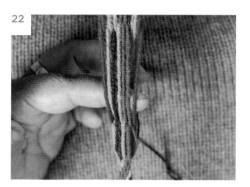

Beat.

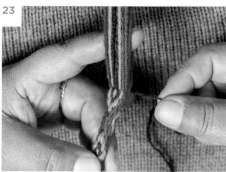

Pass weft and pull tightly (until it shows the Blue Eye).

> Row #4 Blue Eye

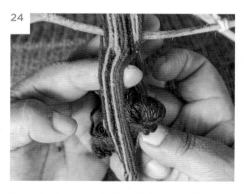

Put index finger at shed made by cross (front of the stick). Beat.

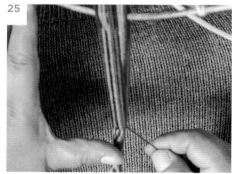

Pass weft.

> Continue working these four rows for each eye until you have the desired length.

CHICHILLA (WOVEN BORDER)

Chichilla is an eye border technique related to ñawi awapa in structure, but woven differently. Rather than working with a forked stick to pick out each line of weaving, chichilla uses four string heddles that control all aspects of the eye pattern. In the chichilla technique, the main eye is always in the middle while in ñawi awapa the two main eyes alternate to either side of the tube. Putting in the heddles is the most difficult aspect of chichilla. After forming the heddles, a weaver merely passes the weft and does not need to pick out any patterning, making it a fast and easy technique to weave.

Various communities weave chichilla onto the borders of their textiles, including Accha Alta and Chahuaytire. In each community, some aspects of the warping and heddling process might be slightly different, but the end result is the same or very similar. Chichilla requires at least six colors.

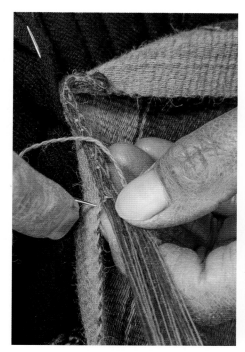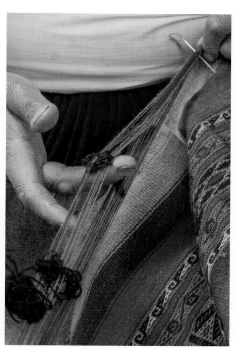

LEFT: A Chahuaytire chichilla simultaneously woven and joined with the weft onto the edge of a manta.
RIGHT: Manipulating the string heddles while weaving the chichilla.

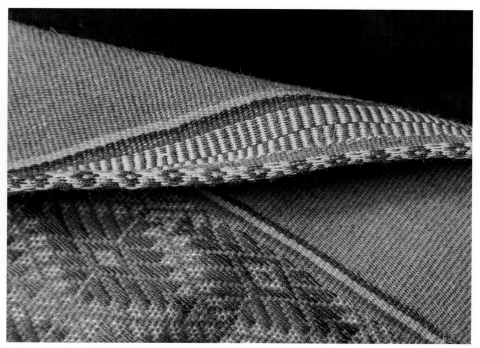

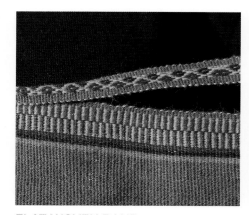

FLAT WOVEN BAND
A band woven flat is rounded over the edge of a textile and stitched on, creating the effect of a tubular border.

KUMPAY, CHUKAY, AND TIKACHAY
JOINS, SEAMS, AND EMBROIDERY

KUMPAY (LOOPING EMBROIDERY STITCH)

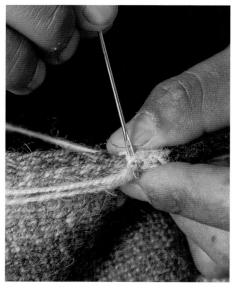

Kumpay is a looping embroidery stitch. There is some evidence that it was once used for the borders of ponchos and blankets. Today, however, few communities still use this border stitch to decorate and protect textile borders. In Accha Alta, weavers now use kumpay to join and decorate the edges of costales, or sacks used to transport produce such as potatoes. The looping stitch creates rows of loops which run horizontal to the edge of the textile. You can put in just one row of loops along the top edge of the textile, two rows (one along each side of the textile), three rows along the top and sides, or up to four rows.

Stitching kumpay onto the border of textiles is not hard but can be labor intensive depending on how close together you make the stitches and how fine the yarn is. For costales, weavers typically place the stitches farther apart to go faster. When they use kumpay to decorate and cover the edges of the Momia Juanita lliqlla, however, they make the stitches much closer together which makes the process very slow and tedious. The end result, however, is much finer and more elegant.

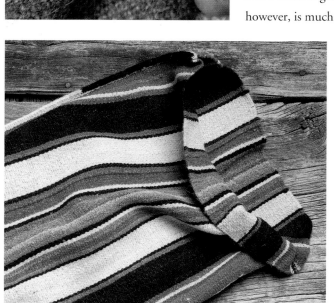

ABOVE: Kumpay joining a costal, working from left to right.
BELOW: Costal from Accha Alta.

To embroider the kumpay border you will need one large needle and as many colors of thread as you want. You can create the kumpay border in just one color, or almost an unlimited number of colors. Weavers from Accha Alta often use three to five colors in sections about two inches long.

You can sew kumpay either from left to right or from right to left, creating the chain of stitches in the direction that you work in. We find that it is easier for right-handed people to work right to left, and vice versa for left-handed people. This allows you to hold extra color threads not currently in use in your non-dominant hand, keeping them straight and organized so that your dominant hand can work with the color currently in use. We will assume the perspective of a right-handed person working from right to left. Simply reverse the direction of the instructions below to work left to right.

These instructions (starting on page 114) are for kumpay with two rows, which is the most common. To create kumpay with one row, three rows, or four rows, simply follow the beginning stitch instructions to add more or fewer cross stitches for the number of rows you wish to make.

MOMIA JUANITA MUMMY JUANITA

The Mummy Juanita, also known as "The Ice Maiden," was a frozen mummy found on Mount Ampato near Arequipa, Peru. Archaeologists have dated this eleven- to fifteen-year-old girl to around A.D. 1440; she is one of the best preserved mummies to be found, naturally preserved in ice for over 500 years. Juanita was discovered wrapped in a woven mantle, a head cloth, and a lliqlla around her shoulders.

Members of the CTTC have viewed and researched the Momia Juanita textiles and have worked to replicate them. This project began in 2005 when the CTTC coordinated a collaboration with the National Geographic Society with the help of Johan Reinhard, who found the mummy, and Bill Conklin, a textile specialist who unwrapped the mummy and shared the information and photos. We presented the project of producing a replica of Juanita's lliqlla, belt, and her *axu* (dress) to the weavers. At first examination, the weavers found the textiles to be so complicated that they couldn't determine the techniques and designs from the photographs. The CTTC sent a group of weavers to the *Museo de Santuarios Andinos* (Museum of Andean Sanctuaries) in Arequipa to see the mummy. It was still a challenging endeavor, but after many months of practice, finally some weavers were able to decipher Juanita's textiles and reproduce them. After that, the CTTC held a weaving contest, which resulted in some very fine textiles. Since then, many weavers who work with the CTTC weave these replica textiles.

The kumpay border used for costales in Accha Alta is very similar to the embroidered border found on the Juanita Mummy textiles, as well as on many other textiles of high-ranking people in the Inca Empire. While the two stitches are not exactly the same in structure, they are very similar in appearance and end result. The Juanita border technique was likely created with two needles, not with one needle as in kumpay for the costales. Today the CTTC weavers use the kumpay border to finish the edges of the Juanita replica pieces as the original border has been lost to time.

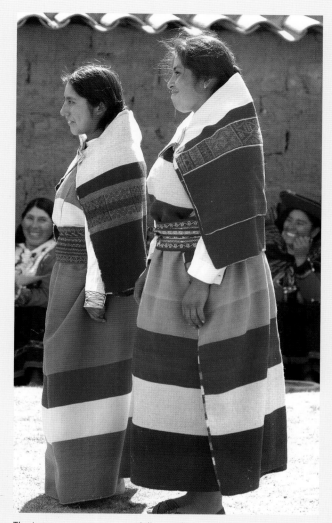

The two young weavers modeling replicas of the Momia Juanita textiles from the 2006 weaving competition. ABOVE LEFT: Rosa Pumayalli Quispe is one of the first members of the Jakima Club in Chinchero. ABOVE RIGHT: Alina Cusihuaman Quispe is an accomplished member of the Chinchero adult weaving association. The striped cloth that forms the skirts is finished in kumpay. BELOW LEFT: Kumpay on a Juanita textile.

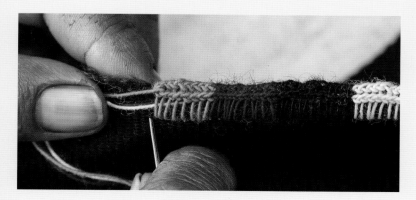

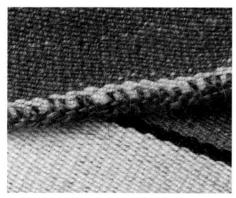

ABOVE: Deeper kumpay stitches of the Juanita textile showing the crossed platform for the first crossed stitch. BELOW: Shallow kumpay stitches of the costal.

1 Creating the Platform for Your First Cross Stitch Thread your needle with the color of thread you will start with. Run the needle through the textile in the direction of the weft so that you hide the tip of your thread with the weft between the warp.

a Bring the needle and thread out of the textile near to the edge on the back side of the fabric—the side facing away from you. The distance between the edge of the textile and where you bring the thread out depends on how wide you wish to make your stitches. If you want shorter stitches as for the costales, then bring the needle out close to the edge. If you want longer stitches like the Momia Juanita manta, then bring the needle out farther from the edge.

> Beginning the first stitch is the hardest part. Once you have established the crosses with this first stitch, the rest is easy.

b Sew one loop of the thread over the edge of the textile, back to front, bringing the needle through the cloth at the same point on the other side of the fabric so that it reappears on the beginning side in the same place.

> Repeat this to create a second loop around the edge of the textile.

c On the front side of the cloth—the side facing you (the needle should be on the same side facing you), run the needle from left to right under the two loops you have just created.

d Pull the needle and thread from right to left over the two loops.

e Bring the needle over the edge of the textile to the back side.

f On the back side of cloth, run the needle from left to right under the two loops.

g Pull the needle and thread from right to left over the loops.

2 Forming the Cross Stitch

3a Completing the Cross Stitch

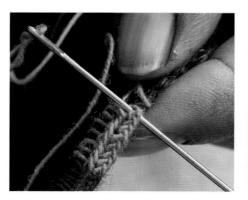

On the back side of the cloth, look carefully at the two loops with the crossed length of thread over them. They should form a cross. Run your needle under this cross from top to bottom.

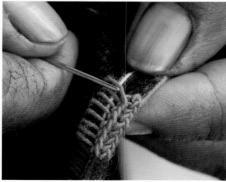

Bring the needle back over to the side of the cloth facing you. Again, look carefully at the stitches you made and find the cross.

Changing Colors Changing colors in kumpay is very easy. Remove the needle from the current color you are using. Thread the needle with the new color you will use. Insert the needle in the edge of the cloth from the opposite side to the side facing you at the place where you made the last stitch in the other color. Pull the needle through, leaving a short tail (1 inch) on the other side. Use your left hand to pull this thread tail taut along the edge of the textile along with the first color you used. Continue stitching kumpay with the new color exactly where you left off with the first color. Make sure that the tail of the new color and the length of first color are enclosed by the kumpay stitching.

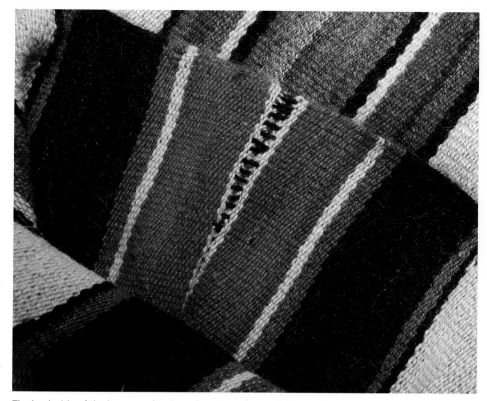

The back side of the kumpay, showing where two pieces of the costal were joined together.

3b Completing the Cross Stitch

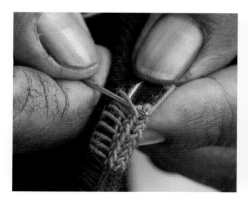

Run your needle under this cross from bottom to top. Finding the cross the first time is the hardest. Now that you have established the cross it should be fairly easy to identify from now on.

3c Completing the Cross Stitch

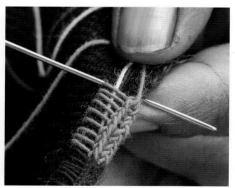

Pass the needle through the fabric for the next stitch and look for the cross formed on the back side of the textile. Repeat Steps 2 and 3 to continue stitching kumpay onto the edge of your textile.

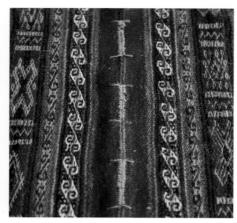

The *Tika* (flower) design embellishes the q'enqo design on this Chahuaytire manta.

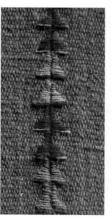

A chukay from Patabamba in the *ñaccha* (comb) design.

CHUKAY (SEAM)

Nearly every community or region has its own, unique seam used to join the two halves of a manta, lliqlla, or poncho. In Chinchero, as well as in many other communities, weavers use a zig-zag stitch called q'enqo that alternates sections of different colors. In Mahuaypampa the traditional seam stitch represents women's petticoats, while in Chahuaytire weavers are known for their rose, or flower, stitch. In some communities weavers try to hide their joining stitch so that it is not seen at all.

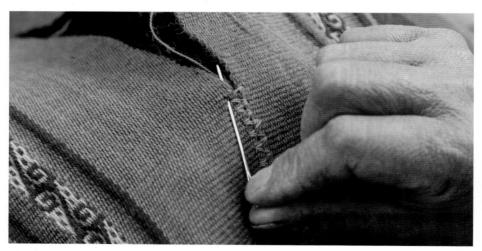

Gregoria Pumayalli Auccacusi from Chinchero seams together two textiles in the q'enqo (zig-zag) design.

Chukay designs from the community of Mahuaypampa. LEFT: *pasna justanniyuc* (girl with petticoat). RIGHT: *pasna* (young women).

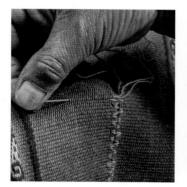 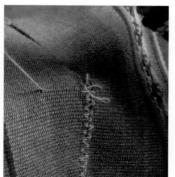 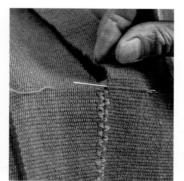

The thread is carried through the fabric away from the seam and broken off and a new color is started on the opposite side. This ensures smooth color changes.

TIKACHAY (EMBROIDERY)

Throughout the weaving communities of the Cusco highlands, textiles are elaborately patterned by laboriously manipulating the colored threads of the warp row by row. Weavers in Ccaccta, the Ocongate region, and Sallac have another way, though. They weave a base fabric of solid stripes, some of which have a different weave structure: pairs of threads are raised rather than single ones, resulting in a "half basket" weave structure similar to fabrics used for counted cross-stitch. When the fabric is completed, the weaver can then take it with her to the fields or hearthside and apply the pattern stripes with needle and thread. This technique has long been used for *watanas* (see page 123) in Sallac, but in other regions they use this technique to make patterns in mantas and ponchos. The only disadvantage? "Our needles get lost in the field, and then we lose a full day of work," the weavers say.

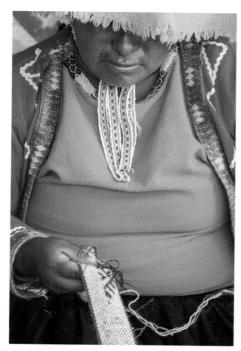

Nieves Mamani Quispe from Sallac embroiders the open weave structure on a belt.

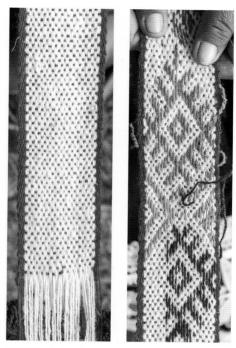

LEFT: The belt prior to embroidery. RIGHT: Sections of the belt embroidered with the chaska design.

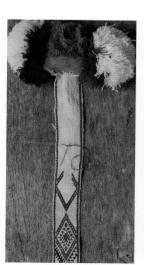
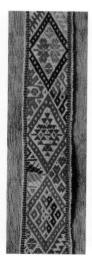

A plain-weave hatband from Pitumarca is embellished with colorful embroidered designs.

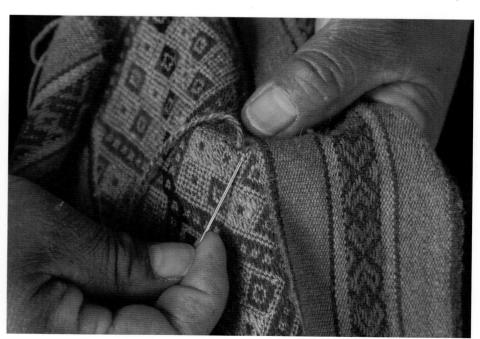

Juana Merma Ccausaya from Huacatinco accents her manta with embroidery in blue and gold threads.

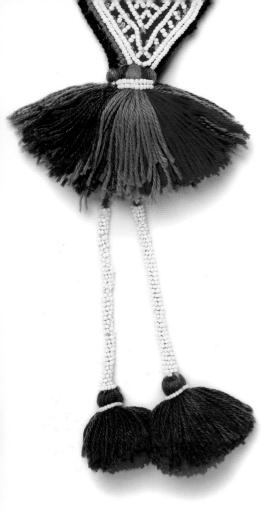

TASSELS, POM-POMS, AND *WATANAS*

HUACATINCO BEADED TASSEL

In Huacatinco, beaded tassels create a beautiful finishing touch on the earflaps of chullos and can also be attached to jackets. They may have one or more colored tassels at the bottom.

Tassels are formed from threads left hanging at the end of a braided rope. The braids are wrapped from the base of the tassel with a string of beads that are stitched in place. The end of the tassel is then stitched to the inside bottom of the earflap on a chullo.

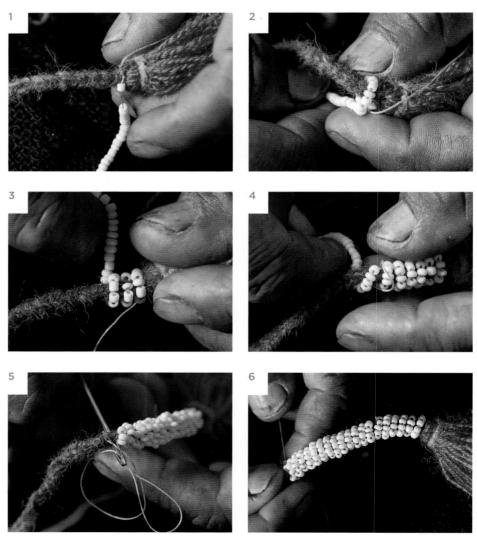

KINSA CHAKI (POM-POM WITH THREE LEGS)

This type of pom-pom is used in Pitumarca, Ausangate, and other regions as well. They are decorative items especially for young people's clothing to be worn for dancing at carnivals, and for llama and alpaca decorations, where they are used as a kind of marking.

Note: *Tassels in the community of Pitumarca often employ braids from waraqa (sling). Please see instructions for braiding the q'enqo design (page 127) for that part of the tassel. The design in this tassel is a variation of q'enqo called jarpapaqui.*

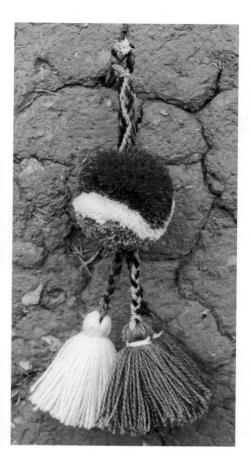

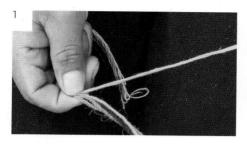

1 Select four colors of threads for the q'enqo design. Cut a length of the four colors about as long as your arm. Remove one color.

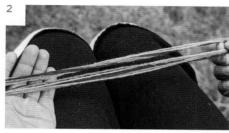

2 Fold the remaining three threads in half, but not evenly. Let one side be about two inches longer than the other side.

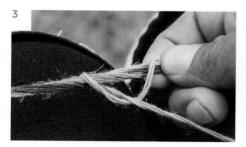

3 Tie an auxiliary thread around the fold in the middle of the threads. Attach this auxiliary thread firmly in front of you (with a safety pin to your pants or hold it firmly between your knees).

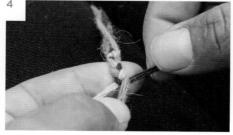

4 On the half of the threads that is slightly longer, braid about 1 inch with the three threads, starting at the bend where the auxiliary thread is. Remove the auxiliary thread.

5 Fold the small braided section into a loop, bringing the hanging, loose threads together. The two sides of hanging threads now will be of the same length.

6 Place the auxiliary thread through the loop and refasten it in front of you.

7

Divide the three colors as you would to braid the q'enqo design. Because it is a sixteen-thread design, and there are only three colors, one of the thread groups will be missing a color.

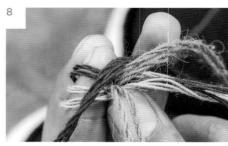

8

Pick up the fourth color of thread that you removed at the beginning.

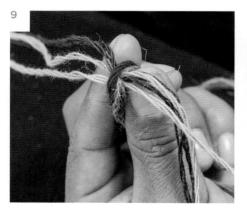

9

Pair it with the thread group that is missing its second color. Lay the fourth color tip to tip next to the third color, letting it lie under the little braided loop. Braid about two to three inches of the q'enqo design. The size of this braid will partly depend on the size of the pom-pom you will make. Remember that the pom-pom will partly cover up some of the braid, so calculate the radius of the pom-pom into how long you want the braid to be. Tie off the end of the braid with a tight square knot.

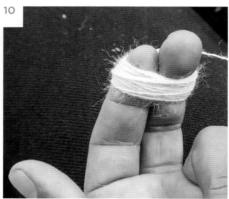

10

Select the color or colors for the pom-pom.

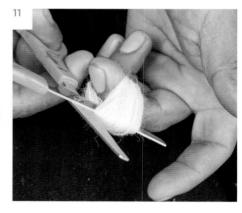

11

Wrap one color around two fingers over and over, building up a bulky ring.

12a

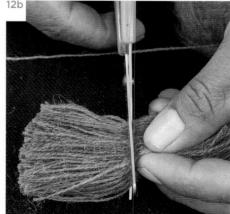

12b

To make your pom-pom full and firm, you must include enough thread. Cut the ring in half, removing it from your fingers. Cut these lengths of thread in half once more. Repeat this if you want to include more than one color in the pom-pom.

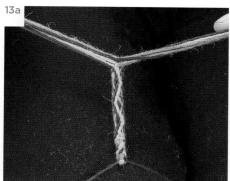
13a

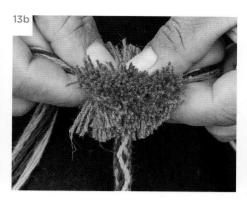
13b

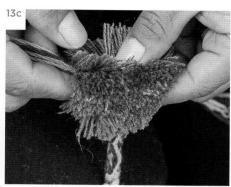
13c

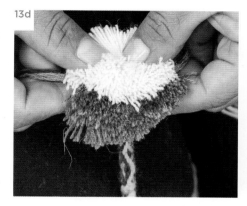
13d

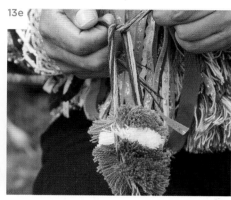
13e

13a–d Place these short lengths of thread over the square knot that you tied when finishing the jarpapaqui braid. Tie the pom-pom threads very firmly with two more square knots.

13e The thread from the braid will still be hanging out the other side of the pom-pom. If you want a simple pom-pom with no leg tassels, then just trim this thread off when you trim the pom-pom down to size. If you want tassels hanging out of the pom-pom, then separate the thread of the braid into three sections. You now have a choice. You can either braid the legs or wrap the legs. Wrapping is the more common way in Pitumarca, and some believe more aesthetically pleasing.

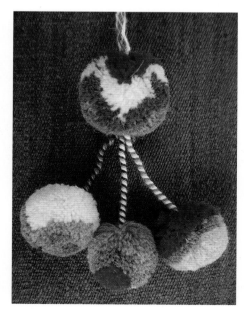

To wrap the legs:

Select which two colors will be on the outside and which color on the inside of the wrap. Hold the inner thread taut and wrap the two other threads around it. Tie them off firmly at the bottom with square knots.

Note:

People will create pom-poms with different numbers of legs. While three legs are more common and make the textile fuller and more appealing, sometimes just one or two legs are put in under the pom-pom if the textile is smaller.

To braid the legs and form the tassels:

1

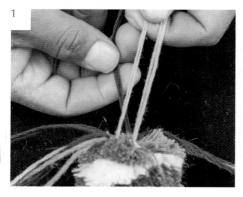

Divide the lengths of the long, hanging threads in three groups.

2

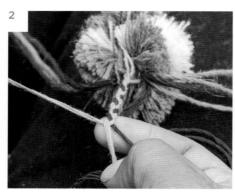

Braid the three groups of threads.

3

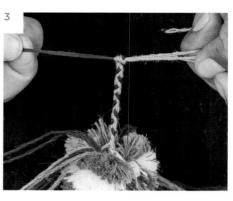

Tie them off firmly at the bottom with square knots.

4

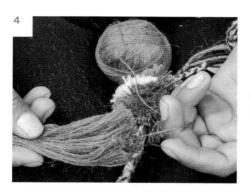

Prepare three small tassels for each leg of the pom-pom by wrapping the yarn around two fingers as you did for the pom-poms but with less bulk.

5

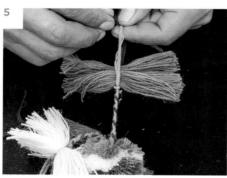

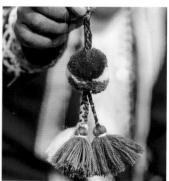

Place the lengths of yarn over the square knot in one of the legs, and tie it down firmly with square knots.

6

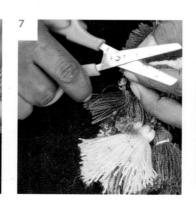

Thread a needle with yarn. Wrap the yarn firmly around the head of the tassel to give it form. Tie the yarn off to itself tightly with square knots. Use the needle to hide the ends of this yarn inside the tassel.

7

Cut the pom-pom down to form. Don't be afraid to cut deeply and take out a considerable amount of the outer thread to make it compact.

Finished pom-pom.

WATANA (NARROW WOVEN BAND)

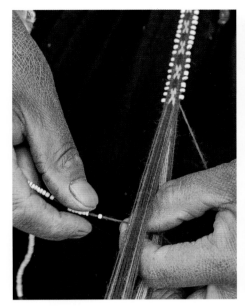

Beads strung on the weft thread are secured to the edges of the watana as it is woven.

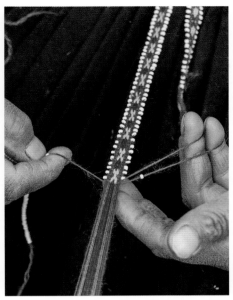

The beads on watanas from Huacatinco used to be spaced widely apart. Today, there is little space between the beads that embellish watanas in ornate designs.

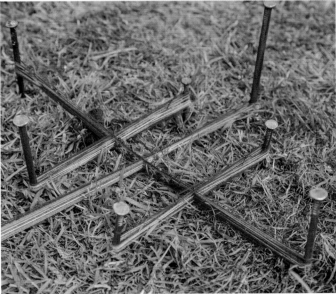

A warped and partially woven wasa watana shows the complex intersection of vertical and horizontal threads.

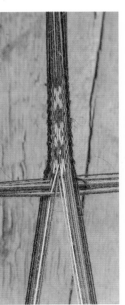

Wasa watana is a decorative band with other bands woven across and through it. They are used to adorn hats worn for dancing and also can be used as accessories for women's hair.

WARAQA SLING BRAID

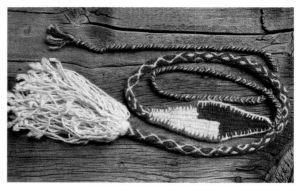

For thousands of years the people of the Andes have used slings in warfare, hunting, and ritual practices. The Inca military used slings in battle, while farmers used slings to protect their crops from birds and other hungry animals. Some cultures also used slings as part of their head wraps. Today, Andean herders continue to use slings to guide and protect their flocks of animals, including llamas and alpacas. Slings also retain many ceremonial and cultural uses today as in the past. In many dances, participants wear fancy, ornamental slings around their waists and chests, and swing another around their head to bring it down swiftly against the ground, making a loud cracking noise.

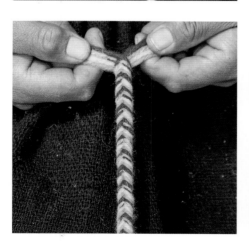

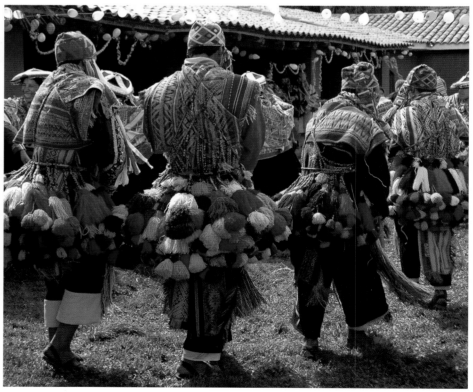

ABOVE: Virginia Castro from Pitumarca braids an eight-strand flat braid. Virginia learned to braid when she was fifteen years old by watching her father because she wanted to make a braid to give him as a gift. RIGHT: Ceremonial dancers wear ornamental slings around their chests.

Typically, slings are braided by men who often collect alpaca and llama fiber to prepare yarn for their braiding. The string for rope braiding must be very strong, so men will often put in a high amount of twist and more than two plies. The best way to procure the necessary fiber is by helping friends and neighbors to shear their animals, as gifts of fiber are given in thanks. Traditionally, young men braid slings for young women as a sign of affection, while young women will weave unkuñas (square carrying cloths, see page 64) for young men. There are also many songs about slings that are directed toward men, especially young men. In the same way, many songs about weaving are meant for women.

The practice of braiding slings, unfortunately, began to disappear as young men were no longer interested in learning the designs, many of which can be very complex and difficult. On top of this, a growing evangelical movement in the Andes prohibits participation in traditional dances and rituals. Many of these dances use slings in various ways. The Q'olla, or people of the altiplano, use very heavy and strong slings in their dances, during which they ritually whip each other. In the Pitumarca region, men use many slings with very fine yarns and tassels.

Men typically make their slings in intricate patterns with yarn in the natural whites, grays, and browns of llama fiber. There are three parts of a waraqa: a thicker braid in intricate patterns, the cradle in the middle, and a thinner braid in a less intricate pattern. The cradle in the center, which is called *tarañan* in Quechua, is where the user places the rock; it often has a slit through the center which is sometimes used to pull one end of a braid through to shorten the waraqa. Instead of a slit through the cradle, some have a circular hole, called *ninrin*, braided into the end of the thick braid in order to insert the smaller braid.

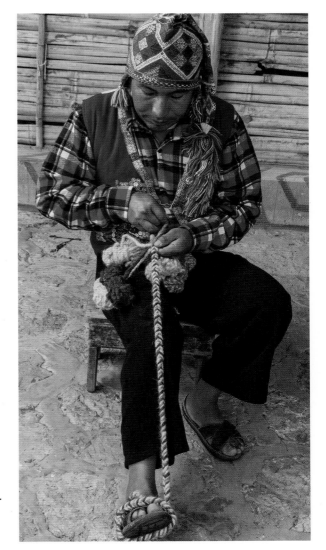

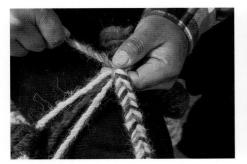 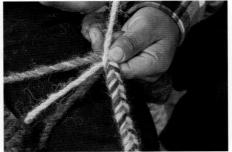 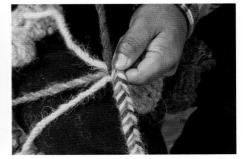

Jaime Condori Huaman from Pitumarca braids a six-strand flat llama rope. He tensions the braid he's already completed around the bottom of his foot.

Because My Heart Adores You

by Yanett Soto Chuquichampi

English	Spanish	Quechua
Because my heart adores you,	Porque mi corazón te quiere,	Qan munakuq sunqoywanmi
I am braiding *amapolas*.	estoy trenzando amapolas.	Amapoltasta siphani
Because my heart loves you,	Porque mi corazón te ama,	Qan munakuq sonqoywanmi
I am braiding llama *ñawi*.	estoy trenzando llama ñawi.	Llama ñawita siphani
I am making my slings	Mis hondas estoy haciendo,	Warakachaytan ruwani
to steal your heart.	para robar tu corazón.	Sunquchaykita suwanaypaq
I am braiding my slings	Mis hondas estoy trenzando,	Warakachaytan simphani
to entrance your eyes.	para encantar tus ojos.	Ñawichaykita apanaypaq
I don't know why my heart	No sé porque mi corazón	Imanancha kay sunquyta
tells me that it adores you.	me dice que te quiera.	Munallasunraq niwashan
I don't know why my eyes	No sé porque estos mis ojos	Hayk'anancha kay ñawitay
tell me that they love you.	me dicen que te amen.	Kuyallasunraq niwashan
They always tell me that they adore you	Siempre me dice que te quiera	Munallasunraq niwashan
They always tell me that they love you.	Siempre me dicen que te amen.	Kuyallasunraq niwashan

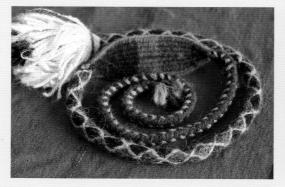 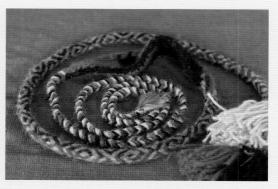

LEFT: *Amapolas*: a sling braid design of poppies that grow on the banks of rivers. Amapolas is also a complex three-color, and occasionally five-color, weaving technique from Pitumarca. RIGHT: Llama *ñawi*: a sling braid design of llama eyes.

Q'ENQO OF SIXTEEN THREADS IN FOUR COLORS

Q'enqo is a Quechua term for zig-zag and is a common design in braiding and in other textiles. This braid can be worked in two colors with eight or sixteen threads. Here it is worked with sixteen threads in four colors.

Preparing the Threads

1 The four colors are arranged into pairs of two colors each. Select the two colors for each pair.

2 Cut two strands, about a yard long, of two colors (Colors A and B).

3 Cut two strands about a yard long of the other two colors (Colors C and D). You will have a total of eight threads.

4 Alternatively, you can use a warping board and wind the threads around the pegs, with no cross, to measure out the strands and to keep them from tangling.

5 Lay A and B yarns across the C and D yarns and fasten them together at the mid-point with a loop of yarn in a different color. Pull the loop tight.

> You will now have two sets of 4 strands each, 16 ends: Set 1, yellow and green yarns, and Set 2, red and gray yarns.

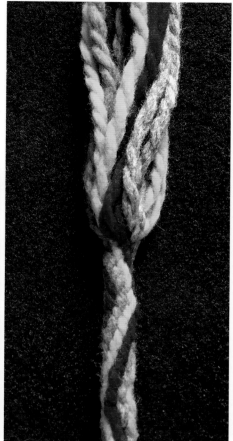

The Braiding

In your left hand, hold the loop of auxiliary string and the Set 2 threads in your fist so that they trail down toward the floor under your hand. Place the Set 1 threads so that they trail upward in the opposite direction, over the fingers of your left hand.

The threads naturally divide where you have tied the strands together. One half will always be draped over the fingers away from you. The other half will always be draped over the thumb toward you. Each half has four threads: two threads of one color and two threads of another color.

Each half is divided into quarters. There is a left quarter and a right quarter. The two threads of each quarter will be of the same color.

You always pair threads together across the center divide, from the top and bottom halves. When you do this, you will always pair threads from one left quarter with the other left quarter, and from one right quarter with the other right quarter.

Left Quarter Right Quarter

Right Quarter

Left Quarter

1

2

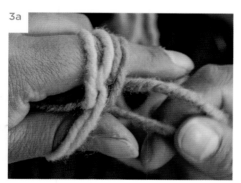

3a

To begin the design, you will start working only with the threads of Set 1. Lay half of the Set 1 threads over the fingers of your left hand and the other half over the thumb following the natural divide.

For Set 1, you will pair the same color with itself: Color A you will match with Color A, and Color B you will match with Color B. In the beginning, it does not matter which threads from each side of the divide you match together. Later, once the braid design has been established, it is very important to pair the correct threads together.

1 To begin, select a thread of color A that is lying over your thumb. Pair it with a thread of color A that is lying over your fingers. Drape both of them away from you over the fingers. Tuck the pair between your index finger and middle finger. Let the threads run through your fingers.

2 Pair the remaining two threads of Color A together. Drape both of them toward you over your thumb. Use the pads of the last three fingers to pinch this pair of threads to your lower thumb or palm of your hand. This keeps them secure and away from the rest of the threads that must be worked.

3 a Repeat this process for Color B. Create a pair with a thread from each side of the divide and drape them away from you. b Create a second pair with the two remaining threads and drape them toward you. You are now finished working the first line of Set 1.

4 Hold the Set 1 threads securely and pull them taut with your thumb and index finger and wide enough to pull through the Set 2 threads from where you are holding them in your fist. Pull the Set 2 threads up around the left and right sides of the Set 1 threads— four threads up the right side (a pair of C and D threads) and four threads up the left (another pair of C and D threads)—and hold them in your right hand. You will now have the threads of Set 1 held in your fist, trailing toward the floor. Arrange Set 2 along the natural divide with half the section laid over your fingers and half over your thumb.

5 Repeat Steps 1–4 with Colors C and D to work the first line of Set 2.

3b

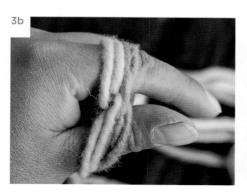

4

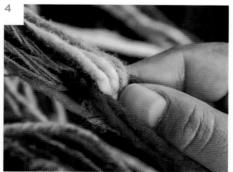

5

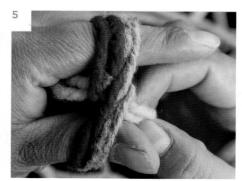

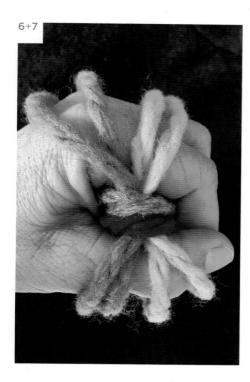

6+7

Working the Remaining Rows

6 Set 1 threads should be draped as you did before, with half the threads over the fingers and half over the thumb, following the natural divide in the threads. This time the B threads will be in the left quarter and the A threads will be in the right quarter. Now that you have worked the first line, it is important that you select the correct threads to pair together.

7 When you look at the two threads of each quarter of the Set 1 threads, you will notice that one protrudes out from lower down than the rest of the threads and one protrudes out from higher up than the rest of the threads.

8 From the threads lying over your thumb, select the thread that protrudes from lower down in the left quarter. Pair it with the thread that protrudes from higher up in the left quarter of threads draped over your fingers. Drape them away from you over your fingers.

9 From the threads lying over your fingers, select the thread that protrudes from lower down in the left quarter. Pair it with the thread that protrudes from higher up in the left quarter of threads draped over your thumb. Drape them toward you over your thumb.

10 Do the same for the threads of the right quarter.

11 Bring Set 2 threads to the top, releasing Set 1 threads and hold them in your fist.

> Repeat Steps 6–10. Select the threads that protrude lower down and pair them with those that protrude higher.

> Continue braiding in this manner for ten rows. After braiding ten rows, you will switch directions.

8
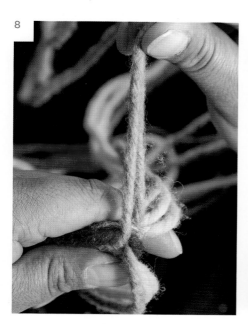

9
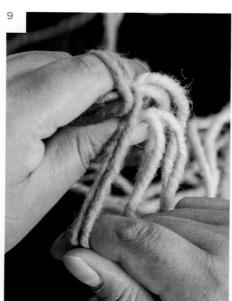

10
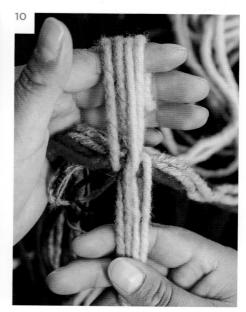

> So far you have been pairing threads starting with selecting a thread from over your thumb, pairing it, and passing it over your fingers. To change directions, select the correct thread from over your fingers, pair it, and pass the pair toward you over your thumb.

> When you change directions, you pair threads in the same exact way as before: select the thread that protrudes from lower down, pair it with the thread on the other side that protrudes higher up.

> Continue braiding in the opposite direction for ten rows before switching directions once again to the original direction.

> Continue braiding in this manner until you have four inches (10 cm) of thread left. Take one strand of yarn and make a half-hitch over the braid. Repeat with 3 to 4 more strands.

Tips and Troubleshooting

> Passing the first thread pair toward you over your thumb sends the zig-zag of the pattern away from you.

> Passing the first thread pair away from you over the fingers brings the zig-zag toward you.

> If you do not change directions of passing threads, the design will be a stripe through the center of the braid rather than a zig-zag. This is called kh'ata, the same term for plain weave.

> Each time you go to pair a thread, give it a firm pull at the base where it comes out of the braid. This will tighten the threads and produce a tight, even braid. Be careful, if your thread is not tightly plied, but loose and fluffy, this tightening can easily pull out the thread over time, weakening it. Too strong a tug may break weak, loose threads.

> If you are working with very long strands that are difficult to pull through due to their length, then fold them in half and tie them off with a slipknot. The shorter length will be easier to work with and you can take out the slipknot to let out more length as you move along.

> It's important to keep mental count of how many lines you have before you change directions. If you are having trouble, use a memory tool like placing a pebble next to you every time you finish a row.

> When you pause in working, it's important to remember for next time where you are so you can start again. Sometimes it's a good idea to finish all the rows in the direction you currently are on so that you know when you come back that you are starting on the new direction and don't have to remember how many more lines to go before you change.

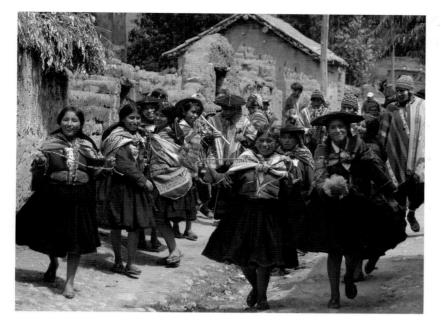

Spinning, weaving, and knitting are the heart of traditional Andean textiles. The techniques for finishing and embellishing these textiles are also quite remarkable, requiring tremendous effort and skill. Rooted in practicality, these finishing secrets are also imbued with cultural significance and spiritual beliefs practiced in the Peruvian highlands today as they have been for thousands of years.

GLOSSARY OF QUECHUA AND SPANISH WORDS

Amapolas: poppy

Apu: mountain gods

Axu: dress

Bayeta: plainweave cloth

Ch'uspa: small purses used for carrying coca and coins and to be worn while dancing

Chakana: a cross design

Chicha: fermented corn beverage

Chichilla: a tubular edging technique that is woven and joined with the weft onto the edge of a textile at the same time

Chinka chinka: a plain weave, tubular edging in which the central threads appear and disappear

Chaska: star motif

Chukay: seams for joining two pieces of textiles, in many case decorative

Chullo: hat

Chumpi: belts

Chunchu: person from the jungle

Chupan: the long tail of a chullo prominent in the communities of Chinchero and Pitumarca

Costal: handwoven sack

Doble cara: complementary warp

Doubleweave: two layers of cloth woven simultaneously

Escalonada: staggered-step design

Golon: woven band sewn to the bottom of a skirt made with a weft-faced tapestry technique

Guanaco: wild camelid in the altiplano

Jakaku sisan: a complex wave motif

Jakima: a narrow woven ribbon or band, also called watana or wato

Jakira: intermesh

Jarpapaqui: a braiding design with sixteen threads

Kaulla: shed sword

Kenti: hummingbird

Kh'ata: plain weave

Kinsa chaki: three legs

Kintu: whole coca leaves usually presented for offering in a group of three leaves

Kipu: Inca knots used for accounting and as a writing system

Kumpay: a looping stitch technique used to join two textiles or to create a decorative border

Kuti q'iswa: simple wave motif

K'utu: bump

Ley: supplementary warp

Llama ñawi: llama eye

Lliqlla: shawl or carrying cloth

Llipta: lime to chew with coca leaves

Luraypu: triangle

Maki maki: hand to hand

Manta: shawl

Maquito: arm warmers or sleeves used by men to protect the forearm while working in fields

Mishmi/mishkuy: a short stick used for twisting llama fiber

Ñaccha: comb

Ñawi awapa: a tubular woven edging with eye motifs

Pachamama: mother earth

Paña lloqe: S-spun yarn plied in the Z direction

Pasna: young women

Pasna justanniyuc: girl with petticoat

Pata pallay: pebble weave

Polleras: women's skirts

Pukhu: small ceramic bowl used for supported spinning

Puntas, picas: scallops

Pushka: hand spindle

Q'enqo: zig-zag motif, braided or stitched and also a textile design

Q'olla: people of the altiplano

Q'urpu: small popcorn or bobble

Ruki: llama or alpaca bone used to beat the warp and weft threads and in some areas, to pickup the patterns

Tanka ch'uru: one of the first designs that young weavers learn to weave

Tarañan: cradle in the middle of a sling

Ticlla: discontinuous warp or discontinuous warp and weft

Tikachay: embroidery

Tokoro: a shed rod

Urpi: bird

Vicuña: wild camelid of the altiplano

Waraqa: sling braids

Wasa watana: a narrow woven band with other bands woven through it

Watana: a narrow woven band

Watay: resist dyeing yarns before weaving

RESOURCES

FURTHER READING

Cahlender, Adele. *Double Woven Treasures of Old Peru.* Interweave Press, 1993.

Cahlender, Adele, Marjorie Cason, and Ann Houston. *Sling Braiding of the Andes.* Colorado Fiber Center, 1980.

d'Harcourt, Raoul. *Textiles of Ancient Peru and Their Techniques.* University of Washington Press, 1962.

Dransart, Penelope. *Textiles from the Andes.* Interlink, 2011.

Heckman, Andrea. *Woven Stories: Andean Textiles and Rituals.* University of New Mexico Press, 2003.

LeCount, Cynthia Gravelle. *Andean Folk Knitting: Traditions and Techniques from Peru and Bolivia.* Interweave Press, 1993.

Lewandowski, Marcia. *Andean Folk Knits: Great Designs from Peru, Chile, Argentina,Ecuador, and Bolivia.* Lark Books, 2005.

Miller, Rebecca Stone. *To Weave For the Sun: Ancient Andean Textiles in the Museum of Fine Arts, Boston.* Thames and Hudson, 1994.

Owen, Rodrick and Terry Newhouse Flynn. *Andean Sling Braids: New Designs for Textile Artists.* Schiffer, 2016.

Phipps, Elena. *The Peruvian Four-Selvaged Cloth: Ancient Threads.* Fowler Museum, 2013.

Reinhard, Johan. *Discovering The Inca Ice Maiden.* National Geographic, 1998.

Rowe, Anne, and John Cohen. *Hidden Threads of Peru: Q'ero Textiles.* Merrell, 2002.

Silverman, Gail P. *A Woven Book of Knowledge: Textile Iconography of Cuzco, Peru.* University of Utah Press, 2008.

Urton, Gary. *Inka History in Knots: Reading Khipus as Primary Sources.* University of Texas Press, 2017.

MUSEUMS

Amano Pre-Columbian Textile Museum, Lima, Peru www.museoamano.org

Fowler Museum, University of California, Los Angeles www.fowler.ucla.edu

Metropolitan Museum of Art, New York, New York www.metmuseum.org

Museum of International Folk Art, Santa Fe, New Mexico www.internationalfolkart.org

National Museum of American Indian, Smithsonian, Washington, D.C. www.nmai.si.edu

The Textile Museum, George Washington University, Washington, D.C. www.museum.gwu.edu/textile-museum

Textile Museum of Canada, Toronto www.textilemuseum.ca

ORGANIZATIONS

Alliance for Artisan Enterprise: A collaboration of resources working to support the full potential of artisan enterprise around the world
www.allianceforartisanenterprise.org

Andean Textile Arts: Supporting the people and communities of the Andes in their efforts to preserve and revitalize their textile traditions
www.andeantextilearts.org

ClothRoads: An online marketplace, providing economic support to artisans worldwide
www.clothroads.com

Center for Traditional Textiles of Cusco
www.textilescusco.org

WARP Weave a Real Peace: A networking organization for textile-based development work
www.weavearealpeace.org

PHOTOGRAPHY AND ILLUSTRATION CREDITS

PHOTOGRAPHY

Joe Coca:

pp. Cover, v, 8–10, 11 top, 12 top, 13–20, 21 top and bottom left, 22–23, 26 top right, 27 top and right, 28, top left, 29–32, 33 left and center, 34–35, 36 top, 37, 38 top, 39 right, 40, 44 right, 46 left, 48, 49 top, 54 bottom, 56–57, 59, 61 right and bottom, 62, 64 left and bottom right, 65 left, 68, 70–72, 73, 74 left, 75 top right, 76–77, 86, 89, 90 top, 92 top, 95, 96 bottom left, 97 top, 99, 112 bottom, 113 bottom, 114–115, 117 top, 119 top right, 123 top left and right, 124 top right, 130

Diana Hendrickson:

pp. 11 bottom, 12 bottom, 21 right, 24–25, 26 bottom, 27 lower right, 28 center and bottom, 33 top, center, bottom right, 36 bottom, 38 bottom, 39 left, 41–45, 46 center and right, 47, 49 center and bottom, 50–55, 58, 60, 61 top and center, 63, 64 top right, 65 top and bottom right, 66–67, 69, 72, 74 right, 75 left and center, 78–85, 87–88, 90 bottom, 91, 92 left and bottom, 93–94, 96 top left and right, 97 bottom, 98 bottom, 100-111, 112 top, 116 top and center left and bottom, 117 bottom, 118, 119 left and center, 120, 121 top and center, 122, 123 top center and bottom left and center, 124 tom and bottom left, 125, 127–129, 131

Sarah Lyon:

pp. 98 top, 116 top and center right, 121 bottom left, 126

Paula Trevisan:

p. 7 bottom right

Center for Traditional Textiles of Cusco staff:

pp. 6–7, 113, 124, 131

Photographs of children on p. 7 are from the following communities:

Top Row, Left to Right: Accha Alta, Chahuaytire, Santo Tomas; Second Row, Left to Right: Mahuaypampa, Accha Alta, Huacatinco; Third Row, Left to Right: Pitumarca, Chinchero, Accha Alta

ILLUSTRATION

Naomi Elting:

pp. 40, 127

Laurel Johnson:

p. 80

Michael Signorella:

p. vi

134

INDEX

OTHER BOOKS FROM THRUMS

THRUMS BOOKS DISTRIBUTION

United States & Canada: Independent Publishers Group; www.ipgbook.com

United Kingdom & Europe: Search Press; www.SearchPress.com